VISUAL ALCHEMY

VISUAL ALCHEMY
THE FINE ART OF DIGITAL MONTAGE

Catherine McIntyre

Routledge
Taylor & Francis Group

LONDON AND NEW YORK

First published 2014 by Focal Press

Published 2019 by Routledge
2 Park Square, Milton Park, Abingdon, Oxon, OX14 4RN
52 Vanderbilt Avenue, New York, NY 10017

Routledge is an imprint of the Taylor & Francis Group, an informa business

Library of Congress Cataloging in Publication Data
McIntyre, Catherine.
Visual alchemy : the fine art of digital montage / Catherine McIntyre.
 pages cm
ISBN 978-0-415-81657-1 (pbk.)
1. Photomontage. 2. Composition (Photography) 3. Photography, Digital techniques.
I. Title.
 TR685.M38 2013
 778.8–dc23
 2013024826

ISBN: 978-0-415-81657-1 (pbk)

Typeset by Alex Lazarou, Surbiton, UK

{ *Contents* }

Preface vii

—————

INTRODUCTION

pp 1–5

Digital manipulation as
a medium of expression 2

THEMES

pp 6–15

Finding your subject 7
Themes 7

BEAUTY AND IDEA

pp 16–18

INFLUENCES

pp 19–29

INSPIRATION

pp 30–36

The influence of practice 32
The influence of environment 32

SUBJECTS

pp 37–77

The portrait 38
The nude 43
The landscape 54
Architecture 58
The natural world 64
Still life 69
Myth 72
Abstraction 74
Absence 76

COLLECTING SOURCE MATERIAL

pp 78–99

Taking source photographs 79
Treasure hunting 80
Finding a model–portraits and nudes 82
Photographing portraits and the nude 83
Anatomy 85
Still life–making your own subjects 87
Building an archive 89
Interiors 90
Taking it outside 92
Public and private collections 94
Found photographs 95
Non-photographed input–scanning and filters 97
Using drawing and painting 98

METHOD

pp 100–119

Technique 101
Resolution and image quality 102
Creating a background 103
Selection 104
Avoiding selection 106
Evolution 106
Shadows and light 110
Combining textures 111
Translucency 111
Cloning 113
Developing your image 114
Practice 116
Saving it and final touches 118

COMPOSITION

pp 120–149

Proportion 121
Geometry 122
Gestalt theory 128
Symmetry and asymmetry 131
Complexity 135
Focal point 138
Achieving perspective 141
Framing 146

COLOR

pp 150–168

Color and space 151
Color and mood 155
Color gamuts 159
Color contrast 160
The absence of color–
 monochrome,
 sepia and color tints 164

TEXTURE

pp 169–178

Finding textures 170
Reflections and refractions 173
Pattern 175
Microscope to telescope
 –playing with scale 177
Using texture 177

TONE

pp 179–185

High- and low-key images 180
Tonal contrast 184

INVERSIONS

pp 186–196

Color and tone inversions 187
Solarization 194
Orientation 194

DISTORTIONS

pp 197–200

DEVELOPING YOUR IMAGE

pp 201–209

Developing style 201
When is a picture finished? 205
Struggling for ideas? 205

THE FINISHED IMAGE

pp 210–213

Archiving 210
Getting your work "out there" 210
Agents 211
Permissions and copyright issues 211

FREQUENTLY ASKED QUESTIONS

pp 214–218

Acknowledgements 219
Model release form 220
Further looking and reading 221–225
Contributing artists 226–229
Index 230–232

Visual Alchemy is for people who, like me, want to make art. Whatever your aesthetic or technical background, I hope to inspire creative development and research by example as well as by suggestion, and help you to analyze and realize your own artistic ambitions.

I am a Scottish digital artist, and have been working in the medium for more than fifteen years now. I am often asked about the creative process, inspiration, and technique. This book explains my method and inspirations, in the hope that it will set you off on your own explorations.

I made traditional art–drawing, painting, sculpture and collage–for decades before approaching the digital, and still do from time to time. I apply the same decision-making processes to whichever medium I choose. These are the subject of the book. This is an aesthetic guide to composition, color, texture and all the other means of communication that an artist has at their disposal. It discusses the creative process–the part that comes after you have acquired the basic tools; it's the exploration, and what to do with those tools. It is about ideas and how to express them, rather than the ins and outs of the software. You won't need too much in the way of kit. Any laptop or desktop computer will happily run Photoshop, or any of the other image manipulation programs; you probably have a camera on your phone. A basic working knowledge of Photoshop will be useful for the reader, but not essential, as the ideas will apply to any digital program, and indeed to any medium. Your most important tools are your eyes and brain. Start to look, and really to see. This book explains how to use the inspiration around you to make art.

Digital montage is still a brand new image-making tool. It is interesting that value judgments are often placed on Photoshop as a medium; no other means of making art are reduced and disregarded in popular perception in the same way (with the possible exception of the airbrush). Just as with photography until remarkably recently, in purist circles digital montage has yet to be accepted as a valid art medium. In August 2012, *The Huffington Post* reviewed an upcoming exhibition at the Metropolitan Museum of Art in New York called *Faking It: Manipulated Photography Before Photoshop*. The review suggests that "In the good old days before airbrushing a zit or sharpening a blurred figure was just a mouse-click away, the task of transforming an image was an art form." I would argue that it still is. It has never been simple; the problems are simply different. The program's flexibility and versatility is almost held against it, for making things too easy; it is dismissed as being slick, even dishonest. This view does not do it, or its practitioners, justice. Working digitally is not somehow "cheating". There is no magic button that makes a picture for you. A computer does no thinking. It simply a tool that allows artists to express themselves with more freedom than ever before. Photoshop allows transformations that were impossible in the darkroom, and makes others much easier; however, all the choice and potential it offers is actually a challenge. You can do anything, so you have to decide what to do.

Art has never been "pure" in the sense that the word is used about Photoshop. It is not a plain, simple reflection of the world, and it should not be. Art relays the world through the artist's eye and brain, and translates, enhances, transforms. Painters and sculptors always did this. Traditional photographers do it too; by selection, dodging and burning, simple cropping, they are presenting the world as they see it. They are improving upon their raw material. If Photoshop can improve it further–and it can!–it is simply Luddite to ignore it. Method is not the product; the image is everything. There is now a growing digital art movement producing work that will, soon I hope, join film photography as a serious, eloquent–and collectable–art form.

I make pictures that I would like to see; no one else has made them yet, so it's my job to find them. It's your job to give your own inner visions to the world. There is no one else who will do it quite like you. I hope this book will set you thinking, and help you along your own creative path. Good luck, and happy picture-making!

For Alistair

INTRODUCTION

Digital manipulation as a medium of expression

Digital manipulation must be the most exciting new medium to become available to artists since the invention of oil paints. Digital artists can make dreams visible, pin down their imaginings onto pieces of paper, depict the impossible, with a fine artist's complete freedom. Combine this with photography's supposed "realism," that persuades us that we're looking at a version of the truth, and you have a very powerful medium indeed.

People take photographs for many reasons. They can simply capture events, the photographer's experience of people and places. Seeming to preserve a version of a moment, to snatch a fragment of life from the stream of time, they make the subject in some small way immortal. Photography has become vital to everyone as an aid to, and a part of, memory. It almost persuades us that we can keep our pasts and take them with us into our futures. The thing almost everyone would rescue from that hypothetical house fire is their photograph album; this surely shows that to lose images of loved ones is in some sense to lose them. These photographs are connections, declarations of love and memorials.

I took this tiny ruby ambrotype out of its case to clean it, and discovered to my delight that the sitter is holding another ambrotype in the image of a man. This is probably a memorial piece of a widow and her husband. Photography has the power to preserve a connection, as moving today as when it was made in around 1855. Collection of the author.

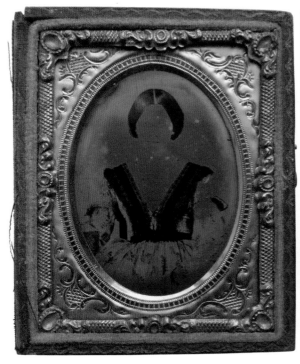
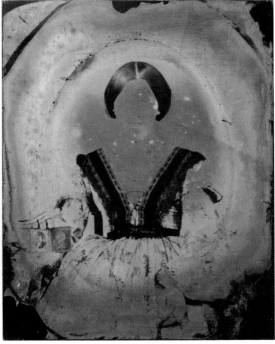

Photography is also a supreme recording tool. From the very beginning its potential for cataloguing, differentiating and measuring its subjects was obvious. The Victorians had a passion for collecting and classifying the discoveries constantly being made in the natural world; cabinets of curiosities were evolving into natural history museums and their contents were being sorted, collated and described. The new scientific taxonomies were preserved and catalogued in new ways, and photography was integral to the developing methods. People, too, were being catalogued. The camera served the police's efforts to corral criminals, the "science" of phrenology and the devoted capture of family life equally.

There was a belief that "the camera could not lie;" people had complete trust in the veracity of its images. This led to early manipulations–perfectly transparent, to our modern eyes–being taken at face value. The famous case of the Cottingley Fairy photographs taken by Elsie Wright and Frances Griffiths in 1917 is an early example of the visualization of an imagined world; they were presented as, and believed to be, simple records of fact. They had the confidence of no less a person than Sir Arthur Conan Doyle, the imaginer of forensic science. Less principled spiritualists than Sir Arthur used photography to deceive; double exposures and darkroom layerings produced images of ectoplasm and apparitions that purported to prove their existence.

Photographs are still used as evidence today. Photo-finish, medical and speed camera photographs are all documents of proof. A modern audience is, however, far more circumspect about photography's documentary qualities. Such simple techniques as selection, viewpoint and lighting can make very misleading statements, even before the subject itself is altered. War photographs are examined for suggestions of setup. Documents such as the moon landing pictures are

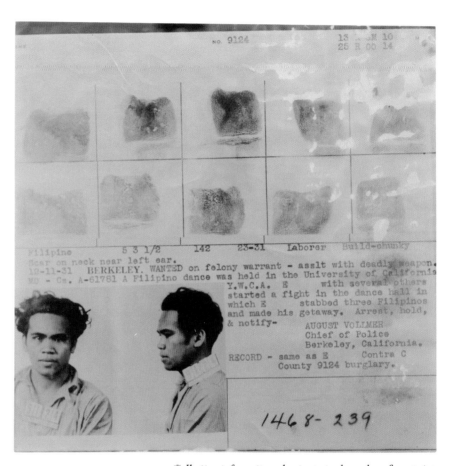

Collecting information about criminals, such as fingerprints and mugshots, on their arrest helped the police to find them again if necessary. This wanted poster from 1931 uses the photograph as documentary evidence. Collection of the author.

Photography captures a great deal of information that speaks across time. This image was made in a Photoweigh booth; popular in seaside resorts in the 1930s and 1940s, they rather oddly combined the once-fashionable, and then declining, weighing machines and photo booths in an attempt to rejuvenate business. The pairing of portrait and information reveals more than expected about the somewhat doom-laden sitter, and about changes in expectations of privacy over time. Collection of the author.

studied meticulously for evidence of fakery. People are very used to seeing the impossible, and we no longer believe our eyes. Nevertheless, photography such as crime scene imagery remains integral to our understanding of fact. It still has an innate believability.

Photography has always been a means of expression too, of course, and so an art medium. From its earliest days, manipulations such as scratching of the print or negative surface have added texture and mystery to images, and imitated drawing technique. Frank Eugene's The Horse of c. 1890 is a powerful example of surface intervention. The Pictorialist movement quickly grew; its ranks boasted such luminaries as Edward Steichen. Like many other photographers since, he had been a fine art painter, and his early forays into photography clearly showed this.

Today, once photographs are made, many people want to take them further. Just like the Pictorialists, we want to refine and develop what we have captured. Improving an image by retouching scratches, removing telegraph poles or correcting color casts is many people's first experience of digital imaging. Once the program is familiar, it is a small step from making these basic alterations to creating something completely new.

The most commonly used program among artists and illustrators is Adobe's Photoshop. To anyone with a natural propensity for collage—for selecting, arranging and making connections between disparate elements—Photoshop is the perfect tool. In particular, the layering techniques available in Photoshop are a breakthrough. Collage had always been restricted by the size and color of found objects and photographs, and by problems of attachment. Some things—three-dimensional, maybe, or too large, or too precious—couldn't be included at all. Translucency was another problem; most layers obscured the underlying material. Digital montage frees the artist from such limitations. Images can be imported

from anywhere, and combined with total freedom and subtlety into a completely new whole. This book will use Photoshop references, but the ideas are applicable no matter which program you choose.

Digital montages are ideas become visible. You are operating somewhere between imagination and a physical reality. Developing pictures are in a state of flux, not yet existing in a hinterland of intangible code, moving both forwards and backwards in time. Digital art blurs realities. By using photography and other ways of recording actual things, the pictures can seem "real" by virtue of their "real" content while being entirely fantastical. The fantastical, when a representation of an inner emotion or motivation, is a different kind of truth.

Photography has always had limitless expressive and artistic possibility. It has never been confined to making pictures of what's in front of the camera. Darkroom magicians such as Jerry Uelsmann make miraculous combinations of multiple negatives to create new worlds. Anna Atkins' cyanotype flower portraits, or Man Ray's "rayograms," or photograms as we now call them, even eliminated the camera itself. Now that color is added to the artist's palette, our toy box is complete. An instinctive process, digital montage frees us from technical distractions, and the business of communication can begin.

Mandible

Antenna

Labrum, or Upper Lip

Maxillary Palpi

Labial Palpi

ForeLeg

Pro-
thorax

Elytron

Scutellum

Mesothorax

Wing

Coxa or
Haunch

Intermediate Leg

Femur
or
Thigh

Trochanter

Tibia or Shank

Metathorax

Hind Leg

Tarsus or Foot

Spiracle

Spiracle

Claw

Themes

Finding your subject

What is your passion? What interests you above all else, occupies your mind, follows you into your dreams and colors your whole life? This is inevitably what you will be making pictures about.

The most important part of any artistic effort is what you communicate. The subject of an image is, naturally, not just the things that are in it. The physical content of your picture–the nude, the setting, the portrait, whatever you choose to work with–is just the beginning. It is the bones of the piece that will support the less literal, emotional level of the work. By association with each other, and of themselves, elements of a picture can be symbolic or representative of things above and beyond themselves.

The fact that digital collage combines images makes it more easily read as allusive than as "straight" photography. As soon as you juxtapose one thing with another you are setting up a dialogue between those two things; a narrative is implied, which may or may not be literal. The stranger the combination the more the viewer is encouraged to find reasons for it, and to read the image's content as more than itself. Pirandello-like, you can make your own scenes and characters, and these new constructs inhabit an anti-reality, a dream place–the real (the thing photographed) becomes the unreal; the distinction itself ceases to exist.

Visual metaphor is endlessly versatile. Artists can invent their own codices of symbol and viewers will interpret them entirely independently, in ways that mean something to them personally. A flower study may indeed be about the flower–its texture, its color, its structure, its place in the ecosystem, its habit–or it may use the flower to represent something else. The artist is free to use the world in any way to make his point, unconstrained by symbolism in the way that, for example, Renaissance artists were. In the fifteenth century, the theologian St. Augustine was always depicted with a book and pen, and St. Christopher carried a child; such associations helped to explain the stories to an illiterate audience. Now, however, fine art imagery is usually made for galleries and individuals, rather than for religious or political bodies, and artists have total freedom of both expression and content. An element's implications can be more or less ambiguous; a chained figure sends a direct message, while an enclosed one could suggest either security or entrapment. Personal interpretation of an image makes that image directly relevant to the viewer's experience, and therefore more powerful.

You may find yourself constantly taking pictures of trees, or dogs, or graffiti, or even water towers like the wonderfully obsessed Bernd and Hilla Becher. Think about why this is. Are you making a collection? Why have you chosen this subject? What does it represent to you? When you know this, you can think about how best to convey your feelings about the subject when developing it.

Making pictures is hard work, but it is immensely exciting, demanding, involving and even cathartic. Once in a while, you will achieve something that speaks to other people and that will last, and that is what we're working towards.

Themes

So, what will you use to convey your message? Your themes will evolve and develop with your work and will follow you through your life, growing and changing as you do. There really is no need to identify them, and it might well be hard to do so. But they will be there, unifying your body of work and often giving you direction.

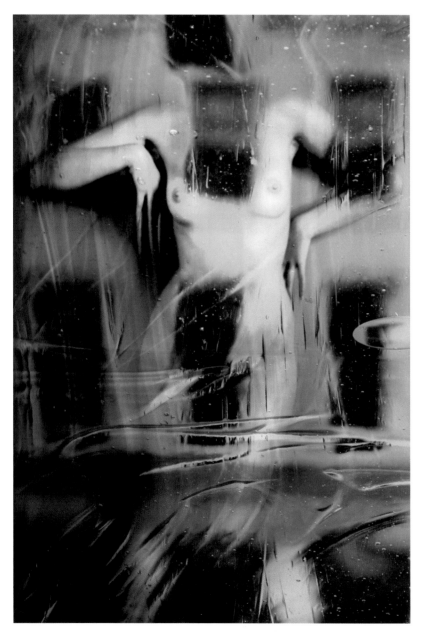

Royal Exchange Square, 2010.

For myself, the nude appears a lot in my work. I've always loved working with the body, ever since life classes at college, and with Photoshop began to make it more than descriptive. The earliest work was often about finding correlations between the nude, or other natural objects, and the manufactured. Living as I was in a city, the emotional content of the work was about being hemmed in, isolated and threatened. Since a move to the countryside a few years ago, the pictures are opening up and becoming lighter. I use the environment—originally man-made surroundings with their textures of decay and layering of time, and then the rural—as a home for the nudes to explore man's place in the world. Now I use both equally; I am trying to reconcile almost conflicting ways of living in my artwork.

The figure does not simply represent a naked human being. The nude as metaphor can lay bare innermost feelings—hope or fear, strength or vulnerability, love or loss. It can symbolize our relationship with the world around us. It can be perfected or broken down, impersonal or approachable, abstracted. The naked body is an icon for honesty, openness and the inner soul. There are limitless ways of representing the nude, of showing us at our most unprotected and revealing our deepest essence. Even now, some viewers only see the female body in a sexual light. But the age of the Victorian soft-porn nude, gratuitous and submissive, has now gone and the body in art expresses so much more than a simplistic eroticism. Advertising and newspapers do deluge us with titillating nudes still—but art reveals different, far more interesting and complex possibilities. I use the outside of a person to represent what is happening within. A body is simply a vehicle, a machine for a soul.

I also make pictures of people. I hesitate to call them portraits. They do not concern themselves with the classic issues of portraiture—the personality, status

or wealth of the sitter. Rather, the subject becomes an archetype, a symbol, just as the nude does. There may be clues as to the character of the person depicted of course, and the viewer may be more likely to see the image as a representation of an individual rather than an allegory or a metaphor. The representation is, however, far removed from reality. Almost all of my models are strangers, of whom I know only the barest minimum; they may be a musician, a dancer, a mathematician, a soldier. Even this minimum is often ignored, and an entirely new persona invented. Again, as with the nude, the concern is with the inner aspects of the subject rather than the external, the general rather than the particular, the universal as opposed to the individual. The people are remade and reimagined.

Depictions and explanations of the natural world filter into my work continually, and I owe a great debt to anatomical textbooks and their engravings describing the mechanics of the human body. One can address the interior, private aspects of a person by showing that person nude or stripped even further down, to the muscle and bone. What better visual analogy for feelings than the heart, for intellect than the brain, for structure than the skeleton? For me, anatomical engravings are not pictures of death, but of life—the fundamentals that support all of us. Gerrish, in particular, has illustrations of surpassing beauty.

This absorption in human anatomy naturally broadened into interests in animal anatomy, especially osteology, evolution, taxonomy and comparative anatomy. Natural history museums, particularly those attached to universities, where the displays are so methodically presented and comprehensive, are a delight. The curators are doing exactly what I try to do in the pictures—capturing both the physicality and the essence of their subject, explaining its structure and workings, while being limited by the very fact of the subjects having

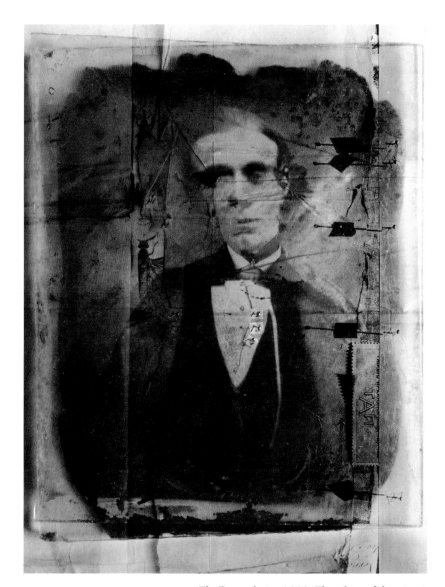

The Entomologist, 2008. The subject of this piece is an old ambrotype, sadly anonymous. I have invented a history and passion for him.

Chest, from Text-book of Anatomy, *ed. Gerrish,
Lea, 1889; 2nd edition, Kimpton, London 1903.
This engraving, by G. Devy and reprinted from
Léo Testut's* Traité d'anatomie humaine, *is both
rigorously descriptive and graphically elegant.*

*Anatomy is not just to be found in engravings, of course. Museums,
pathology collections and even catacombs are all places to
investigate corporeality and mortality. A fascination with flesh
and bone is not necessarily a fascination with death, but also with
structure, and the relationship between form and function.*

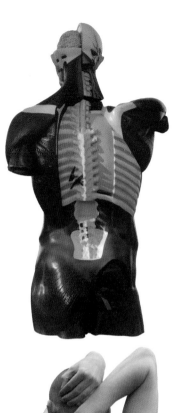

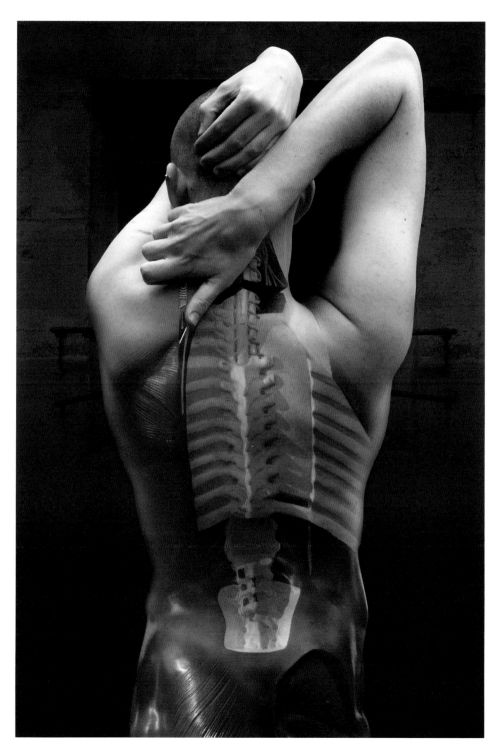

Skin, 2011. This anatomical model, found on an online auction site, has an unusual twist to it; I photographed Sam in a similar pose to reveal his underlying anatomy.

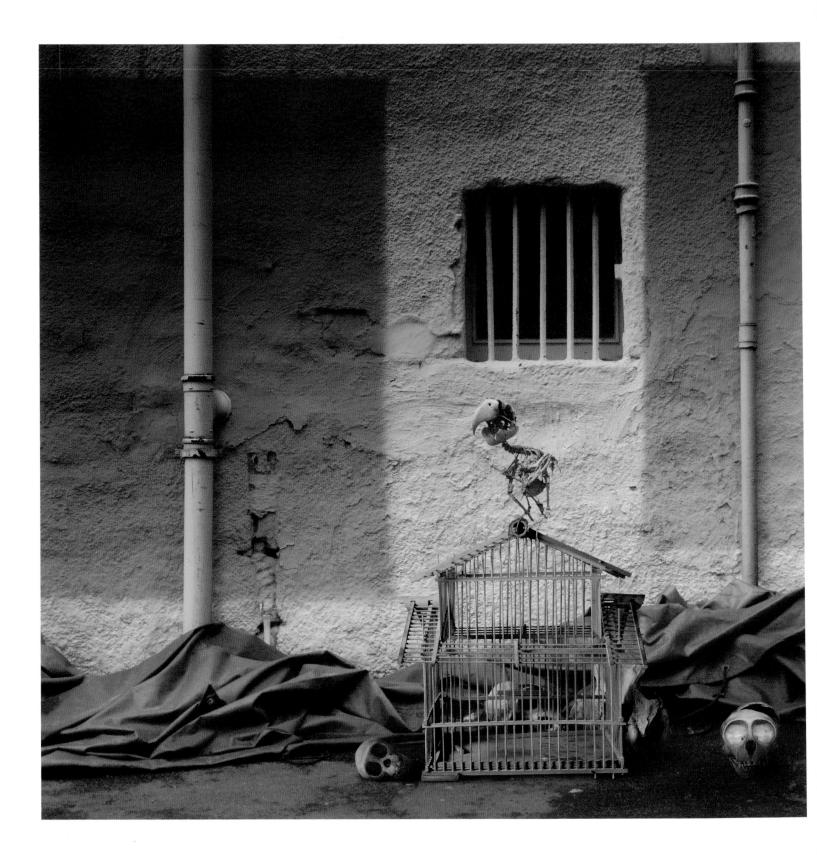

been captured and explained. The tension created by this paradox is delicious. The very making of an animal mount, and a picture, reduces the creature to a subject; it removes its essence by attempting to preserve it. We must replace it with our own interpretation and context, and remake it.

I am particularly fond of old bisque doll heads. Dolls are such interesting things. In child psychology, they are transition objects; children can entrust dolls with their emotions, helping them to relinquish human attachments when the time comes. These psychological overtones make them powerful things indeed. Their empty heads and open yet unseeing eyes, the definite suggestion of a spirit lurking within–and with older dolls, not necessarily a benevolent one–has huge pictorial potential. Loved and discarded, they can look so knowing, even malevolent.

I also have a liking for references to attachment. Wires, string, knots, cables, adhesive tape and photograph corners all feature in my pictures. Pins and needles appear often. They are constructive of course, but their obvious negative associations–pinning down and restraint, injections (to which I have a distinct aversion) and pain, also make them visually threatening. Those marching pins in the Quay brothers' astonishing animation *The Cabinet of Jan Svankmajer* (1984) bring them alarmingly to life.

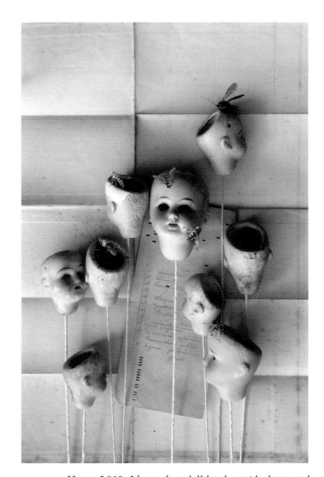

Hover, 2010. I hung these doll heads upside down and then rotated the image to make them float; the hoverflies were added later. I wanted to achieve that disconcerting feeling of displacement common to these relics of play.

FACING PAGE

Remains, 2010. Remains is a response to the natural history collection at the University of Dundee. Once the largest collection of its kind in Europe, it is now much reduced as the museum buildings were demolished and specimens donated to other museums. The remains are of the animals and of the museum itself.

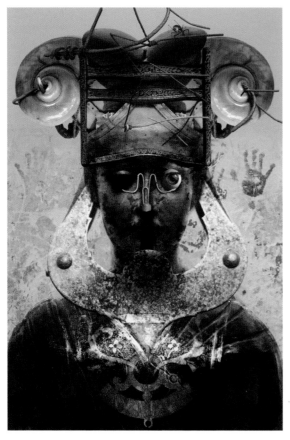

*Automaton, 2009. Knotted wires and
staples, found on a fence post, create a jagged
movement around this creature's head.*

Intimations of threat, both to humanity and to nature, are a constant in my work. I frequently use images of containment, such as partitioned boxes, grilles, bars, shelves and pigeonholes. Many images have the human form trapped by its own creation. The environment itself, particularly the urban environment, can also be oppressed or oppressive. Such confusion of perception is a delightful plaything for an artist. Depending on the context, peeling paint can either be an evocative texture, or show dereliction and decay; bolts can mean either security or imprisonment. Needles are positively practical as well as frightening. Ambiguities of message such as these can make images more complex and thought-provoking.

Another recurring issue in my work is the difficulty of communication itself. This difficulty is one that artists face every day, and not only in their working lives. Any conversation is a microcosm of the dissembling, misunderstanding and pretense of everyday transactions. Misapprehensions are inevitable when thoughts are translated, more or less efficiently, or not at all, into words. The space between implication and inference, into which so much of importance seems to disappear, and the gap between the projected and the true self, can be made visible.

Aging is also an important theme. The beautiful effects of weathering and distressing on often unprepossessing substrates are at once destructive and creative—a paradox mirrored in the aging of the individual. The transformative power of fire, water or decay can make things anew. I, too, try to create something new out of the old, and love to use worn, abandoned objects that bring history and experience with them. The laws of physics act equally upon nature and the manufactured. Some pictures show nature asserting itself and reducing man's efforts to their original elements, while others have nature under threat from encroaching industrialization.

My pictures are constructed upon a form of real-
ity, usually an emotional one, which is supported by
the "reality" of photography. Reductive thinking, the
empirical approach, explains existence as an acci-
dent of atoms, amino acids and DNA, but it has not
yet explained what it is that we really are, only–up
to a point–how we work. The part of us that leaves
when we die, our real self, cannot be described by or
confined to a series of chemicals and their reactions.
This is demonstrated perfectly by the natural history
specimen, beautiful, intricate, vacant, dead. It shows
our desire always to pin down and document what is
unknowable and how, in doing so, so much of impor-
tance is lost. The towns in Egypt may be named on a
map, but this cannot show you how hot sand feels or
how the fruit tastes. You can collect butterflies, describe
and name them, and store them away in drawers, but
those insects on pins are not the same as a butterfly in
a field, and much less. This is the age-old problem for
the artist who's trying to do the same thing; to translate
real emotion–life–onto paper; to preserve the fleeting
and precious.

That so much of life can now be explained empiri-
cally does not, for me, reduce the mystery, but increases
it. So much is known, yet so much more remains
unknown and resists all attempts to be explained in
this way. Other, more intuitive, less clinical ways are
needed. The parts that will not be pinned down become
more real by their contrast with the "concrete", their
very elusiveness revealing their existence. They cast
shadows, plainly showing that there is more to know,
and images reside in these shadows.

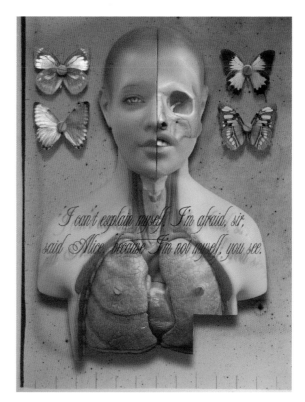

*Alice, 2003. Lewis Carroll pins down the
problem so succinctly.*

BEAUTY AND IDEA

To my mind, there are two essentials for any work of art: that it should be beautiful, and that it should mean something. If a concept has no real visual expression, best to write it; art is about looking. The aesthetic of a work of art is its means of getting directly to our emotions, of burrowing deeper than an intellectual appraisal and touching the heart. I also think that the concept itself should be decipherable and available to the viewer without the help of other knowledge–of the artist's history, for example, or anything else. Images should stand by themselves, clear and self-explanatory. Most importantly, pictures should communicate. They should inspire emotion, encourage thought and make inner landscapes visible.

Beauty is, I think, essential to art. Beauty is not mere prettiness, not a superficial thing. It appeals to the deepest parts of our psyches–dare I say, our souls. It can move you to tears or make you gasp, and it will stay with you. Beauty is not skin deep; it goes down to the bone. Beauty will reinforce any message you want to convey. Art is poorer without it, and has less power. There is no higher aim for an artist, it seems to me.

Beauty is to be found anywhere, and in unexpected places. The works of Sebastião Salgado or Don McCullin, for example, prove this. Their subject may be enormous suffering or horror, but their message is all the stronger, more memorable and poignant for being delivered beautifully. Much of my own work tries to discover the beautiful in the unprepossessing, in the unlikely. For me, it is about finding correlations, echoes, and new resonances between disparate forms and surfaces. Living in a run-down urban setting, one sometimes has to look hard for beauty–but it is there. In a rural idyll, it can take you by surprise; the obvious has less power through being well-used and over-familiar. Everyone knows a rose is beautiful, but look closely at a weed, and you may discover something new.

There have been times when to be new, to shock, to be expressive have been so important that beauty has been sacrificed. The resultant work may indeed shock for a moment, but this cannot last. It will need deeper values to remain relevant and to continue to inspire emotion. Nothing is new forever. Some things endure, however. People will always need beauty in their lives. We have always responded to it and always will. It is a vital human response, bedded deep in biology. An appreciation of beauty in a mate may even have driven evolution and continue to ensure our survival, and that of every animal on earth, today. We feel not just comfortable but elevated, inspired, delighted by it.

Truthfulness is an important part of beauty. Bad drawing or construction can destroy it. This is not to say that drawing has to be accurate; it can develop beyond the actual, and often should to achieve its expressive potential. Michelangelo's David has hands too large for technical exactitude, making them hugely expressive, strong and full of the potential for movement. The etiolation of a Schiele nude is not wrong; the structure is immaculate and the elongation serves to tighten and tension the lines. Drawing should always be built on the fundamentals. Having an arm that does not connect properly with a shoulder does nothing to increase the message of a piece; quite the reverse, it will create a jarring note that will distract from it.

This applies to anything. Perspective, for example, should be logical to the piece. It doesn't have to be formally right, but it does have to make sense within the context of the image. You can condense or exaggerate it, or flatten it out altogether, but whatever you do should be consistent; don't just have one roofline at the wrong angle. Escher plays exquisite mind games with perspective, which is always correct, while also being impossible. He sets up spaces only to collapse them–which he could not do without excellent draughtsmanship.

Beauty is not just correctness, however. It lies in harmony of form and proportion. It is balance and richness of color. It is smoothness of transition. It is also found in small variations from perfection. It is essentially indefinable, which makes it all the more wonderful when you see it. It gives feelings of recognition, involvement, simple joy. Beauty is eminently achievable when working with digital montage. To make your image irresistible, make it beautiful.

Idea, too, is crucial. By adding to and working with photography, you are making it something more than it was. When changing an image, ask yourself, to what end? Your idea may be profound or not–you may not even know what your image will be about when you start work. It may not be the content at all; the subject, the fabric of the piece, will be the conduit for the message. It doesn't have to be an intellectual or abstract concept. Your picture may not even be of, or about, anything at all. It may simply be a mood or a development of form–but whatever it is, the idea is your reason for making the piece. Personally, I find it best not to start out with some grand intellectual idea, or the piece can turn into an illustration. Better to explore deeply held fascinations, beliefs and feelings. Ideas, I find, evolve along with pictures.

What is important about your picture is that it should communicate to your audience. There is little point in making artwork that requires documentation and explanation; it will only confuse and ultimately alienate. Intrigue your audience, of course, and make them want to know more, but don't leave them in the dark. Digital montage is naturally allusive. The artist will have one thing in mind when making an image, while a viewer, with their own ways of seeing and life story, may read it differently. I don't worry about this, and leave images open to interpretation. I often lead people along a certain path when choosing a title, but if the picture tells a different story, that's marvelous. As long as it connects, and speaks, the piece has done its job.

If your picture says something well and beautifully, you have made a work of art. This book will help you with both aims.

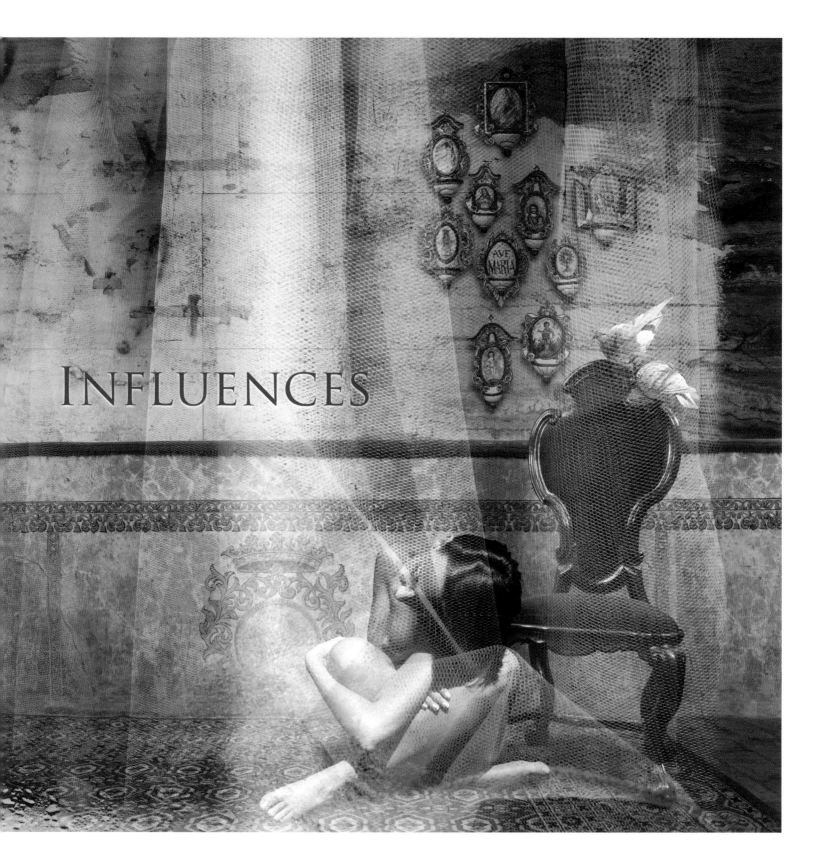

INFLUENCES

Art has never sprung, fully formed, out of nowhere. Every artist needs visual, intellectual and emotional stimulation, and every artist grows up with an awareness of all that has gone before. It is probably true that there is nothing new to be said, but each artist will bring their own unique outlook and experience to their work, making it completely their own. This chapter is about some of the many artists who have helped to shape my own outlook and process, who I hope will also inspire you.

The first book I remember making a deep impression on me was the extraordinary *Transfigurations*, published in 1986. A collaboration between Veruschka (von Lehndorff) and the photographer Holger Trülzsch, the images depict painted and even sculpted nudes, assimilated into and absorbed by the landscape. They still delight me with their approach to the body, to beauty, to human interaction with the world. Veruschka had been a fashion model, but knew that her body had more expressive potential. She and Trülzsch used body paint to blend her almost imperceptibly with various backgrounds–woodland, a factory wall, a seashore. The pictures are startlingly beautiful; they are also unnerving and alarming, tranquil and joyous. The range of emotional responses they provoke is extraordinary. An image of Veruschka covered with mosses, almost engulfed in a forest floor, is quiet and peaceful, yet also terrifying. Beauty is mortal.

I clearly recall the first time I saw the series of images that made me want to take photographs. Standing in a bookshop's magazine section, browsing through *Vogue*, I discovered Herb Ritts (1952–2002), the master of surreal classicism. The Body Watch shoot is a series of nudes against the sea and black sand (Hawaii, I now know). The contrasts between the smooth, pale skin and the sand, the dramatic cropping, the movement in some of the pictures, the sharp focus of others–the sheer beauty of these images will always delight and inspire me. They are the epitome of sculptural perfection. Ritts' classic, quirky and inventive imagery makes the world a beautiful place.

Albert Watson (b. 1942) has been a major influence. He makes such powerful, expressive images. A large and gorgeous print of his portrait of Mike Tyson (see p. 39) was on a wall in Duncan of Jordanstone College of Art & Design when I studied illustration and photography there; Watson, too, is an alumnus. Its impact was immediate and it retains its power to this day. It was a revelation. Sculptural or evanescent, monumental or intimate by turn, Watson makes compelling portraits. He also creates still lives to rival Penn. Impeccably lit, they show an eye for quirky juxtapositions and clear, graphic simplicity. He makes casually chic *mises en scène* and elaborate studio setups; stark, graphic and incisive landscapes and sumptuous nudes. The mood moves from edgy to romantic, lush and saturated to the rigorously ascetic, sculptural to painterly. The range is extraordinary, yet his work has a total coherence of vision. Often, these immaculate images are then broken up and enriched by the use of cyanotype, or by the rough edge of a liquid light print. His constant attack on the standard format, and his lack of preciousness about the images, is an inspiration. Almost as if he tires of his own technical brilliance, he occasionally subverts it with grainy or blurry shots, introducing spontaneity and atmosphere. He does whatever it takes to bring out the image's essence.

The work of Luis González Palma (b. 1957) is very special. Having only discovered the work of this Guatemalan myth-maker quite recently, I suppose I cannot really claim him as an influence, yet the terrifying beauty of his singular images is precious to me. He transforms the native Mayan people of his homeland with a simple headdress or sultry lighting into mythic

Lynn, Birdcage, Marrakesh,
Morocco, 1989, by
Albert Watson. Image
courtesy the artist.

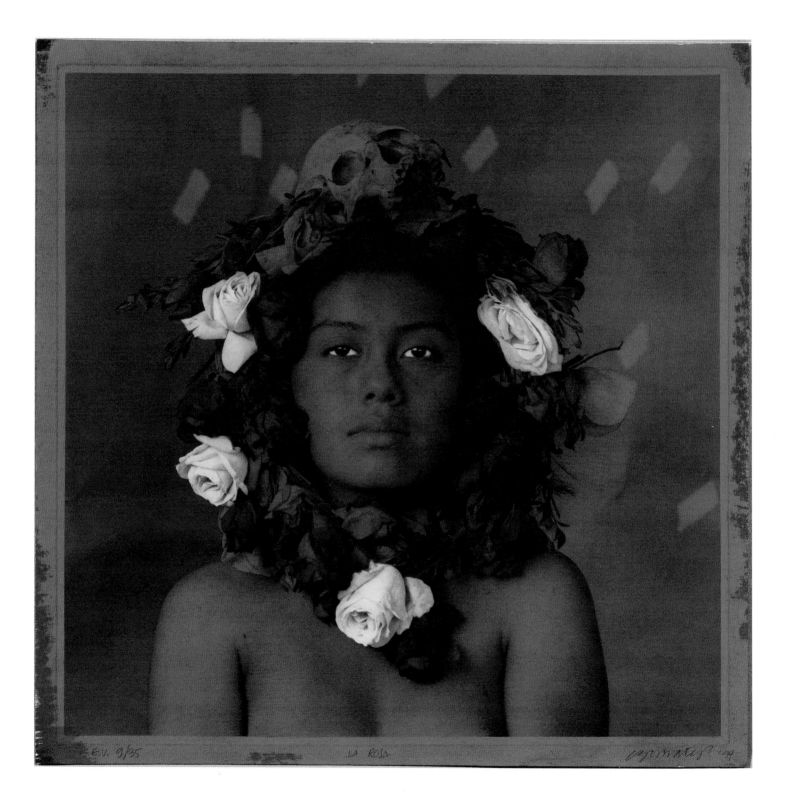

E.V. 9/35 LA ROSA [signature] '04

creatures. His use of color–a recurring deep earthy red, warm and intense–is so simple yet so strong. Earthbound and ethereal, with direct and unfathomable gazes, his images are paradoxical and haunting.

Natural history collections seem to inspire conflicting reactions in a great many artists who, like me, feel both astonishment at the complexity and beauty of natural forms and sadness at their loss–of the individual, and sometimes even of the entire species. The most beautiful museum photography I've seen is by Rosamond Purcell. For such books as *Illuminations: A Bestiary* (Norton, 1986) and *Finders, Keepers: Eight Collectors* (Hutchinson, 1992), Purcell photographs the remains of animals, preserved, fossilized or simply found. These creatures are quite removed from their natural environment; already collected, organized and categorized, they have also been given new contexts. No longer what they once were, they have been assimilated by human minds and become something new–captured beings, sad, beautiful and very moving.

Science and art were not always as apparently irreconcilably divided as they seem now. Early photographers, for example, were adept chemists, and many used their technical frame of mind to invent new ways of making the invisible visible. Étienne-Jules Marey (1830–1904) made images unlike any other photographer. He captured movement as it happened, showing things that had never been seen before. Within a single frame, his multiple exposures reveal the graceful arc of a jump or a fencer's parry. Compressing the chronology into one image shows the flow of travel more clearly than the sequences of Eadweard Muybridge's more famous studies. I find Muybridge fascinating for his spirit of discovery and exploration of a new medium to reveal new things. Marey's pictures, however, while equally revolutionary and descriptive, are also amazingly beautiful.

Fish on Music, 1990, by Rosamond Purcell. From Bookworm, *The Quantuck Lane Press 2006. For more by Purcell, see* Texture *(p. 175), and* Color *(p. 163). Image courtesy the artist.*

FACING PAGE
Lotería I: La rosa, 1989 (Lottery I: The Rose, 1989), from Poems of Sorrow, Arena 1999. A wonderful piece by Luis González Palma. For more by González Palma, see Myth (p. 228). Image courtesy the artist.

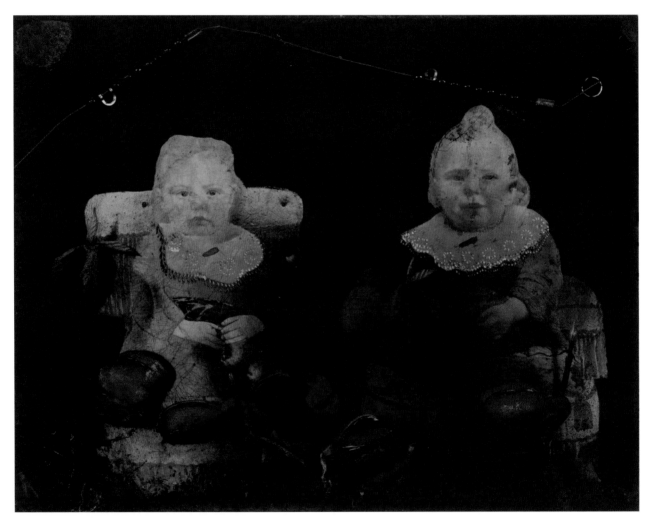

Children with Acorns, 1981, by Olivia Parker, from Under
the Looking Glass, *Little, Brown 1983. For more by Parker,
see Still Life (p. 69). Image courtesy the artist.*

That Karl Blossfeldt's plant studies are beautiful is almost accidental. Blossfeldt (1865–1932) taught architecture. He made an extraordinary series of monochrome prints to demonstrate plant structure and to inspire his students with their forms. The images are therefore entirely simple, with white backgrounds, designed to show as much information about the subject as possible. There is no arrangement or composition, and the lighting is consistent. All your attention is focused upon the amazing structure and detail of the plants themselves. When seen as a group, the variety of forms is breathtaking, and the repetition of pattern hypnotic.

Eugène Atget (1857–1927) lived in Paris and was its premier photographic chronicler. His large-format negatives preserve the late nineteenth and early twentieth century for us in perfect and evocative detail. His œuvre comprises largely architectural studies of a Paris that has inevitably disappeared, but he also caught the people who made it. The softly distorted and ghostly presence of these residents in doors and windows brings these beautiful textural essays to life. The images have layers of content–reflections and refractions, graffiti, the wear of decades–that suggest the depth and complexity of city life, and naturally appeal to a montage artist.

Consumed by collecting, Joseph Cornell (1903–1972) made his famed collages, boxes and assemblages from the fruits of constant forays into New York. Cornell's process was surprisingly similar to that of digital montage. He assembled completely unrelated objects, giving them new meaning by juxtaposition. He used layers, of mesh, paint or glass; he metamorphosed the found object and created new realities. The base material for his pieces is just that–base, ordinary, commonplace. Anything and everything was grist to his mill. By bringing together very humble objects–such as shot glasses, marbles, magazines, feathers, shells and

engravings–he transformed them, elevated them and conferred on them deep emotional significance. He created the precious from the mundane. Cornell's tiny imagined worlds seem to entrap and preserve a happily remembered childhood.

Another artist whose constructions have made an impact on my own practice is the still life photographer Olivia Parker. Using found photographs and objects much as Cornell did, she also has an astonishing way with light. Her earlier books of silver based and Polaroid photography show a purist's delight in formal yet surreal arrangement. *Under the Looking Glass* is a work of glowing precision. Parker has been working digitally since 1993 and these more recent montages also have strength and subtlety, combining an unwavering feel for composition with depth, vitality and movement.

Sculpture has always been a passion. A visit to the *Treasures of Tutankhamun* exhibition at the British Museum in 1972 has been a powerful influence ever since. Hundreds of years of repetition condensed the Egyptian experience into a single, expressive, sinuous line. The people and animals in Egyptian art have been impeccably observed, then taken into their stylistic canon and perfected. Realism, in the sense of the depiction of the individual, was not their goal. Even the extraordinary portraiture produced under Akhenaten's reign in the Amarna period is probably not literal representation of the subject. A new style developed along with the new monotheism of the worship of the sun god Ra. Massive cultural and political shifts were reflected in the first radical developments in Egyptian art in thousands of years. Occasionally odd to our eyes, the distortions of the body and face show new forms of beauty, and depict the royal family as the divine, superhuman beings they were believed to be. Etiolated, exaggerated and even grotesque, sculptures of Akhenaten are the embodiment of his cultural revolution. The era

produced some of the most beautiful sculpture in the world. The bust of Nefertiti is a classic of timeless feminine beauty, poise and grace. I think the line of that neck has influenced every artist who has seen it since it went on display in 1923, from Tamara de Lempicka to Herb Ritts.

Sub-Saharan African sculpture is highly emotive. Until such nineteenth-century artists as Picasso and Matisse began to collect it for its vigor and sophistication of form and color, it was underestimated in the West as being simply artifact, not even art at all. Now, it is no longer termed primitive, and its expressive and plastic qualities are properly understood and appreciated. It is rooted deep in ritual and belief, which gives it a profound spirituality. Often highly abstracted, the purity of line of a Bamana headdress or the distilled elegance of a Fang mask clearly influenced artists such as Modigliani and Brancusi, and have now become a deep undercurrent in modern artistic consciousness worldwide.

Visits to ethnology collections revealed to me the beauties and power of such African art, as well as that of Oceania and South America, in particular. A special moment for me happened in the Ethnologisches Museum (Museum of Ethnology) in Berlin. The African art there is spectacularly displayed. There is a wonderful collection of masks, figures and Benin bronze heads, each spotlit and floating in a cool, dark space. Upon entering a narrow corridor, the compression of the smaller and even darker space is almost uncomfortable—and then you see the nail fetishes. They stand and regard you. They are completely unnerving, captivating, fascinating. Made for ritual purposes, they seem violent and frightening, and some of them were indeed made to identify wrongdoers and exact retribution. Others were believed to have healing powers. Their visceral power was undeniable, and unforgettable.

Film, of course, is also enormously influential. Such directors as Tim Burton, Terry Gilliam and Guillermo del Toro have a sumptuous way with the fantastical; they create intensely beautiful new worlds of the imagination. Two hours' immersion in a film such as *Brazil* or *Edward Scissorhands* will lead you off to new areas of visual exploration. Animated film is even closer to still photography; every single frame is constructed, lit, examined and controlled like a still life photograph. The work of the Quay brothers is a prime example. Narrative tends to be less important in their films, as the emphasis is firmly on atmosphere. Their mittel-European sensibilities are indulged in subterranean worlds peopled with dolls and monsters, in which rusted machinery and the very walls are every bit as alive as the characters. There is a concentration of emotion in the films, and an oddness, that I always find inspiring.

Everything will influence you. All the other, nonvisual, ways that a creative mind expresses itself will also inspire artwork. Music is an obvious motivator and shaper of imagery. I defy anyone to listen to David Gilmour's guitar without that uprush of emotion that always makes one want to create. Your reading, whether fiction or non-fiction, will also motivate you to work. Fig. 43 (Observatory) (p. 203), was made in response to the marvelous 2011 book *There but for the*

FACING PAGE
A growing collection of modern African pieces has a clear influence on my work. Shown here are a Dan mask from the Ivory Coast, four Akua Ba figures from Ghana, a Dogon granary door from Mali and a nail fetish from the Congo. Collection of the author.

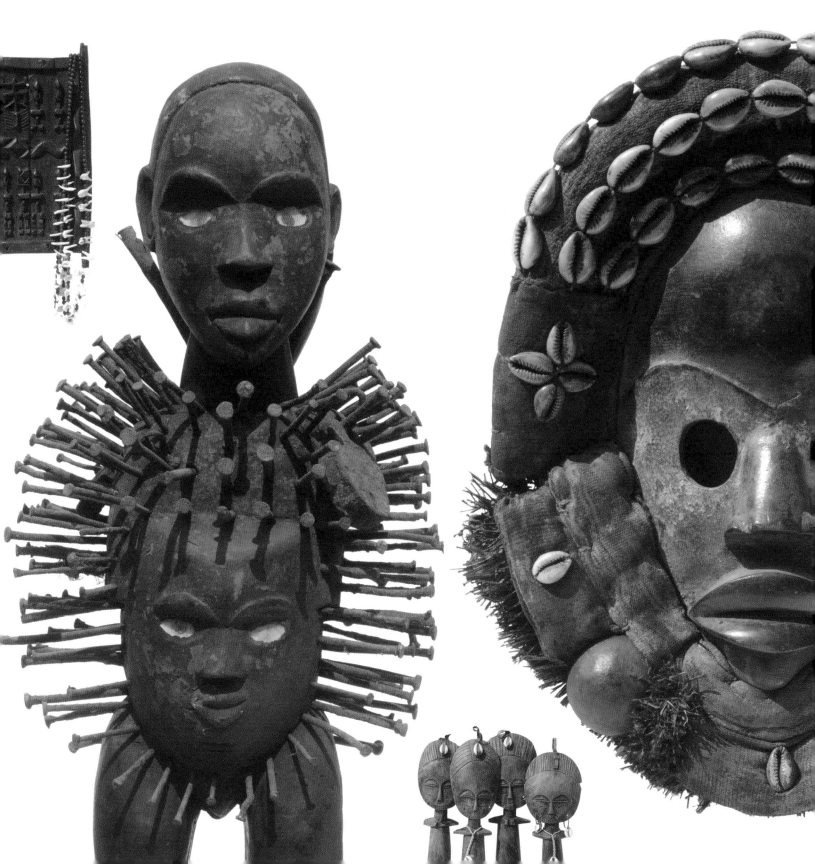

by Ali Smith. Your environment, most of all, will perco-
late into your art almost unbidden. The cool color pal-
ette of the Scottish landscape has inevitably filtered into
my work–if I lived in India or Hong Kong, I am quite
sure my work would look completely different. Urban
living will give you different source material and differ-
ent patterns of thinking than rural. Your relationships,
working environment, social activities and very nature
will of course shape your work, just as it shapes you. No
wonder that every image can be read as a self-portrait;
it's unavoidable.

FACING PAGE

*Five Akua Ba, 2010. Akua Ba figures, also known as
Akuaba or Akaba, are made by the Ashanti in Ghana. They
are fertility figures, carried by women who wish to become
pregnant; they are also worn tucked into the waistband
by pregnant women hoping for a beautiful child. Those in
my own small collection are worn smooth and beautifully
patinated; I feel sure they have been cared for and used.
When we lost a much-loved greyhound, I made this piece,
Five Akua Ba. The fourth figure from the left is turned to face
the wall, and represents our girl, who was our fourth dog.*

Inspiration

Inspiration is a nebulous thing. It strikes out of the blue—sometimes, if you are lucky, in the middle of working on a piece. As an artist, you develop an awareness of your surroundings, constantly on the lookout for ideas. You have to be alert to the world around you to spot the potential in things–the potential to explain or communicate your beliefs or passions. Inspiration seems to happen when you see something that chimes with you on a deep, emotional level and which might help you to externalize those feelings.

Looking at the work of artists you admire will help you to understand your own aesthetic sense and preferences. It can also make your own vision, the direction you want to take, clearer to you. Your favorite art will be invaluable in developing your appreciation of form, tone and atmosphere. Try to work out what it is that you like about any given image–maybe its color sense, its dynamism, or perhaps its textural interest? Such analyses will help you to develop these qualities in your own work.

Art is not confined to galleries and books, of course. While you will find enormous encouragement and inspiration there, your research need not be limited to digital artists, or even to photographers–painting, sculpture, architecture and film will all affect your way of seeing. The same concerns of communication, balance, beauty and expression are intrinsic to them all. Film directors, book and magazine designers, animators, advertising art directors, graffiti artists, creators of video games–they all have distinct visual styles and languages. Much can be learned from them about expression and communication.

Copying an artist's work closely can teach you a lot, but your own vision will soon take over. Creativity is naturally a very personal thing; once you have the technique, you'll embark on explorations of your own. You will always be learning. Looking and working

Fairy, 2007. The fantastical visual feast that is Pan's Labyrinth, *directed by Guillermo del Toro, inspired this subterranean lake and its inhabitants.*

all the time is important. Being alert to the potential of everything around you, being prepared to capture it, and making lots and lots of imagery will guarantee you good results.

The influence of practice

I love life drawing. The life studio is a place of total concentration, of absorption in form and the complexities of translating it into two dimensions. Drawing the nude is the perfect way to learn about light, dimension and composition. It also focuses you completely upon the body as object and makes you consider the relationship between form and function. I became absorbed in anatomical study and the expressive potential of showing the structure of the body in the studio. Allusions to measurement also appear often in my work, which must in part be due to the constant analysis of dimension and distance that life drawing demands.

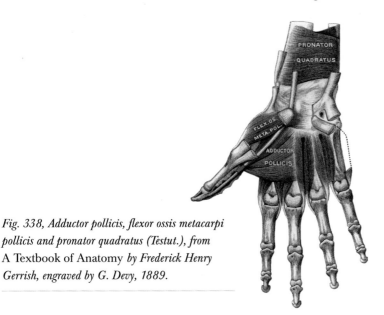

Fig. 338, Adductor pollicis, flexor ossis metacarpi pollicis and pronator quadratus (Testut.), from A Textbook of Anatomy *by Frederick Henry Gerrish, engraved by G. Devy, 1889.*

You will probably have made art in many different ways and these will clearly feed into your new medium. Whether it is the close looking required when drawing or the control of color and texture of a painter, the awareness of form and shadow of a sculptor or the narrative skills of a filmmaker, use your existing talents in new ways in the digital arena. You can even incorporate the artworks themselves, of course, to give your new work a connection to the old while continuing your development. Your photographic archives will be invaluable, and any darkroom experience will shape the way you see textures and tones. All your history, both artistic and personal, will have a huge effect on your work.

The influence of environment

Your everyday surroundings will inevitably imprint themselves deeply on your work. For myself, I usually work with relatively subtle colors, and enjoy sepia and selenium tones. I think that living in Scotland has an enormous influence on my chosen palette. The light here is beautifully subtle. Of course, we have spectacular sunsets, but a lot of the time we're surrounded by heathery, slaty, mossy, woody hues, bathed in a lovely pearly light that accentuates the pinks and grays.

Wherever you happen to live and work, your palette will be vastly different. Frida Kahlo's intensely saturated, rich and vibrant colors surrounded her every day in her native Mexico and infused her painting as naturally as breathing. Australian aboriginal dot paintings exude the heat and light of the desert from which they came. The quality of light changes endlessly, wherever and whenever you are. It changes the intensity and the hue of the colors you work with. Whether directly, as you take your source photographs, or indirectly as a

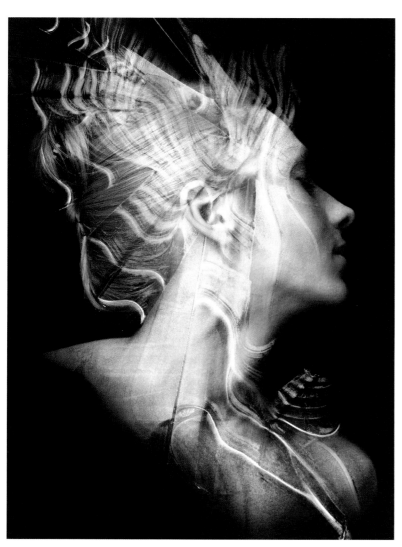

This image of a wall in Marrakesh epitomizes the color combination of the hot, earthy pinks and the deep blue of the skies there.

Ice White, 2004. There are only two components to this very simple piece, the portrait and a photograph of a frozen Scottish puddle. I had never before seen such extraordinary ice formations, and I have never seen them since.

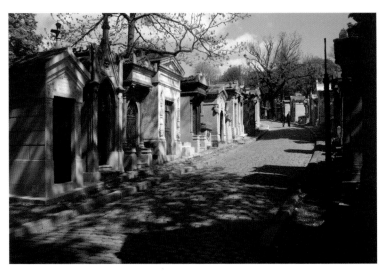

An avenue in Père Lachaise, Paris, 2012.

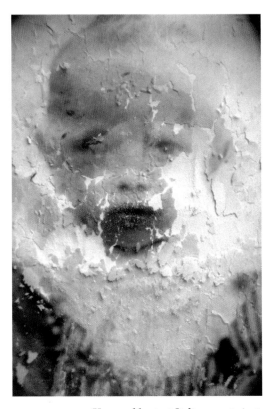

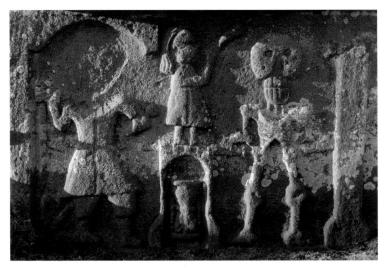

We have some very old graveyards in Scotland, with marvelous carved headstones and crosses. This tomb is in St. Cyrus Nether Kirkyard, which dates back to the Middle Ages.

You would expect Italian cemeteries to be spectacular, and you would be right. San Michele, an island south of Venice, is a prime example. It was here that I first discovered examples of ceramic memorial photographs on headstones, all beautifully weathered by the Mediterranean sun and sea air.

way of thinking and being, your environment will permeate your work.

It's no wonder so many artists travel. Van Gogh famously loved the hot intensity of Arles, in the south of France, while Gauguin travelled further, to French Polynesia, for his sumptuous visions of native life. Travel has to be the greatest opener of minds and source of ideas, not to mention escape from routine and everyday travails.

When abroad, there are a few places I always try to fit into the itinerary. Like many people, I love graveyards. They are repositories not just of sculpture, portrait photography and, if you're lucky, rampant undergrowth; they are also full of dreams, grief, peace, stories, acceptance and life itself. My favorite must be the extraordinary Père Lachaise, in Paris. Its long avenues are lined with family sepulchers, each a tall stone reliquary for memorials, ancient bouquets, stained glass, Madonnas and crucifixes, and even the odd bird's nest. Oscar Wilde's tomb is smothered with kisses and lipsticked messages written in every language. Portraits, flowers, messages and gifts convey so much about the people remembered, and make for some marvelous still life photography.

Museums, especially ethnology museums, are always top of my list of priorities when traveling. Obviously, the artifacts themselves are a joy, and often directly inspire imagery as source material, but these places are much more than this. They are often beautiful buildings in themselves, lit to perfection and full of history and cultural inheritance. The old style of curating was to crowd enormous collections of similar objects together in a blissful cacophony of things from all over the world, from all cultures and tribes, from all points in history. The Pitt Rivers Museum in Oxford is surely one of the best examples in the world of the resultant almost chaotic abundance, and one of my favorite places to be.

Feathers, 2008. The feathers at the heart of this image are in the Museum of Archaeology and Anthropology, University of Cambridge.

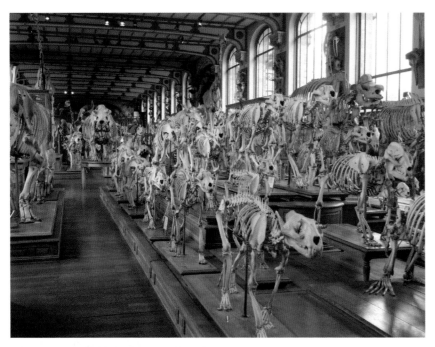

The grand hall of the Galeries de Paléontologie et d'Anatomie comparée, part of Le Muséum national d'Histoire naturelle in Paris, has a breathtaking march of animal skeletons.

A real Wunderkammer, it is a glorious survivor of the museum's earliest form. The huge Musée du quai Branly in Paris has a very different, and no less exciting, atmosphere. An exceptionally beautiful new building, gorgeously lit, it has the space for many large, evocative and spectacular pieces and is particularly strong in African, South Seas and American treasures.

Natural history museums are another favorite haunt. There is nothing more inspiring than nature itself, and such museums allow close examination of the other creatures with whom we share the planet. Taxidermy mounts preserve a sense of their physical presence, while skeletons and spirit collections help with an understanding of structure. There is always a tension in such places between awe at the beauty around you, sadness and even anger at the destruction of the beasts, and fear of the loss of some species forever. This emotional conflict is a rich hunting ground for an artist.

Wherever you are, and whatever you are doing, be aware. Look, really look, at things. Study the effects of light. Watch movement and contemplate color. Then bring the outside in, to your computer and to your art. Use what you have seen to create something altogether new. Look outwards then look inwards to yourself for an expression of your experience, and what you feel about it.

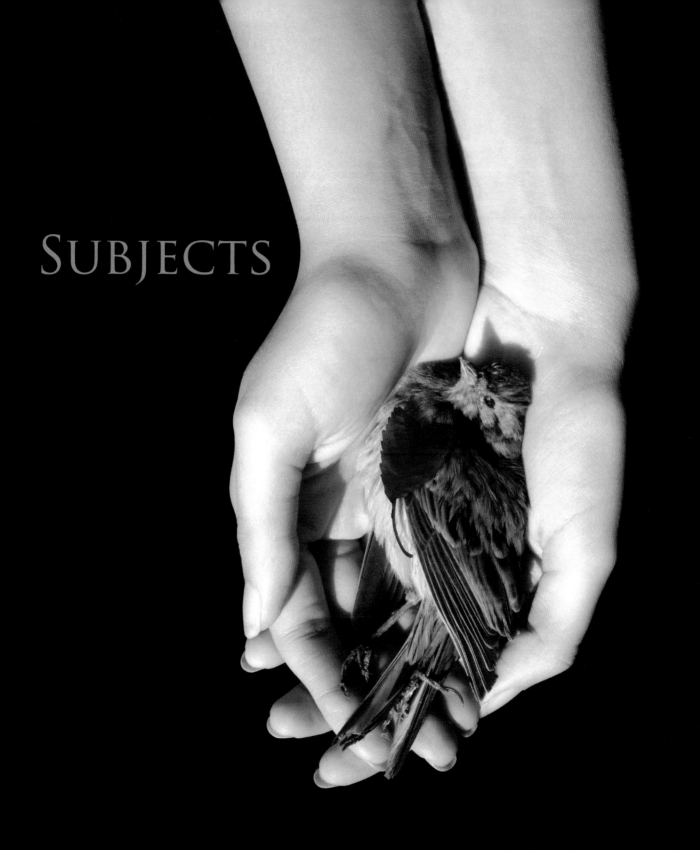

SUBJECTS

What will be in your pictures? Even the most abstract images you make will have some content. This content may be its *raison d'être*, the message itself–the beauty of a flower or the grandeur of a cathedral. You may also use these things as metaphor to articulate your message. The history of art shows that an artist will exploit anything and everything to make a point. This section will suggest reasons for using and ways of working with some of art's best-loved subjects to communicate your artistic message.

The portrait

A portrait is not simply a photograph or painting of a face. Indeed, it may not even show a face. Rather, a portrait is a revelation, a connection with the subject. It is the product of a symbiotic collaboration between the sitter and the artist, a give and take, a communication. It may have taken place over weeks, or even months; it may have been a fleeting, revealing moment. Whatever its genesis, a portrait seeks to understand something of its subject and, maybe, reveal a little of their deeper self–their personality, circumstance, even predilections or aspirations. Inevitably, a portrait will also reveal much about the artist who made it.

We have always searched physiognomies for clues to or evidence of character. Victorian collections of photographs of "roguish types" or "intellectuals" attempted a classification typical of the age, closely allied to the pseudo-science of phrenology. (This categorizing, analytic gaze was first usefully deployed by Alphonse Bertillon, a police officer in France in the 1880s. He developed anthropometry in order to identify criminals and his mug shots live on in police photography today.) We still cannot help inferring character from faces, however erroneously. That the murderer Ted Bundy

should have been so handsome gives us a jolt, and is a reminder that a beautiful or ordinary visage can hide a very different personality.

The average human face, if one can imagine such a thing, cannot have changed much across the millennia–unlike the society that produces the portrait and the methods and intentions of the artist. Idealism will reflect the age as surely as a ruff or wig, Biba dress or eyeliner. A commissioned piece will often seek to flatter. Making a person closer to an ideal will reveal much about both the commissioner and the society in which they live. Since the height of Roman realism, maybe only Cromwell–and even he, possibly apocryphally–has ever asked for a portrait "warts and all". Indeed, if an image fails to impress its audience it may not survive at all. Winston Churchill and his wife, Clementine, famously disliked Graham Sutherland's 1954 painting of him, feeling that it made him appear old and enfeebled (it was presented to him on his 80th birthday). Lady Churchill had it destroyed. This reveals the power of the portrait as an icon of the sitter, a distillation of them and their place in the world upon which even their reputation may rest in the future. A direct connection with another person, maybe long gone, one established with the artist and relayed to us across time, is a very moving thing.

Throughout history, portraits have striven to immortalize. Renaissance papal portraits are demonstrations of a very worldly power and authority. The "Portrait of Innocent X" of 1650, by Diego Velázquez, is a sublime example of the portraitist's art. Velázquez made a monumental pyramid of the man, transforming him into a timeless declaration of the supremacy of the Church. He also revealed much about the man beneath the miter. In today's more individualistic times, Francis Bacon became obsessed with this image. He made upwards of 45 versions of it, in which the pope's wary,

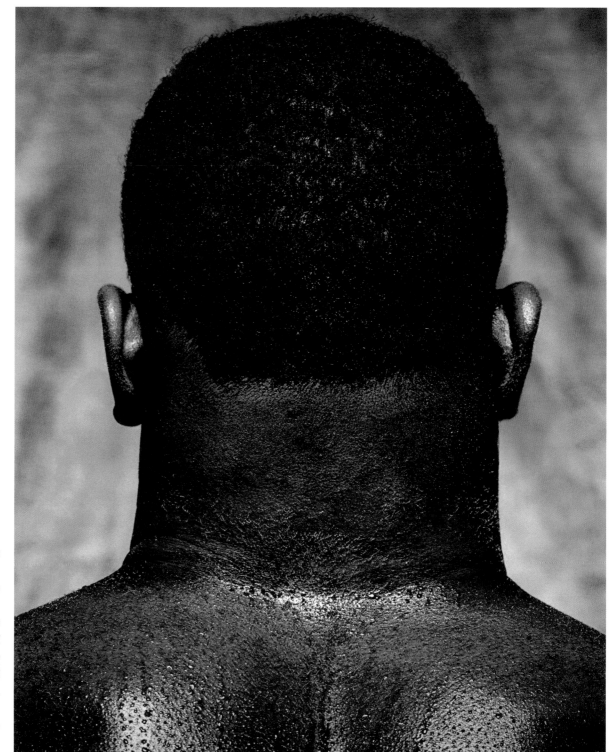

Mike Tyson, Catskills, NY, 1986, by Albert Watson. This portrait, showing simply the back of a man's head, says everything about the sitter. Its sculptural solidity, uncompromising formality and textural beauty give it an imposing grandeur. Image courtesy the artist.

 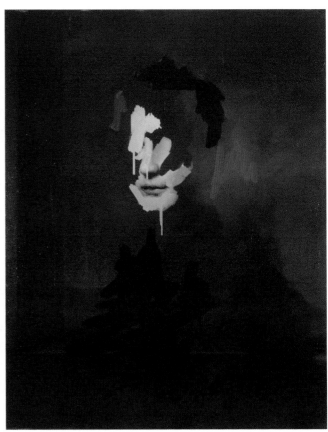

Nocturne 80, 2011 (left) and Nocturne 113, 2011, by Chad Wys. These are haunting deconstructions of paintings. It is fascinating that pictures with subtractions should become so much more than they were. The sitter, at another degree of separation from the artist, is no longer the subject, and the work becomes about the act of making a portrait itself. Images courtesy the artist.

calculating, politician's face is opened into a scream. These are no longer portraits of an individual and his position but expressions of the artist's own angsts and aesthetic decisions. Bacon's portraits can, indeed, be seen as self-portraits. The painter is working with very personal issues here, and the subject is a vehicle for them. The artist is immortalized, rather than the subject.

The self-portrait is a very different beast from the commissioned. Many artists, when faced with their own reflection, affect a brush and a scrutinizing gaze,

and pose. They are very aware of the impression they are making and are probably advertising their services. Albrecht Dürer, depicting himself as a startlingly Christ-like figure, made not only a self-promotional technical tour de force but also a most revealing display of complete self-confidence, to the point of hubris. By contrast, Rembrandt van Rijn probably made the most haunting self-portraits ever painted. Rembrandt seems not to care what his audience thinks of him. These are private acts of confrontation, with his own self and with the future. The look of despair in some of his last works is terrible indeed. These paintings are an almost brutal self-assessment. They form, as a series, a brave study of the decline that is inevitable for us all.

Today, chancellors, mayors and royalty still need to be defined and acclaimed in formal portraits, and artists still examine themselves and others for the truth. Artists also make pictures of people that are about something else. My own are this latter form. I suppose, strictly speaking, they are not portraits at all. I almost never know the subject in my portrait imagery. If I did, I would find it much more difficult to impose the picture-making process upon them. I would be distracted by the knowledge of the sitter—she climbs mountains, he is a librarian, whatever it may be, would soon filter into the picture. For artistic carte blanche, choose a complete stranger. I rely on the kindness of strangers. I have had the impertinence to march up to hundreds of lovely people over the years and ask to take their photographs, and have almost never been refused. People's generosity never ceases to amaze me.

I tend to take profile and full-face shots, which I put down to the influence of both Egyptian and Cycladic art. I love the simplicity and elegance of both. There is also a suspicion of Bertillon. It may even be related to a method of making a sculptural portrait head by establishing the major masses and then the profile; once you

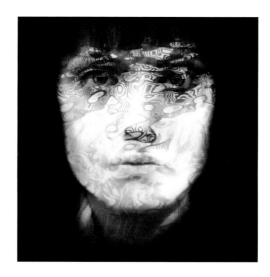

Pool, 2012. This is an invented face, a combination of three photographs. The reflections are of a simple iron barrier in the water of a reservoir. I took a huge number of shots of the ever-changing abstract patterns, and found one that needed minimal alteration to fit the face.

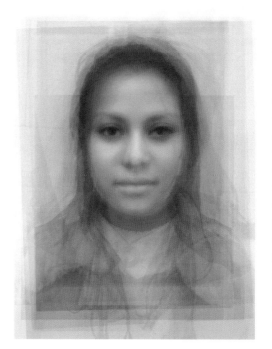

There does seem to be a universally accepted form of beauty. Generally speaking, the more "average" a face is, the more beautiful it is seen to be. Symmetry is a preference, worldwide and across all cultures historically; while no one's face is perfectly symmetrical, those who approach it most closely are always deemed more attractive. Youth, of course, is an asset, as are clear skin and eyes. These things all denote health, and therefore probable fertility. This image, composed of twenty randomly selected photographs I have taken of women over the years, shows that I tend to choose models possessing a classic beauty. African, Asian and European women are all represented here.

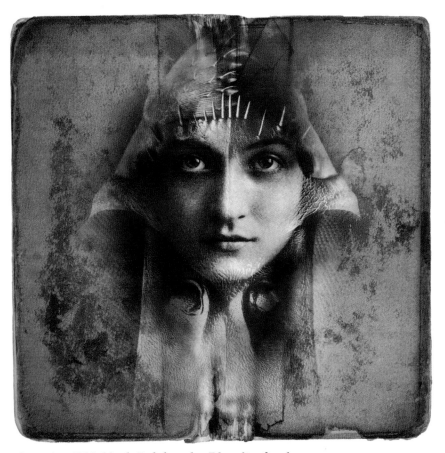

Queen Ant, 1998. Maude Fealy has a less Edwardian face than many (she even has ears in one image, strangely—Edwardians seemed not to admit to having them), possibly because she is very close to a modern ideal of feminine beauty. Hers is a soulful, symmetrical face, doe-eyed and even childlike. She has a grace lacking in some of her more heavy-jawed actress peers.

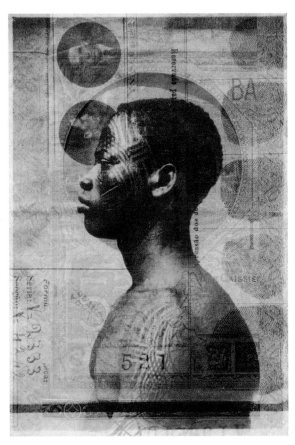

Reservado, 2008. As with my nudes, if identity is a subject it is usually not specific to the person in the image.

have these roughed out, you have a sound basis for the rest of the head. All sorts of seemingly unrelated interests and habits will feed into your work.

I also use found photographs. Picture postcard faces, with their careful styling and lighting, are so redolent of their age. Flea market finds of Edwardian postcards and *cartes de visite* come with their own magic–lost people, their stories and sometimes even names now separated from their images, they seem to need rescuing from imminent oblivion. Such images are a delight to work with.

The images I make with these photographs may well be about identity, but likely not that of the sitter. They tend to be, like the nudes in the next section, allegorical. Like every portrait artist before me, I want the people in my work to embody ideas, but the individual is less the subject than a conduit for those ideas. No doubt because they are not commissioned pieces, they can be detached from their subject and become metaphor.

The nude

To make images with impact, with psychological and emotional resonance, consider working with the beautiful, fascinating, impossible-to-ignore nude. The very words "naked" and "nude" arrest the attention. It is the consummate subject with infinite possibilities, whose iconography refers back to thousands of years of history yet has the immediacy and directness of observation and, most particularly with photography, the actuality of a human presence. It arouses feelings so fundamental as to be common to us all. It expresses desires and needs basic to anyone, anywhere in the world, both physical and spiritual. It is no surprise that the nude is one of the classic subjects.

Aesthetic considerations are not always paramount in the first glance at any work of art; the first thing anyone does is to identify its content. One cannot escape the subjective view of the representation of any object, still less of a nude. The question of what manner of nude it is comes next. Subjective reactions are overlaid with and manipulated by the treatment of the figure. The artist's personal response to the subject pervades the whole work and makes the message clear.

The naked body is the outward expression of ourselves, the soul-house, the enabler and motivator of the inner self. Our deepest sense of ourselves is never so near to the surface as when we are reminded of our physical strengths and frailties. The nude has been used in myriad ways over the centuries–indeed, millennia. It can be an archetype. It can mean anything, independent of history, place or circumstance. You probably won't sit down with the resolve to make a classical or a surrealist nude but, while your work will inevitably not fit tidily into categories, it may have elements of any or all of these approaches.

The idealized nude

The desire for perfection is a universal aspiration. While the ideal itself has changed throughout history, and still varies across the world, physical perfection is an eternal human dream. Youth and health are a constant, as is symmetry and a sinuousness of line. The ancient Egyptians were the first to establish a code, a theory of beauty. The lithe, supple and graceful figures of their art are very close to the slender healthiness of today's aspirations. Their ideal was distilled from the observed. The Greek ideal, which has inspired Western culture ever since, is altogether more conscious and systematic than the Egyptians' simple delight in youthful form. Good health is still a major factor but now, rather than being

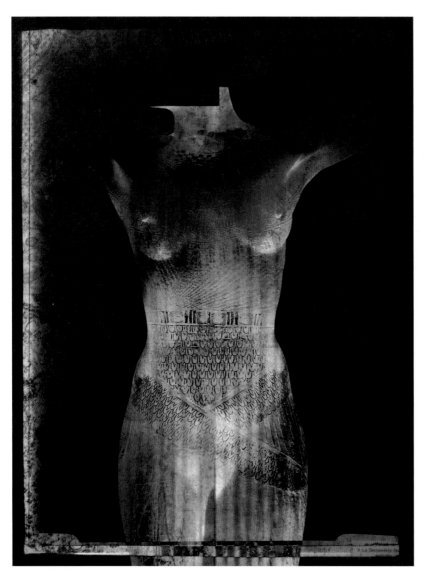

Isis, 2004. Rather than a direct reference to a particular myth,
this is an imagining of Isis, the Egyptian goddess, whose name means
"throne". The shape of the cut-out echoes that of her heiroglyph.
Egyptian sculpture shows an uplifting delight in the human form.

a gift of the gods, it can be attained. We still believe this today. Diet and exercise, hard work, discipline and, if all else fails, surgery, will win us the perfect form–and if it doesn't, there is Photoshop. The impossible dream has become possible with digital intervention.

So, Photoshop has become almost synonymous with the artificial and unattainable. In the hands of an artist, however, the medium has more expressive potential. While continuing the age-old search for an ideal state of being, using a physical ideal as metaphor, we can contrast that beauty with reality–a photographed reality. The resultant tension between the dream and the real increases the power of both.

The classical nude

The classical nude is a specific form of idealism. When such Greek sculptors as Phidias and Praxiteles broke away from the ancient adherence to the frontal in the fifth and fourth centuries BC, they began one of the most important revolutions in the history of art. New copper tools, used with softer stones such as marble, allowed sculptors much greater flexibility of pose and therefore expression. The body moved out of the symmetrical, static block in which it had been encased for thousands of years. Arms and legs broke free of the matrix and energy and movement burst through. A new realism was possible.

As with many revolutions, given time and usage, eventually these radical ideas became mainstream. Innovation froze up into convention. Once progressive and utterly new, the classical nude was codified and systematized until today it is almost a symbol for establishment art. It is so familiar it is difficult to see in a fresh light. People no longer even seem to see classical nudes as nudes; they are tolerated where other forms of representation of the naked human being would not be,

Le Vase Brisé, 2011. The reference to an ancient civilization and the stone-like body paint point up the classicism of the pose, in which the hand delicately hides the breast, while also drawing attention to it.

especially in religious contexts. This implies not only that the classical nude has lost its eroticism, but that it no longer inspires strong reactions of any kind.

The classical can still be re-seen, however. There is a repertoire of poses chosen for their exposition of the body to its best advantage. With the weight to one foot and a sinuous twist of contrapposto, they embody grace and a harmony of proportion. They hark back to centuries of art history. Artists can use the classical ideal today to give their work balance, poise, elegance and the weight of centuries of authority.

The rational nude

Measured, contemplative and intellectual, these works coolly examine the nature of physical presence. A sublime proponent of this most descriptive approach to the nude is Euan Uglow (1932–2000). The importance of measurement and control is stressed by the inclusion of construction marks in the finished painting. There is no lack of sensuality–the gorgeous delicacy of color ensures that–but the emotion is highly controlled. Actual form is rendered with a precision that concentrates attention upon the planes, lines and colors of the nude; the painter's practice has become a large part of his subject. This analytical yet passionate way of looking is very suited to the digital artist, whose method allows both for great accuracy and for the grand gesture.

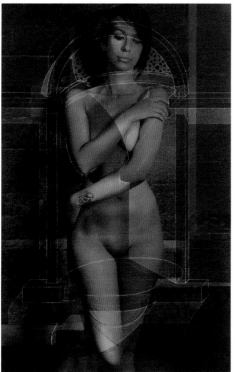

Schematic, 2010. This image envelops the figure with both photographic and diagrammatic architectural references.

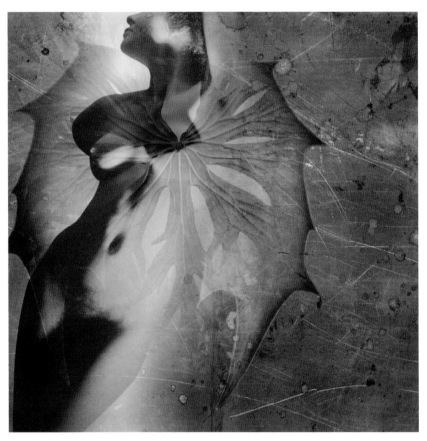

Vampire, 1998.

The romantic nude

Full of imagination, mysterious, thrumming with emotion–the romantic outlook has an irresistible energy and potency. Romanticism, from the art historical standpoint, is all about individualism and expression, and so a very appropriate mindset for an artist working today. In the late eighteenth and early nineteenth centuries, particularly in France, there was a philosophical revolt that reverberated throughout the arts and sciences. It kicked against the neo-classicism of the time, which was becoming stiff, stale and suffocating. A new individualism appealed directly to the emotions and was a breath of fresh air.

Today, we still rebel against the authoritarian. This is in an artist's nature and is essential for creativity. We live in an increasingly empirical and secular age and in many parts of the world the power of religion is on the wane, but there is always a need for mysticism. People are turning to other belief systems–the power of crystals or runes, Tarot, whatever it might be–in their search for mystery and the thrill of potential revelation. Science has become so specialized that the old-style "gentleman naturalist" cannot possibly exist; no one can encompass all the disciplines in any depth. This can leave people feeling excluded from such arcane explanations and looking for new ways of imagining the world. In such a climate, a way of seeing that embraces wholeheartedly the original, the unique and the intuitive will be well received.

The romantic nude is highly expressive, emotive; it abandons the rational in favor of the flight of fancy. (Do be careful–it can veer into the hysterical and nonsensical if not grounded in some kind of reality!) Illogical and dreamlike, the romantic vision is perfectly suited to digital montage.

The expressive nude

The expressionist artist can harness the power of the nude to shock, involve or even alienate to create intensely personal visions of the world. Assaults upon the body such as war, disease or famine have all left their mark on the history of the nude in art. The medieval world produced exquisite examples of the anguished, suffering nude. Made for religious institutions, these were often warnings. The prevalence of many incurable and horrifying diseases, particularly syphilis, at the time may well have heightened their anxiety about sexuality and its potentially fatal consequences. So many awkward, gaunt figures peopling the medieval Eden seem damned by their own physicality.

The frailty of the body has been probed ever since. Frida Kahlo, for example, elucidates the most personal attack on the body. Kahlo paints her own body as she feels it, bound up in plaster and braces, split open from neck to waist, pierced by nails. Her world was full not just of the color, life and heat of Mexico, but inescapable pain. An accident that left her, at just eighteen years old, with a back broken in three places affected the rest of her life and all of her art. Painting the nude, for Kahlo, is a catharsis, an externalization of her pain. To present it to the world must have helped to make it bearable.

This physical anxiety remains an important element in the modern depiction of the nude. Whether showing post-operative scars, wrinkles, emaciation or corpulence, the body is shown to be vulnerable. It reveals intimations of mortality, such as pervade the beautiful x-ray figures of Benedetta Bonichi—we all, soon, will be but bones. The nude can even take us beyond death, notably in the work of Andres Serrano, Jack Burman and Sally Mann. The changes a body goes through, during and even after life, have all inevitably been explored by artists using the nude.

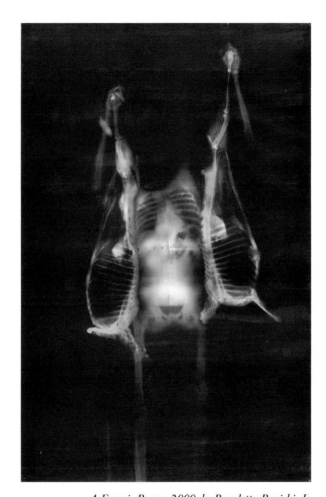

A Francis Bacon, 2000, by Benedetta Bonichi. In her radical portraits, Bonichi strips her subjects right down, past the skin to their hidden depths. In 1952, John Deakin made a photograph of Francis Bacon holding up a cleaved carcass; Bonichi's extraordinary reimagining of it reduces the artist, too, to flesh and bone. Image courtesy the artist.

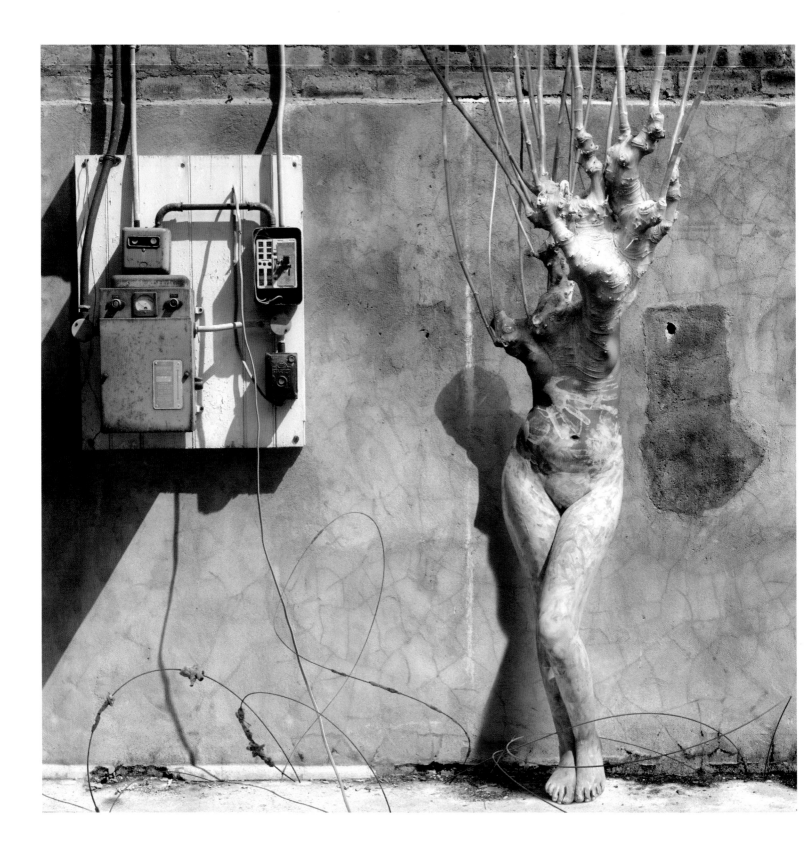

Over Ascreavie, 2011. The human-tree in this image has been repeatedly pruned, clipped and curtailed. The ability to overcome such control is suggested by giving it a wholly human shadow.

Subjects 49

The surreal nude

The Surrealists loved working with the nude. Usually passive and appearing unconscious or even dead, she was disassembled, juxtaposed with accidental or incongruous objects, and always female. Their themes were irrationality, sex and violence. There was a dissociation, a kind of emotional detachment, about much of their work. Their concerns were rather experimentation, the abandonment of logic and intellectual jousting. They cut into images, often literally, and made unnatural or simply odd connections between objects as a way of revisualizing them and achieving newness.

Accusations of misogyny have been leveled at the Surrealists, and I would largely agree. In their imagery, women are often treated with dispassionate objectivity and, at worst, subject to violent attack (the group was deeply interested in the works of the Marquis de Sade). Women were very much muses in the most objective sense; mannequins had as much erotic appeal as a real woman, it seems. There is plenty of passion, but there is an emotional disconnect.

Their methods, however, if not necessarily their message, have been absorbed by artists since, and are especially well suited to digital montage. The Surrealist's fondness for odd combinations is a particularly useful trope for a montage artist, and was absorbed into mainstream culture very early. Fragmentation or truncation of a body might imply a psychological state—disempowerment, maybe, or isolation—or it might simply be a way of achieving a harmonious pose or composition. A surreal work, now, does not inevitably espouse the philosophy of the art movement that inspired it.

The erotic nude

Eroticism is the one aspect of the nude that dominates all others. The first nudes ever made are prehistoric sculptures of women, hugely rounded, with exaggerated breasts and almost no head. They are probably fertility idols and are certainly all about sex. The nude must be the best way of exploring one of the most basic and important instincts enjoyed—and suffered—by mankind.

Erotica has guts and power and a visceral punch. It confronts the human need, obsession, head on and has something to say about it. It is important, I think, to distinguish between the art of the erotic and the soft pornography that has dulled people's perception of the

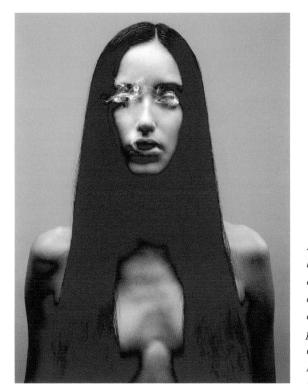

Nika Smoke, Hamburg 2006, by Carsten Witte. The model's direct gaze makes an immediate connection, and her parted lips are more provocative than any physical display could be. Image courtesy the artist and Monika Mohr Gallery, Hamburg.

former, and is all too easily confused with it–particularly in the area of photography. The intention of the artist is the vital point. There is of course a huge market for anonymous pictures of pretty half-dressed girls in artificial and provocative poses, whose only aim is to invite lascivious attention. They conform to a code that has distilled and exaggerated one or two aspects of a more robust eroticism. There is no art in these and there is not meant to be; they are caricatures. True eroticism is not the canned, codified and sanitized stuff of the pin-up. It is the embodiment of a passion for the erotic and the nude. It is direct, individual, truthful, most of all emotionally involved and personal.

The mechanized nude

The body can be improved upon by technology. We can be healed, enabled, even created by medical intervention. Many of us are kept alive by machines, even having them implanted in our bodies. We can also be destroyed by them. This uneasy alliance is very interesting to explore.

Everyone in the developed world is, to a greater or lesser extent, reliant on machines. As our dependence on them has increased, so has our fear–fear of their malfunction and fear of their function in others' hands. We have all experienced their failings. It is easy to project crashes and glitches until, ultimately, we imagine an apocalypse in which we have lost all control of our creations. Still more frightening is the possibility of our enemies being better armed than we.

Our bodily safety was threatened by our own inventions long before the arrival of the ultimate annihilators, the atomic and nuclear bombs. Machines can kill, by accident or design. Our relationship with our inventions is uneasy and complex. Science fiction has articulated this by imagining the next step in the

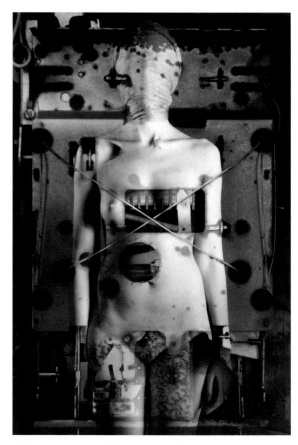

Unknown Device, 2010. Automata fascinate me, so I made this hybrid. The steel trap in which this soul is enmeshed is a junkyard find. Parts of it grow into the figure and begin to absorb her.

progression: unconscious robots develop into autonomous beings such as androids and cyborgs, blurring the difference between un-alive and alive. The projection is that such biomechanical creatures might be sentient yet unencumbered by emotion, and thus ruthless. Hence the anxiety–we would be no match for them.

Cinema provides most of the references here. Fritz Lang's masterpiece *Metropolis* was the first of many fantasies ranging from the dystopian to the apocalyptic. In films such as *Westworld, Terminator* and *I, Robot,* the machines threaten to overthrow their makers. Imagining such worlds probes the boundaries and explores what it is to be alive—and digital montage is a perfect medium with which to explore.

The dissected nude

Some work literally gets under the skin to expose the essence of being human. Memorial statuary has never balked at showing the hard facts of mortality's effect on the body. Before surgery was as survivable as it is now, the body's workings were only ever visible either as the probable precursor to, or the result of, death. The connotations were always negative and usually terrifying. Christian religious imagery reminds us of the frailty of the mortal body, of Judgement Day, of the inevitability of death.

However, the dissected body has other potential readings. Disassembling a body may be an act of violence, or it may be manipulation of form. As the Surrealists show, the body is vulnerable to assault and even destruction, and this anxiety—or possibly fascination—is unsurprisingly a powerful motivator to art-making. The act need not be a violent one, however; it can be an abstraction or an exploration. The discovery of so much classical sculpture, broken yet beautiful, has been a visual inspiration ever since. When a body is reduced to it, the form of the torso is much stronger. Rodin, for example, simply ignored the parts of the body that were not pertinent to his composition. If arms, heads or feet were superfluous distractions, he left them out. This is not a negative, obliterating thing, but a way of distilling a pose to its expressive essence. Also, now that we

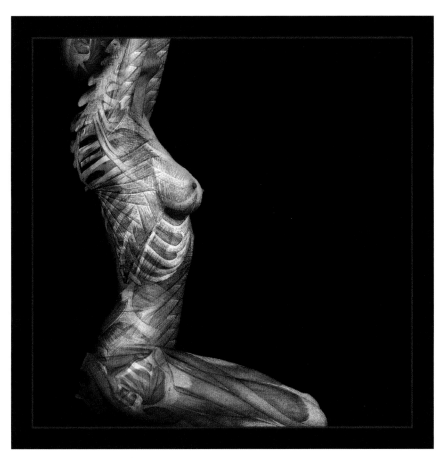

Equus grevyi, 2004. This is clearly not an accurate representation of anatomy. Rather, it is an abstraction, a reinvention of structure.

are used to seeing the interior and secret workings of our own living bodies by means of x-ray or scan, they have less fear attached to them. The modern artist can refer to bodily mechanics in metaphorical and exploratory work, in which a peeled figure can reveal interior thought or express emotion without having to be an object of revulsion.

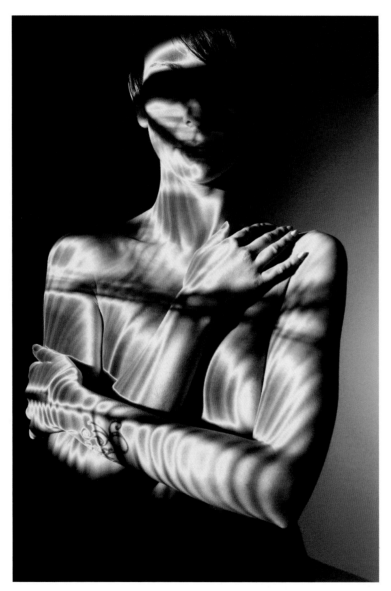

Birdcage, 2010. A nude is more enigmatic without a face from which to gauge mood. A single studio light was focused on the model through a bird cage for this shot, which was then partially solarized.

The unidentified nude

People search faces for clues. They tell us much–although maybe not as much as we think–about personality, history, age, mood; but these specifics can distract from the message of the picture. To create an archetype, an everyperson, you need to remove the figure's individuality. Hiding or otherwise excluding the face effectively depersonalizes a figure. An anonymous figure is more easily seen as a symbol rather than an individual. A face will always be unique to the sitter. A body with a face becomes a nude portrait, while a body alone can more easily represent anyone and everyone, or something altogether more abstract.

A face is also a compositional distraction. It is an area of small detail and high contrast, which will attract attention whether you wish it or not. Eyes, in particular, are an irresistible draw, taking the focus of a picture away from the intended message. Working without an identity frees you to say more universal things with the nude.

The abstract nude

Reduce a nude to a series of curves, dots or lines, and it will retain meaning. The proportions of the body are so engrained in our consciousness that only the tiniest clue is needed for us to construct one. There is a classic experiment that shows just how little information is needed to construct a human shape in the imagination. Lights are attached to a black catsuit at the main joints of the body–shoulders, elbows, knees and so on. The wearer stands against a black background that is randomly scattered with more lights. When the wearer is still, he disappears, merging into the background. However, with the slightest movement, he springs from it, fully rounded. The brain needs remarkably little prompting to visualize a human form.

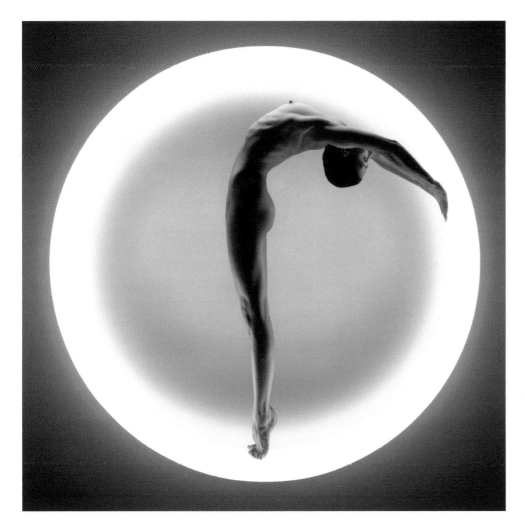

No Title, 2001, by Klaus Kampert. The extremity of pose and the perfection of environment of this piece emphasize its graphic qualities, and make the figure a cipher. The image is a sandwich of two identically lit shots, of the figure and the neon, to make a seamless whole. Image courtesy the artist. © Klaus Kampert.

An abstracted nude retains all its emotive power even when stripped down to the minimum. Photography and digital montage are excellent media for abstraction. Removing the background, or giving the figure a purely formal or graphic environment, will dissociate it from any usual context and pare away preconceptions with it. Focusing on parts of the subject will also draw attention to the body's form over a narrative. Cropping and fragmenting, disassembling, contrasting texture and isolating the essential will create a tension between the formal surface qualities of the work and its sculptural depth.

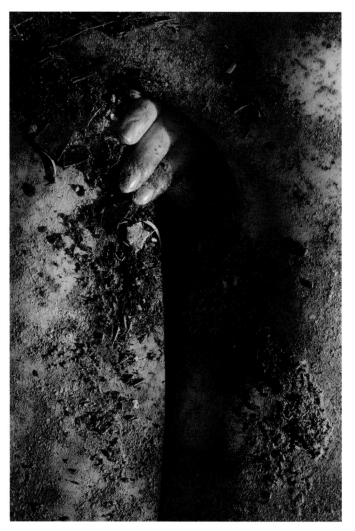

Curl, 2010. Cropping in to a small detail effectively abstracts this nude. The earth in this image was added later in a Linear Burn mode layer.

The landscape

Constantly changing with the hour, the weather and the season, the visual and emotional potential of landscape is endless. From serene vistas to raging seascapes, barren wastelands to lush and living rainforest, breathless mountain passes to intimate country lanes, our world is dramatic, inspiring and beautiful. It is only relatively recently, however, that landscape has taken center stage. Historically, it was, for the most part, confined to a backdrop for other subjects such as village life, mythologies or portraits. A portrait set in rolling countryside made a statement of ownership, a forest set the scene for Diana and Actaeon, a seascape told the story of a battle or an adventure.

Increasingly, with industrialization, the countryside came to be viewed from an urban standpoint. By the end of the Industrial Revolution, people were crammed into filthy, noisy and disease-ridden cities, and the clean beauties of a country life were fondly remembered. Pastoral idylls reveal a nostalgic desire for a return to country living. It is no coincidence that the landscape itself became a subject for Western painting only when cities began to absorb most of the population. The harsh poverty and manual work inevitable in most people's rural lives was generally elided in a search for a lost Eden. Landscape began to take over from the putative subject until mythological characters were reduced to tiny figures who did no more than establish scale. With such painters as Turner, Caspar David Friedrich and Frederic Edwin Church, the landscape itself, its moods and spirituality, finally became the subject.

FACING PAGE
Illuminated II, 2011, by Ysabel LeMay. Full of light, life and movement, this is a deeply seductive imagined land.
Image courtesy the artist.

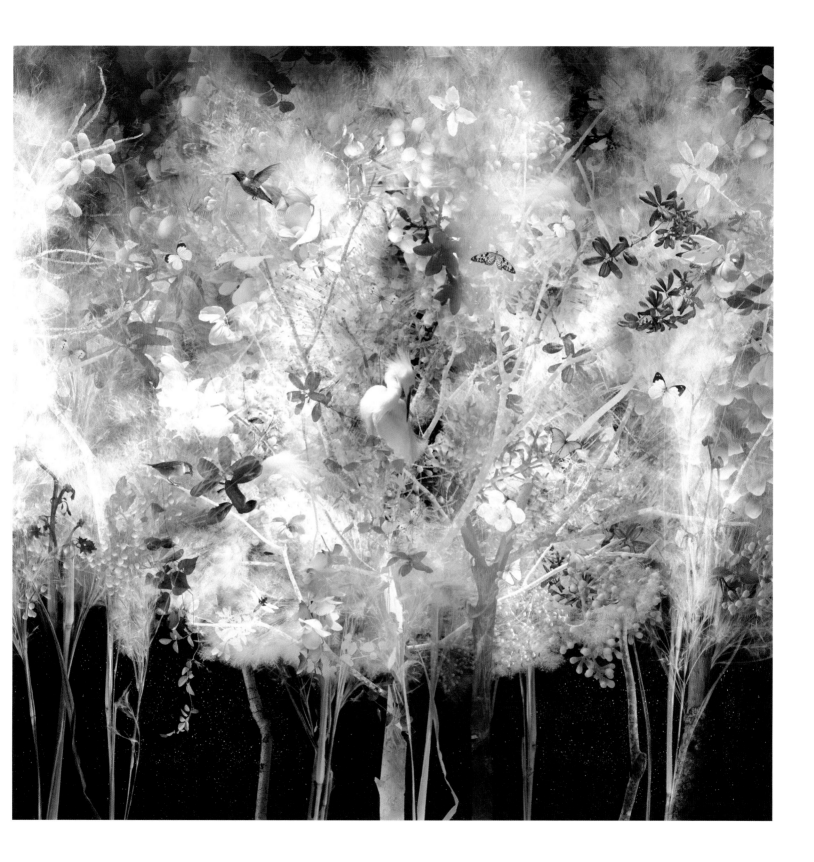

Butte aux canons (Bois de Vincennes, Paris, 2006) by Alexandre Duret-Lutz. Duret-Lutz makes his "Wee Planets" by first shooting many photographs of his entire surroundings, ground and sky included, and stitching together 360° × 180° panoramas. These are then transformed with stereographic projection software into beautiful conformal projections. This pastoral world was shot from an elevated vantage point in Paris' eastern park. Image courtesy the artist.

Landscape, 2012. This landscape comprises two photographs of hand-made glass, through one of which can be seen distorted railings. It needed only the addition of birds.

Other artistic traditions embraced the landscape as subject much earlier. Australian aboriginal paintings, wonderfully abstracted representations of their land, belong to an ancient tradition. Japanese woodblock prints are also sublime examples of landscapes depicted in their own right. The printing process, invented in China, was initially used largely to represent city living. Gradually though, as in the Western world, the emphasis shifted from people–here, the wrestlers, geishas and actors of the ukiyo (the "floating world," that of entertainment)–to the exceptionally beautiful Japanese landscape. By the first half of the nineteenth century, Mount Fuji is the subject and star of almost every Hiroshige and Hokusai print.

In modern times, landscape, or rather environment, is used in all of these ways, from the social and political to the romantic, from the realist to the highly abstract. Its versatility is as enormous as its variety. The implied freedom of a deep vista stretching away to endless distant possibilities can turn into the desolation of an abandoned wasteland; Paul Nash's wartime images of no-man's-land are some of the most powerful and impressive landscape paintings ever made. Photography, too, explores all of the subject's expressive potential. Huge vistas or intimate corners, naked of life or teeming with creatures, scarred or pristine, impressionist evocations of atmosphere or the stinging clarity of an Ansel Adams–there is no end to the diversity and

beauty of the world around us, and the stories it can tell. Landscape imagery can also transcend the facts to become metaphor.

With landscape, as with any other subject, there is no need to restrict yourself to a traditional approach. Horizons do not have to stay flat, gravity does not have to apply. You are not even dependent on actual landscapes for your montages, any more than painters are for their imaginings. Whole new worlds can be created inside the computer. Using three-dimensional programs such as Bryce, you can design mountains and valleys, expanses of water and deserts, and you can clothe your realms with grassland, scree, rocks, trees and cities. Personally, when I work with landscape, I prefer to work with photographic input—but that still doesn't limit me to photographs of landscape.

Placing a subject in a natural-looking landscape that conforms to the rules of perspective will make your image more believable as a representation of reality, even when it is clearly an invention. By keeping shadows consistent throughout your picture and maintaining correlations of scale, you will create pictorial depth. Remember too that color casts will help greatly in the illusion; fading colors through to cooler blues in the distance will generate aerial perspective.

Landscape may be nothing more than an impression of enclosure or space. Your image may demand a claustrophobic, compressed feeling, or a limitless open arena. Making space within the confines of the picture's dimensions will rely on tricks discovered by first Roman and then Renaissance fresco painters. *Trompe l'œil* painting developed once linear perspective had been established by such painters as Paolo Uccello and Piero della Francesca. The use of vanishing points, and the implication of recession by decreasing the size of objects as they move into the distance, creates a powerful illusion of depth within a two-dimensional surface.

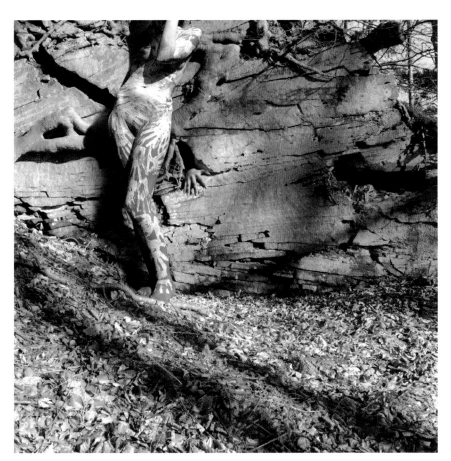

Quarry, 2011. While logic dictates that no hand should be reaching out from a solid rock face, it starts up a narrative with the hand-printed body.

The eye is tricked into perceiving space. A sheet of paper will become boundless.

The marvelous Landsat satellite imagery available on NASA websites introduces an entirely different viewpoint. Traditional perspective is irrelevant to this new way of seeing the world—the viewer is placed

Ministry of Truth, 1998. The threatening potential
of a deep red is used here to create a brooding atmosphere.

states of mind, relationships. Making imagery with a recognizable space can make them read more literally than I'd like. In Ministry of Truth, the landscape is merely an implication. Here, I've used a family snapshot of my great uncle walking across a bridge. The perspective of the figures disappearing into the distance, along with the handrail cutting across the middle of the picture, is enough to create spatial depth and suggest context.

Landscape may be your subject, or it may be your setting. It can be an end in itself, showing its own history, drama and beauty, or it can create a mood and a home for your image. You can also travel through it into the realms of the imagination.

Architecture

Architecture is a vibrant reflection of the society that builds it. Everywhere, people make themselves private and public spaces in which to live their lives, engineered to fit those lives perfectly. From a riad in Marrakesh to a New York loft, a hut in a stilt village to a troglodyte's cave, homes reflect the climate, culture, environment, social order and métiers of the settlement and its inhabitants. They are, to quote that radical modern architect Le Corbusier, "machines for living in" (*Vers une Architecture*, 1923). Public spaces are reliable guides to the beliefs and functioning of society as a whole, even at their most practical. Often centers of administration and power, they have a dual purpose: they are both practical workplaces and assertions of the order of society. The larger they are, the more explicit and unavoidable the message. Today's equivalent of the ancient Mayan pyramid or Roman coliseum is probably the skyscraper; that soaring, aspirational temple to modern capitalism. Architecture as a subject says much about people, too.

outside the environment and looks down on it rather than across and through it. That it is seen from above lends a flattened, abstracted look to the picture, and brings out the pattern and logic inherent to geographic features. Patterns repeat, and scale is hard to judge. The representation of landscape is returned to two dimensions. This helps the reading of clues as to the creation of the landscape itself–the winding course of a river or the branching of a delta are much more easily understood from this distance. The mapmaker's view of the world is no longer theoretical.

My own pictures are often not concerned with "real" space but with the inner dimensions of feeling,

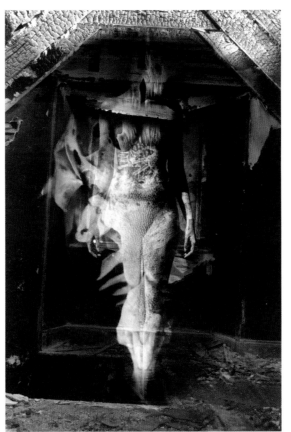

House Fire, 2012. This beautifully-situated house in Angus, Scotland was sadly gutted by fire and simply boarded up and left. Thanks to the local children, the door was wide open for me. Up in the attic, the sun was streaming in, showing the glossily quilted scorched beams. The ghost may be an occupant, or that of the house itself.

Reached by camel, this Nubian settlement in Egypt is a cool blue oasis in the desert.

Ruins

The nostalgic romance of the ruin has been a photographic subject from the very beginning. Their picturesque and gothic appeal had a natural pull for Victorian sensibilities. The drama of history adds to the visual delight of complex, weatherworn texture.

Ruins, vernacular and high architecture alike were chronicled by such masters as David Octavius Hill and Robert Adamson. In 1843, a very fortuitous pairing of a painter (Hill) and an engineer formed the first photographic studio in Scotland. Hill had originally been interested in the new calotype process as a study aid for his painting, but immediately became aware of its

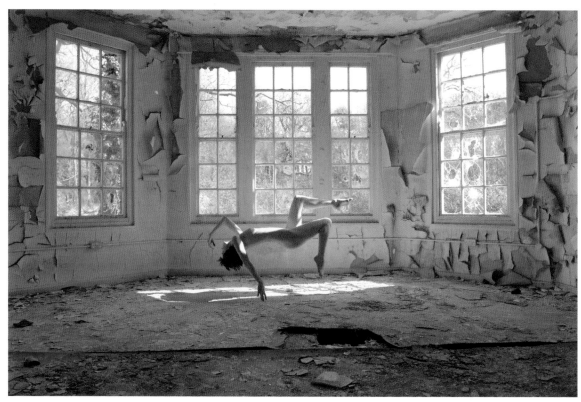

Floating, 2012, by RomanyWG. The mood of an urbex piece does not, of course, have to be nostalgic and dark. This exuberant piece has a lightness of mood to match the lightness of the athletic model. The beautiful sharp yellows and the sunshine streaming in make for a buoyant and bright image. Surprisingly, it is not a montage, but a straight capture. Image courtesy the artist.

own artistic potential. When he was introduced to the much younger Adamson, an artistic collaboration and a firm friendship was formed. The pair photographed the people and cities, fishing villages, abbeys, castles and towns of Scotland and the north of England. The painterly effect of the calotype process combined with the topography to create beautiful, rather romantic imagery.

Today, the ruin still has a potent attraction. Urban exploration–urbex–is a growing trend in photographic circles. Old, abandoned buildings, often industrial or municipal, are excellent settings for a dramatic image.

Overgrown and neglected, the lure of a broken door leaning on a single hinge is irresistible. You have to step in, over the nettles and into the dark. These private places, long deserted, speak silently of lost lives and deaths. It is a transgression, an invasion, but one justified by the salvage of a few tantalizing impressions of the past. Some very beautiful buildings are abandoned to their fate. Through an owner's death, an institutional closure or a simple change of use, they are closed up against vandals and forgotten. Then, after a cracked tile here and a shattered window there have let the elements in, nature does her work and begins to

take over. It seems very sad that such places should be left to go back to the earth–although, if they were not, there would be no urbex work, which would also be a loss! This paradox gives these pictures their edge. Sadness combined with beauty is an intoxicating mix. Even the most prosaic and functional building takes on a new mantle of romance when invaded by ivy and owls.

Old buildings can be enhanced by monochromatic depictions that not only exploit their texture, but also remove the subject one step from reality and the present day. Bright blue skies do not help to create an aged, nostalgic feel. You can add to the layering already present in the peeling paint, crumbling masonry and creeping ivy by shooting through doorways from one room to the next, through windows to landscapes, and into dusty, cobwebbed mirrors.

Modern architecture

Modern architecture is an abstractionist's delight. With its clean lines, reflections in acres of glass, lights and emphasis on material, post-classical building has a powerful presence. It is a rich source of angular blocks of surface texture, smooth curves, dizzying heights and perspectives. The best of modern construction, as it increasingly returns to organic as well as functional inspirations, will teach an appreciation of the intrinsic texture of material and of sculptural form. As with all architecture, play with symmetry and asymmetry by photographing both angled and frontal approaches.

City 4, 2011. Berlin's Kurfürstendamm at night is an exciting collage of color, light and reflections. Even supermarkets there have a sharp, intense beauty.

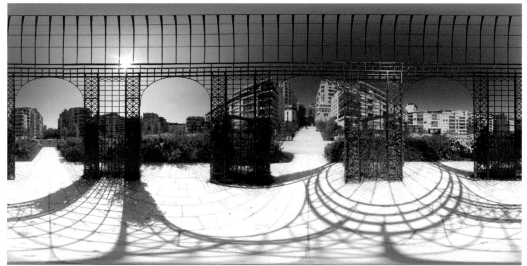

Parc de Passy, 2007, by Alexandre Duret-Lutz. As we saw on p. 56, Duret-Lutz radically transforms his surroundings twice to create brand new worlds. An ordinary Parisian garden is the subject of this equirectangular panorama, stitched from sixteen pictures; when processed into a planet, we look up—and down—into a sunlit idyll of springing, rhythmic lines. Images courtesy the artist.

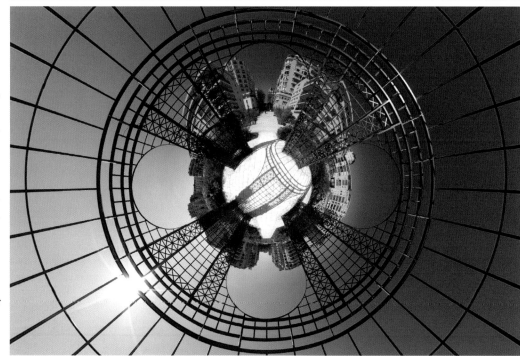

FACING PAGE

The Muscovite, 2006. For this piece, I combined a streetscape with a Russian passport to suggest the story of a young immigrant. The image of New York is one of few that survived the four x-ray machines between Edinburgh and JFK in the days of film. Very grainy as a result, the image actually lends itself rather well to an impressionistic approach to the subject. Film grain effects can be achieved digitally either in camera, in many compacts, or as a Photoshop filter.

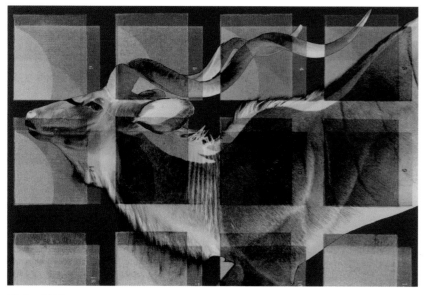

Kudu, 2009.

The natural world

Fauna

The natural world has been an inspiration to artists from the very first. The meaning and message of the Paleolithic—or possibly even earlier—cave paintings may be disputed, but their content is not; beautifully observed, sensitively drawn animals. The animals have a vibrancy that the human figures do not. They are summoned from the rock, using the contours of the stone to increase the solidity of the form. The line is unerring. These animals have been studied, inside and out, and are understood.

In modern times the human race has become increasingly estranged from the natural world, to the point where many people don't even see themselves as the animals we are. We lose so much by denying ourselves connection with the rest of this planet's inhabitants. Studying animals, and trying to understand them, is the only way to get closer to them, and making art about them is a very good way to do this.

Animals are supremely beautiful. Even the most snaggle-toothed deep-sea fish has a fascination and its own extraordinary beauty. Theirs is a particular beauty, that of form fitting function. While most human bodies are now so separated from the fight for survival that they have lost fitness, wild animals' bodies have to be exquisite fight-or-flight machines if they are to live.

Without sliding into sentimental anthropomorphism, anyone who shares their life with an animal will tell you that some of them also have character and emotions very akin to our own. Social animals, in particular, will have evolved these attributes for the same reasons we did—to interact with their peers, for their own and their species' survival. It is not unreasonable to suppose that a dog—a pack animal, like us, who needs to communicate successfully—will have similar emotions to our own and will exhibit behavior that suggests this. It might be impossible to prove empirically, but it is eminently observable.

Animals have personality. You can as easily make a portrait of an animal as of a human being. The best animal art rises far above sentimentality. George Stubbs' exquisite studies of the horse are built on a sound understanding of the beast's anatomy, won by hard graft dissecting and engraving. They transcend the structural, though. They have fire, they breathe, they are strong and noble. Or look at Théodore Géricault's Horse Frightened by Lightning in the National Gallery, London—this animal is trembling. For the best photography of the horse, there is the exquisite book *Equus* by Tim Flach. These images quiver with life. They reveal not just the creatures' strength, power and beauty, but their gentleness and intelligence too.

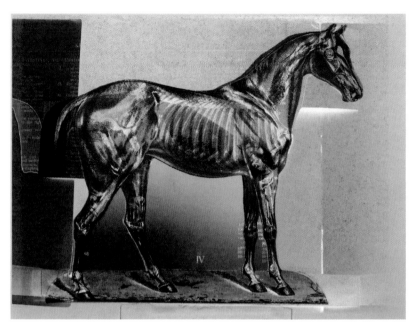

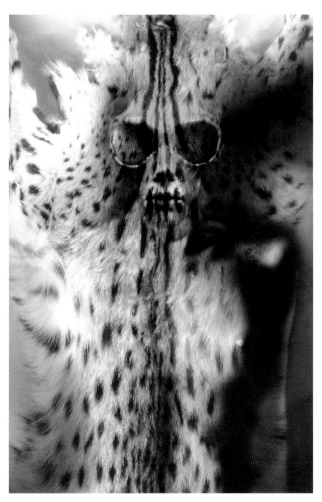

Bucephalus, 2006. I have a particular love for equines. "There is something about the outside of a horse that is good for the inside of a man," said Winston Churchill, who can be relied upon for a good quotation; this one was told to me by the man who bought my Arab cross, Chance, many years ago. Since, I have missed Chance, and missed being around horses. When I was lucky enough to help a friend with her beautiful horses, I was inspired to make some equine studies. An old paper anatomical model of a stallion is the basis for several.

Pelt, 2010. As with every other subject, the representation of animals does not have to be literal, of course. A lot can be said by combining animals with each other, or with the human form. Pelt contains an endangered animal's skin confiscated by Customs and displayed in a museum. When combined with a monkey skull and a nude the message is that by placing the natural world under threat, we also threaten ourselves.

Spider lily - iii - w, 2009, by Macoto Murayama. Plants are ideal subjects for an intellectual structural analysis. Dissecting them to explore their anatomy is a fascinating development on Blossfeldt's surface analysis. Macoto Murayama (see also p. 132) is a young Japanese artist who makes intimate examinations of flowers. He cuts apart a real example, photographs and draws it, then sets about remaking it as a 3D computer graphic. The results are delicate, rigorous, ruthless and gorgeous. They epitomize the search for truth and beauty that is common to both science and art. Image courtesy the artist and Frantic Gallery.

Jeanne, 2005, by Nicola Murray. Murray is a Scottish artist whose scientific background is very clear in her beautifully analytical work. She works with many interesting techniques; this piece combines a thoroughly modern digital composite with one of the more traditional processes, cyanotype. Several photographs of different plant specimens were combined digitally to create a new plant image, which was printed out onto acetate. This was then used as a negative for a cyanotype print. Painting any paper with a dilute liquid mixture of ferric ammonium citrate and potassium ferricyanide, and letting it dry, will achieve a light-sensitive substrate. Murray placed her transparency onto this paper under a UV exposure unit to create a lively, elegant plant portrait. Image courtesy the artist.

Flora

Plants have such richness and variety of structure and color, they are irresistible subjects for an artist. From the technical tour de force of the classic Dutch still life to Arcimboldo's completely original approach, from Leonardo and Durer's analytical examinations to Georgia O'Keeffe's exuberant erotica, from Lalique to Gaudi, the history of art is full of hymns to plant forms.

The potential moods and messages of flora in your work are innumerable. Flowers have overwhelmingly positive associations. Sweet scent, soft summer days, romantic gestures, hope. They will give your work beauty and happiness. That tangled thorns, tumbleweeds, naked trees and shattered stumps will lend a

bleaker mood is equally obvious. Karl Blossfeldt's photographs of plants were not intended to evoke mood at all, but to describe their plastic form for the use of his architecture students. He made thousands of close-up photographs of plants, descriptive examinations of the endless inventiveness of the structures of nature. The results happen to be incredibly beautiful.

The message can also be political. Conservation and environmental issues are vital concerns and are the driving force behind powerful and important imagery. Abandoned buildings being reclaimed by nature are strong statements about nature's ability to regenerate, while other images of desertified or ruined wilderness show its vulnerability to human intervention.

Artists also use plants for their sexual implications. Being genital organs themselves, and none too subtle about it, flowers make for potent erotic symbols. Robert Mapplethorpe's book of floral still life, *Pistils*, is a direct parallel with his more controversial nude work. Georgia O'Keeffe's juicy paintings are beautifully poised somewhere between the plant and animal kingdoms.

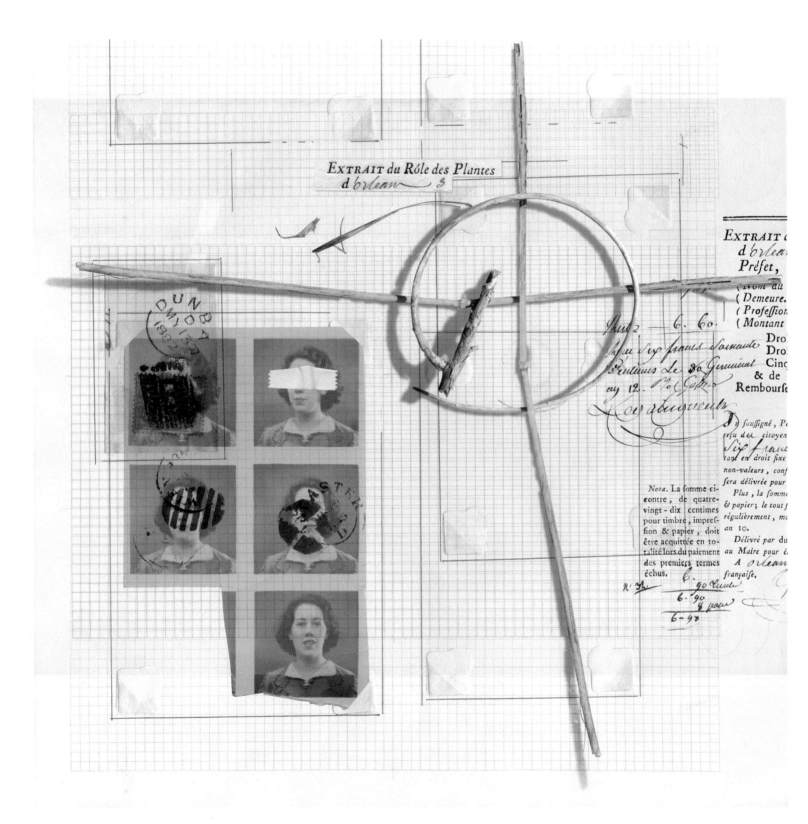

Still life

This is a somewhat under-appreciated area of photography and montage. In French, still life is *nature morte*, and the earliest literally were "dead nature", often portraying hanging rabbits and pheasants, skulls and flowers. They were enactments of the still life paintings that had been made for centuries; formal arrangements, exercises in tone and lighting, whose feel was that of the memento mori. While being very beautiful, they tended to be introspective and a little obsessive. As photographic technology improved, exposure times fell and the camera came out of the studio. Still life arrangement fell out of favor somewhat and became a less common specialism.

Fortunately, the tradition of arranging natural form endures. Its subject, the very "thingness" of things–their weight and presence, their particularity–has never been more elegantly pursued than in the work of Irving Penn. His still life work, some of the earliest of which was made for publication in the forward-thinking *Vogue* magazine, which commissioned his imagery for decades, was both radical and well rooted in the history of the form. It had a distinct frisson of the macabre in common with the early painters. He might include an ant or a rotten apple in a food image. He also used increasingly ephemeral or unvalued materials in their construction. His great series of studies of cigarette butts, made in the 1970s, makes monumental objects from the most overlooked

FACING PAGE
Rôle des Plantes 3, 2011. The plant here is reduced to its minimum–a calligraphic gorse branch, which echoes both the handwritten text and the circular postal franks. One of a series of plant studies, it is a formal arrangement exploring connections of shape.

The Peach, 2012, by Olivia Parker. This is a thoroughly modern still life. Movement in the form is unusual, and this image has a wonderful precariousness about it. The teetering almost-movement of the peach, combined with the fleeting half-presence of the figure, gives it a delicious tension. Image courtesy the artist.

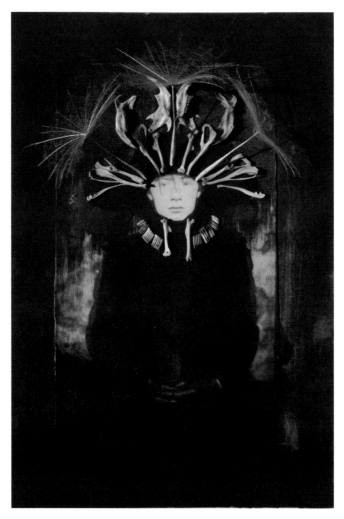

Bones, 2008. This is an un-retouched photograph. The portrait is a junk-shop find; I painted her with brown and black ink to remove all unnecessary detail, and to concentrate attention on her hands and her extraordinary face. I then arranged the mouse bones and seeds, and photographed in strong natural light. It harks back to the earliest natures mortes in atmosphere, if not in form.

detritus (and made a museum exhibitor of a commercial photographer).

Rosamond Purcell, Olivia Parker and John Blakemore, too, each bring sensitivity, delicacy and finesse to the medium, while each firmly impresses their own aesthetic on their work. Purcell, as I have mentioned, works largely with natural history museum specimens. She makes eloquent, potent images, suffused with a deep, melancholic beauty which brings life back to her subjects. Parker not only transforms, but invents with light. In her digital montages, she sets things moving and, using motion blur and toppling angles, creates dynamism out of stillness. Blakemore's series of tulip photographs is a poem to decay. Trembling on the edge of disappearance, they are graceful, elegant and poignant. While achingly sad, they also assure us that beauty still exists in decline. Still life has a lot of life about it, still.

For the montage artist, the still life is a delight. You begin arranging and layering before you have even taken a photograph, and start up associations and correlations that you can develop once inside the computer. Light is the extra, magical ingredient that setting up a still life will bring to your composition. You can, of course, make light effects digitally, but there is nothing like the serendipity of a reflection or refraction, the soft fade of a shadow, or a perfectly positioned glow within an object. Light will not just enliven but create a composition.

Still life does not have to exclude the figure, as Olivia Parker has shown. Its defining characteristic is that the photographer works in a managed space, and controls both the content and the lighting. Brian Oglesbee's Water Series is easily seen as a still life series, to my mind. Made as they are in a studio, and set up so that the artist has control of every nuance of lighting, composition and even air speed, their technique is every bit that of the still life photographer. The results are sparklingly original, almost unbelievable.

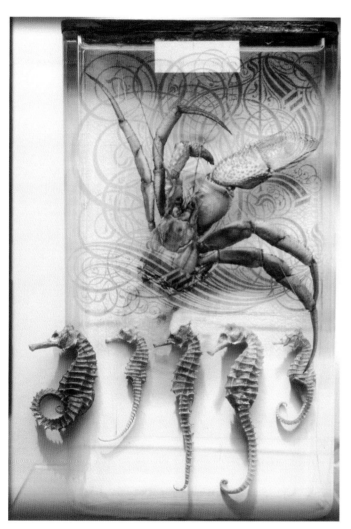

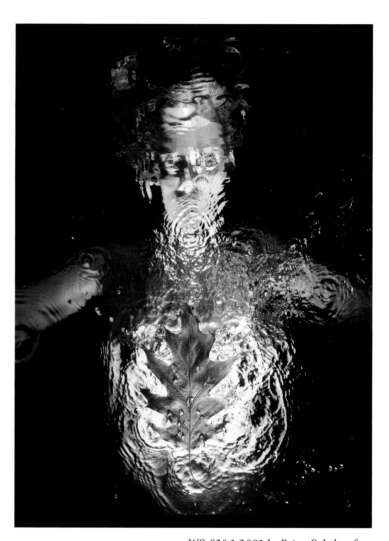

Marine Calligraphy, 2009. The crustacean is a specimen from a museum's spirit collection, while the seahorses are my own. I combined them by photographing the seahorses with the same direction of light, and keeping the levels of contrast similar. The calligraphic curves are from an old German banknote, and echo the similar curves in the animals.

WS-82#1 2001 by Brian Oglesbee, from Aquatique, Insight Editions 2007. See also p. 200. Image courtesy the artist.

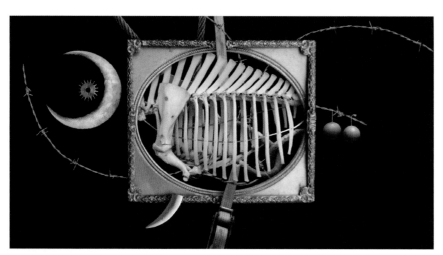

Analogue 2, 2011. This image was inspired by the Minotaurs of Picasso and the Surrealists—such full-blooded, vital imaginings.

Myth

The human soul needs myth. We need to feel that we have come from somewhere, that there is some purpose to our being here, that behavior has consequence, and even, maybe, that death is not the end. Every culture on earth has produced myth as a way of explaining existence (and some would argue that the empirical explanations now being offered by science are simply more myth-making).

Mythology is rich in visual imagery. Ancient stories tell of heroes and heroines, animal spirits, adventures and explorations, horrors and delights, injustice, caprice and vengeance, brutal consequence and chance. They speak of life, death and everything before and after. They are perfect inspirations for artists. The moral principles

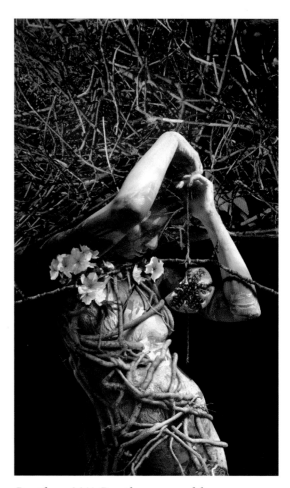

Persephone, 2011. Persephone, queen of the Greek Underworld, was abducted by Hades. She was tricked into eating pomegranate seeds, condemning her to spending several months a year there even once released. Her mother, Demeter, goddess of the harvest, refused to grow vegetation while she was away, accounting for its disappearance during the winter.

Eden, 2010, by Kris Kuksi. Kuksi's Eden is an inclusive place; many belief systems find a home here. This is Paradise indeed. For more by Kuksi, see p. 137. Image courtesy the artist.

of Greek, Native American, Chinese or Oceanic myth are just as pertinent to us today as they ever were. These ancient stories define the state of being human, and what better subject could an artist want?

Myth has a way of passing on into other cultures, being assimilated and inspiring new art as it goes. Much of the Greek pantheon moved into Roman mythology, and both have turned up everywhere else ever since, from sculptures of the Three Graces, Aphrodite or Apollo to paintings of Diana and Actaeon, the birth of Venus or the various amorous escapades of Zeus. These myths offer exciting narrative and a full cast of heroes, heroines and monsters, and are often good reasons for a beautiful nude. Pagan holidays and characters were absorbed into Christianity, too, easing the transition from one belief system to another.

There is much, much more. The Australian Aboriginal Dreamtime has inspired literature such as Bruce Chatwin's *The Songlines* and films including Peter Weir's *Picnic at Hanging Rock* and *Australia* by Baz Luhrmann. Norse mythology, all thunder and light, has inspired opera, fiction, poetry, painting, film and more–Der

La coraza, 1994 (Armor, 1994), by Luis González Palma, from Poems of Sorrow, Arena 1999. With echoes of Icarus, this is an earthbound, and very modern, angel. For more by González Palma, see p. 22. Image courtesy of the artist.

Ring des Nibelungen by Wagner, Tolkein's *Silmarillion* and even Marvel Comics' Thor all appropriated Norse gods and quests. Inuit folk tales find their way into modern children's stories. Aztec and Mayan myth and prophecy are particularly favored by science fiction. The references are endless. There will always be a need for quests and heroes, it seems.

Artists construct their own fables, too. While devout artists depict their own mythology with complete conviction and belief, a more secular artist uses myth as metaphor, or invents their own. Implied narrative is the one thing a myth must have; after that there is complete laissez-faire. Impossible things happen to impossible creatures in impossible places. Hieronymus Bosch filled his extraordinary worlds with angels and devils and hybrid monsters to create nightmares both personal and universal. The singular vision of William Blake imagined chimeras and hallucinations to fill his own religious worlds. The digital realm is perfectly suited to the pursuit of the fantastical and modern mythologies.

Abstraction

Many people think that abstract art has no subject at all. When the artwork is a piece of chewing gum stuck to a wall, I tend to agree. However, for many considered pieces of abstract art, the subject is picture-making itself. It is a release from the mimetic, from story-telling or scene-setting; it goes straight to the heart of an artist's practice and shows the creative mind at work.

Abstraction is usually something that happens with time, rather than being a starting point. Arriving at abstraction after long study and experience, as a result of finding the essence of a subject, gives it authority, a depth and power. It is not a matter of removing the subject, but rather of distilling your subject until you no longer need to depict it. (This does not apply to conceptual art of course, whose purpose is more illustrative than pictorial, and whose priorities are largely intellectual.) Look at the progression of Piet Mondrian's paintings of trees. In his earliest work, he made Post-Impressionist landscapes, with clearly representational trees in full leaf. Influenced by the Cubism he saw in Paris, they gradually became more simplified, full of springing arches and curves. Eventually, even these

Run, 2009. Figurative elements creep in even within my abstract imagery. The inclusion of an Eadweard Muybridge running man series creates movement through the image without actually telling a story. The repetition of the figure removes it one stage from reality - it is more a diagram of running than a man running, which makes it fit well with an abstracted scenario.

disappeared and the image becomes a balanced grid of black on white with pure, primary color. As these final abstractions demonstrate, including linear elements increases the abstract qualities of an image by emphasizing their restriction to two dimensions, and stressing the linear arrangement and other aesthetic qualities over its subject.

Long before modern art allowed artists the freedom to eliminate the subject from their work altogether, artists were moving towards abstraction. Titian's very late painting The Deposition resolved the figures into a swirling desaturated pattern of movement. Michelangelo too made late drawings of crucifixions that have become insubstantial, ethereal and mystical; less depictions of body than of soul. As an artist grows, very often the superficial gets stripped away and the work is distilled into abstraction.

This happens with digital composition too of course–and quite fast. Because images can continue to develop non-destructively, series can grow from a single starting point. Experimentation is easy and the removal of the initial subject itself is as simple as switching off a layer. This encourages artists to work with unprecedented freedom towards resolved work, which may or may not retain its (literal) subject.

Through the Wall, 2010.
Almost all that remains
of this evanescent figure is
her shadow.

Absence

We have talked about metaphorical images whose subject is something other than the things depicted in them. Other images are about the very things that are not in them—missing things. Leaving something out can be as potent a statement as putting something in. Omitting the expected has a very powerful effect. Bodies without heads and limbs are jarring but possible, while a reflection or a shadow without a body is startling for its sheer implausibility. Whether the emptiness is total or leaves barely discernible traces, it is a loss, a sharp pain. One feels something all the more keenly for its absence.

One can make images of things that are not there, things lost, evaporated, dissolved, extinct. Elegiac still lives document the spaces left by vanished things. They reveal the ghosts of objects, and so of people. One can show the disappeared, whose traces too are almost gone. A single nail in a wall, above the shadow of a mirror and its string. An empty photograph mount, a page in an album bearing only delicate imprints where images have been. This seems the ultimate loss. Even the memory is gone, and the once-preserved has ceased to exist at all. It is haunting indeed.

Work about absence brings to mind the unbearably poignant imagery that emerged from Europe after the Holocaust. The sense of loss that a single pair of glasses or a pile of shoes can bring is terrible. When nothing remains but worn-out leather and smashed lenses, erasure is almost complete—yet, miraculously, the people to whom they belonged are still in some way present. These spaces bear the most fleeting and banal traces of their history. However mundane or minute the clue, though, they speak loudly. Everyone carries loss, and these images make us feel it profoundly.

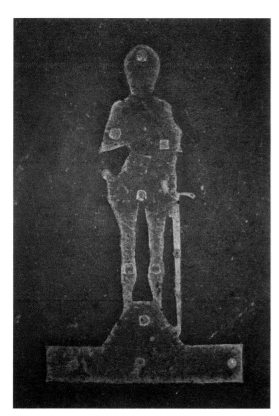

This is all that remains of a knight's
tomb in the floor of Gloucester Cathedral.
His brass memorial has long since
disappeared, leaving him anonymous.

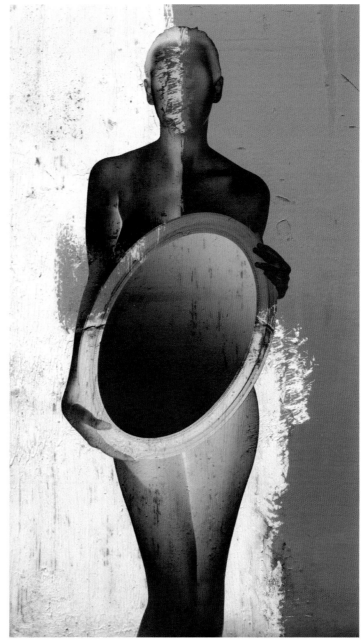

*Mirror, 2012. The absence may be of
an emotional, rather than a physical,
kind. This is an image of detachment,
reservation, self-possession—whatever there
might be to this, she seems to say, you will
have to bring yourself.*

Collecting Source Material

Francis Bacon's studio floor is an anarchic goldmine of torn scraps, paint-spattered newspaper cuttings, ripped open books and folded photographs (interestingly, none of which were actually taken by Bacon). Transferred in every detail from London to Dublin, it still exists as a creation in itself, a glorious testament to an eclectic eye and to the ability of the mundane to inspire great art. Every artist needs a jumping-off point, something (or, often, someone) to make them lift a brush or a guitar or a laptop. The gathering of actual ephemera, as Bacon did, or of photographs, scans or other potential subjects is a delight and a lifelong obsession. Of itself it will inspire you.

Taking source photographs

Taking photographs for a digital montage is a very different thing from taking a picture. I often find that I take two sets of images—one has a pictorial purpose and one is for source material. These latter are made with a view to future development. You do not need to worry too much about making a composition at this stage, you simply need information. Keep it as sharp as you can and get as much light in there as possible. Extraneous details can be cloned or masked out later. I find that deliberately underexposing high-contrast photographs a little helps retain maximum information and prevents "blown" highlights.

If you'll only need an object and not its background, fill the frame for maximum detail. (Do be aware that focus always softens a little to the edges, so if that area is important give it a little space.) If you want to keep a greater depth of field, step back and zoom into the subject, as closer focusing distances reduce the available depth of field. Getting plenty of light on the subject and setting a small aperture will also increase usable information. You can always soften later, should you need to.

Always carry a camera with you, and take pictures even if you're not sure how useful they'll be. Things outside your normal spheres of interest will enliven your work and keep new ideas coming. Keep an eye open for the unexpected. The old wall behind you as you're admiring St. Mark's Square could well be the perfect backdrop for your next picture.

It can be useful to take pictures in black and white. Sometimes, the color is the subject, as with this red poppy. It looks completely different in monochrome, however; the contrast is no longer between the dusty purple and the red, but between the shadowed upper area and the sunlit lower part. Also, the texture becomes much more important to the image. If you are shooting in RAW format (see Method, p. 101), you will still have the color information in the file, should you need it, but taking and reviewing images in mono lets you see the subject in a new way.

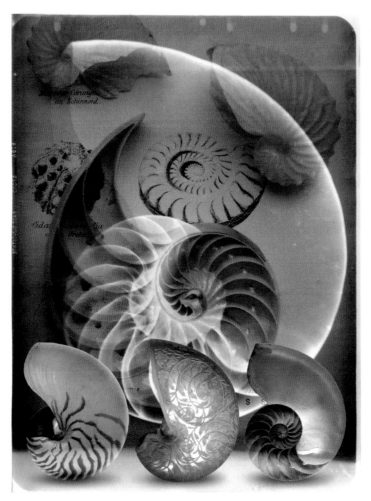

Nautilus, 2012.

Treasure hunting

I am lucky enough to be an inveterate collector. If I have two of anything I have started a collection. I dream of a beautiful, clean-lined, white Mies van der Rohe house, all angles, glass and clear bright space. It's never going to happen. My home is a collection of collections, gathered as source material or simply inspiration. Many of them have featured in imagery and they all contribute, directly or indirectly, to my work. Their creation echoes that of the pictures; they have in common patient assembly, layering of detail and texture, pattern, accumulation of meaning by juxtaposition. Natural history specimens, in particular, have always held a fascination, and dog-walking finds—whether flora or fauna—are lovely to work with. Bones, feathers and all life forms are so beautiful—perfect expressions of function, marvelous machines, honed to immaculate form by time. Bones, in particular, often have only negative associations for people, but there is so much of life and strength in them.

Ephemera is a delight. Old typefaces and handwriting have an atmosphere all of their own. Banknotes are incredibly beautifully engraved and often have lovely colors too. They add instant complexity and texture to a picture—try using them in an Overlay layer mode to create "tattoos" on bodies. Use only parts of them, and preferably old ones out of circulation, for obvious legal reasons. Passports and ID cards are also rich in meaning. They often carry photographs of their holders and are layered with stamps, signatures, punched-out holes and bounding boxes, all telling of journeys and lives.

Keep an open mind about what you need. When I go looking for something I very often find something else entirely. I once went to a favorite junk shop in Anstruther for some old photographs and came home with several beautiful sets of medical instruments. You

Try to find several different ways of representing the same idea. Combining them in one image will give it richness and depth of allusion. A shell, for example, could be scanned, photographed, drawn, or x-rayed. You could also use an old engraving of a shell, or maybe a sculpted architectural shell.

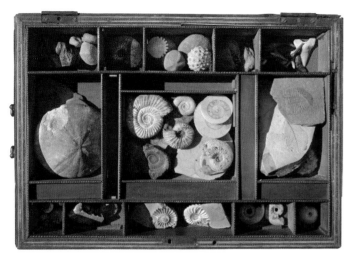

I keep my collection of fossils, some found and others purchased, in an old gaming box which has itself figured in pictures.

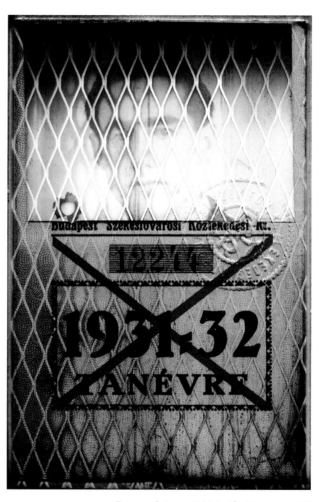

Restricted Access, 2006. The Hungarian ID card already had the red cross and the embossing on it; all I had to add was the grille.

can make great discoveries that lead the work in new directions.

Fortunately for my bank balance, the more ruined a thing is the more I like it. Junk shops, car boot sales, auctions, scrap yards and flea markets are treasure troves. Layers of meaning accrue to an object through use and decay. I try to use things that have a patina of age on them, which embody in some way the people who owned and used them. They become portraits in themselves. Old books wear beautifully. Edges polished and darkened by innumerable fingers speak eloquently of the previous owners and add so much to the textural interest too. If you're lucky enough to find one in a foreign script, even better. Cyrillic, Arabic, Chinese, Japanese and so many other scripts have an innate beauty. That I don't understand the meaning, while others will, I find delightful–I am allowing the image a life of its own.

Sakura, 2009. Japanese banknotes
are particularly beautiful; this image
combines several.

Finding a model– portraits and nudes

I do have problems myself sourcing things, especially nudes (I used to do the modeling myself, but no longer). If a model is unavailable, I use public sculpture, pre-1900 anatomical engravings or my own drawings instead; there's always a way round the problem. For the main subject of an image, you really need your own stuff.

If you're in the lucky position of not having to worry about expense, there are of course excellent model agencies who will help you find your perfect model. It doesn't have to be such a costly business, however. I ask people I see in the street if I can take their photograph and they're amazingly kind and generous with their time. I also have some lovely nude models, and I impose on friends too.

It is often easier to work with imagery of people you don't know very well, surprisingly. Naturally, if you want to make a portrait–a picture that is about the subject, which explores their personality, situation or métier, for example–the more you know of them the better. However, I've noticed that faces I've shot in the street can be much more versatile. You won't be constrained by knowledge of their character and tastes. You can impose your own ideas upon them and imagine them as someone altogether different.

I always use beautiful models. I tend to think that if the model is less than beautiful the picture becomes a portrait–the person him or herself becomes the subject. People start to ask who they are and wonder about why they're there. If you use someone beautiful, he or she can become a metaphor more easily. In other words, oddly enough, a beautiful woman is more everywoman than an everywoman–she has fewer individual characteristics and has a more "general" face.

Photographing portraits and the nude

Planning is essential. Do you want to work inside or outside? Are you telling a story? Do you plan a particular pose for an image, or are you looking for inspiration and source material? Think the shoot through beforehand. You will then have a clear idea of what you want to achieve, which will greatly increase your chances of achieving it! Make sketches of ideas for poses, and for lighting if you're working in a studio. It's helpful to collect imagery of poses you'd like to approximate to show the model. If they have something to look at, they will have a much better idea of what you are after and will be easier to direct. If you want a certain mood—relaxed, spiky, anguished, joyous, whatever it might be—talk about it with your model and they will be better able to act it out for you. Don't be too stuck on your plans, however; take opportunities when you see them. Let your model react to their surroundings, especially when outdoors, and take advantage of natural movement. A relaxed pose resting between shots could be the most successful of the day.

If you're going to be working outside, look after your model. Make sure they have sun block as sunburn can happen all too easily when you're involved in a shoot. Take lots of water to drink, and snacks too—it's an exhausting business. Be prepared to stop when it gets cold, or when flies move in, or when a dog walker or cow shows up—for all its hazards, I love shooting with natural light the best. Research your location thoroughly. Be careful to find out-of-the-way places where you aren't going to shock or offend innocent passers-by if you're doing nude work.

For a studio shoot, set up your lights before the model arrives. You should have a good idea of the effects you want; do test shots with a willing guinea pig

to check you're on the right lines. Again, stock up on water. For nudes, have a heater and a pair of slippers standing by in case it gets cold, and hand your model a dressing gown whenever you take a break so they can relax properly.

Bring props. I have a prop bag into which I drop anything that might be useful at some point. It contains, at the moment, a chain mail butcher's apron, some white poster paint, white and black muslin, an elaborate hand mirror, some bone necklaces and skulls, a repoussé metal box, some tiny passport photographs, a few butterflies and a brocade curtain. Bigger things like branches, chairs and rolls of barbed wire or carpet clog up the garage until I need them. Just having these objects on hand when faced with a model looking for ideas can be invaluable. You will be able to pounce on one with a plan and the ice is broken.

When your model arrives, talk about your ideas. Taking photographs of nudes, particularly, demands trust on the part of the model that you will treat him or her with respect. You should already have shown them your work and explained your process so that they will not be shocked should you disembowel or peel their image later on! If you're shooting with a new model, be aware of their comfort levels. The model may or may not be accustomed to such work, and even if they are there might be tension. I'm lucky; being a middle-aged woman, my models are not threatened by me at all. If you don't fall into that category, your models may feel differently. When nudes are planned, I always try to start with unrevealing, covered poses. Shooting a few pictures with the dressing gown on while checking the lighting can be helpful. Then, try some poses draped with muslin, or a few compact, curled up or reclining poses, which will help to relax your subject. Avoid a frankly assessing stare, and look into the model's eyes when you're talking to them.

Remember to come in close and explore details.

When you're working, take your time. It's much better to have two good shots from a session than fifty mediocre ones. Try not to exhaust your model by leaving them in a difficult pose for an age, though. Stretching and holding positions is very tiring; it's not unknown for a model to feel faint, especially when it's warm. Make sure they have proper rests.

Show the model how work is progressing. Yet another advantage of digital is, of course, the instant feedback you get on your work. Share this with your model.

Arrange each pose carefully, being aware of exactly where the shadows are falling. Don't touch your model without asking. If you need to move hair out of their eyes, ask them to do it. Demonstrate what you have in mind. Personally, I avoid the staple "model" poses—pointed toes and arched backs speak of cheesecake. I prefer much more natural, expressive movement. I find that preconceptions of what is beautiful are not helpful, even stale; try to discover beauty in new ways. This is a very good reason for having an inexperienced model, as they will not fall into an habitual way of working but will be open to your ideas.

Keep moving when you work. This may be hampered somewhat in a studio by cables and tripods, but even here you can duck, stretch and move backwards and forwards to fine-tune the framing of your shot. Find things to stand on, or get down on the floor to give a different perspective. Remember to move in closer sometimes for a telling detail. I often take several shots of the same pose—a full figure, some tighter views and a detail or two.

Try leaning your model against a wall, or having them sitting down or holding things. Interaction between a model and the environment is difficult to fake. Musculature shows exactly where stresses and weight are distributed, so do it for real to get it right (also, the shadows may be useful later).

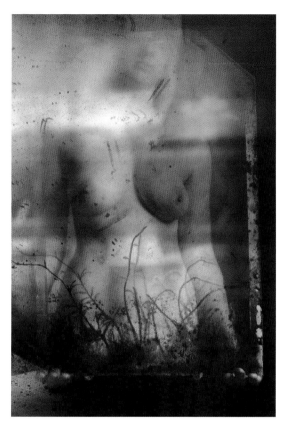

Two Mirrors, 2012. Mirrors are marvelous props. Your model or an assistant can hold the smaller ones, while the larger not only give you two views of your subject but also enhance the light. If it's not possible to exclude yourself and the studio lights from the reflections by judicious angling, you can always remove them later. For this image, the bevelled mirror was held in front of the model; the hands that appear are not actually the model's own. The mosses are reflected in a different mirror (at a different scale) and superimposed.

Time can pass very fast when you're working hard, so don't overdo it. Most of all, enjoy yourselves! A relaxed and happy shoot will show in the pictures. Finally, do send your model a thank you note and email them some shots so they can see how it went. Build up a strong working relationship and you may even find a muse.

Anatomy

Perhaps surprisingly in these increasingly secular times, the human cadaver is as inaccessible today as it was in the days of the bodysnatchers. Access to the dissection room for observation is usually tightly restricted to medical students. Fortunately, there are other ways to investigate our inner machine. Anatomical models are very useful, both for research and for photographing directly; your local hospital or university will have a collection to

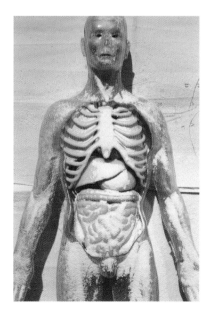

This Visible Man model dates back to the late 1950s, but they are still available and are particularly useful for their transparent skin. This one has been dusted with flour.

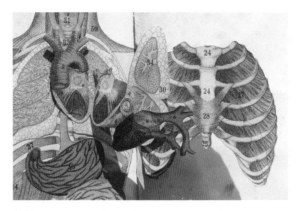

Fold-out anatomical manikins are very versatile source material. This is a Philips Anatomical Model, dated 1911.

Suspended Self-Portrait, 2002, sculpture installation by Carolyn Henne. This piece is now in the National Museum of Health and Medicine, Maryland. Image courtesy the artist.

which you can request access. Smaller models are easily found and make fascinating playthings.

Old anatomical textbooks often have imagery that is not merely useful, but highly evocative. The older, the better—engravings have a lovely springy quality of line and no half-tone pattern. Importantly, they are also out of copyright, as illustrations in nineteenth century books and earlier are in the public domain. Many publishers also produced beautiful paper models with moveable layers showing osteology, musculature, the nervous system and organs. Those made by Baillières, Rouilly and Philips are particularly colorful, the Philips being my favorite; they have a delightful liveliness and clarity of style, and remain easily legible even when layered with other material.

There are also "digital dissections" available. The Visible Human Project is an online resource with huge potential. A series of cross-sections of two cadavers, one male and one female, were photographed, and are being digitally combined to create three-dimensional, virtual, dissectible bodies. The results are extraordinary. Invaluable for teaching purposes, analysis of the resultant huge database has even unearthed errors in anatomical textbooks. It is of interest to artists as well as medics for explaining gross anatomy and for its sheer beauty. The project has been used directly in several works of art, most beautifully by Carolyn Henne in her Suspended Self Portrait. Henne cast herself and created cross-sections of her own body. She then painted them, life sized, with the corresponding section from the Visible Human database, onto 89 suspended vinyl sheets. These sheets move when touched, giving an illusion of breathing. This phantom has an eerie life of its own.

Still life–making your own subjects

Still life is a surprisingly neglected area of exploration. There are some excellent practitioners working with still life, yet there is little discussion. Possibly this is because it is such a solitary practice. It involves many quiet hours with the assemblages, tiny movements of lighting or subject, long contemplation. It is a deeply satisfying way to spend a day, and the results can be spectacular.

Try laying out small collages of things and photographing them. The resulting images are sometimes an end in themselves, or they can become elements in another picture. Appropriate lighting is crucial to the success of a piece. Some pieces, such as 1845 (right), need soft descriptive light which doesn't cast too strong a shadow; the image registers evenly across the plane. Others need to be enlivened with a harsh sidelight, which picks up all the texture and casts eloquent shadows to echo the objects. Reflecting light into the workspace from irregular surfaces, prisms or crystals can create delicate and unpredictable effects. Setting up a foxed mirror to bounce some fill-in light into the shadows, filtering light through patterned materials or placing subjects on glass above something else will give new effects to play with. Beautiful accidents will happen as you work with elements. The things that you choose will clearly influence your design, but they don't need to dictate it. Be fluid in your thinking while building your setup, add things and take them away constantly, and you will be surprised and inspired by what unfolds in front of you.

I use natural light. In Scotland, of course, it isn't as reliable as one would like! I often set up and have to wait for the clouds to pass, and then contend with wind blowing things everywhere or snow sifting across them.

1845, 2009. This simple arrangement needed very little post-production work, just the addition of the fingerprints and ID photographs.

The advantage is this very unpredictability; it makes you keep rethinking and rearranging. It's all about experimentation.

I always start by simply piling some things together on a board and watching how the light affects them. I have an idea of the feel of the image, but not necessarily its message, at this point. I choose things for their tone and texture very often. Whether the picture will be high or low key is decided by the background, and built upon from there. The process has something in common with the Dadaist method of cut-up

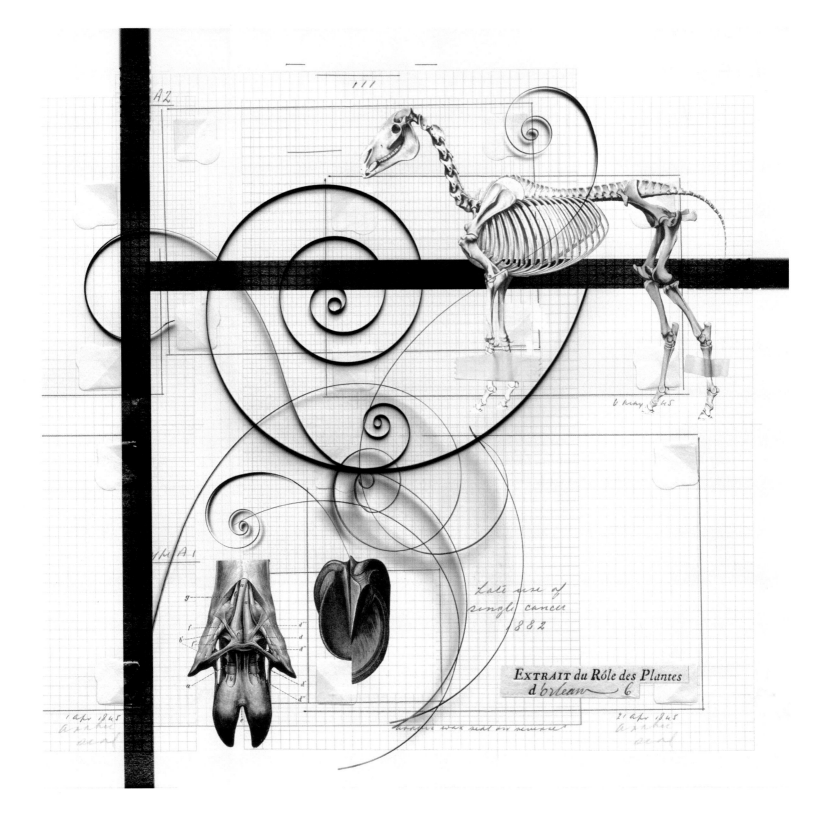

writing—randomness, even chaos, can be the mother of invention and is achieved intuitively and instinctively. Having chosen my "words", I then watch for some kind of logic of arrangement to form.

Means of attachment are not just a practical concern, but also an aesthetic one. I'm always attracted to things that show evidence of work, of process and of manufacture, and am constantly photographing tangled wire, ties, knotted ropes and string. Pins and nails are interesting ways of attaching parts of your still life. They cast shadows, you can tie things to them, skewer things and use them to move delicate objects about. Sewing is a decorative way of securing things, as are adhesive tapes and wires. I'm quite happy to let the construction show—it's an integral part of the piece.

Once I have a photographed still life, I then set to work adding the things it was impossible to include in actuality. Without the need to have the object, or for it to be on a manageable scale, there are no limits now to what can be included.

FACING PAGE

Archaeology 3, 2011. This image started life as a photograph of the watch springs against white paper (shadows like these are very hard to imagine; far better to use real ones). I used this as a Multiply layer over pages from a vintage collection of postmarks, and increased the contrast until the white paper didn't register. The diagrammatic feel of the springs is echoed in the old engravings. The tapes holding down the skeleton's legs, another favorite form of attachment, are from an herbarium. Note also the photograph corners. This image is about construction itself.

One of many cigar boxes full of rubbish with potential.

Building an archive

An archive is very revealing of an artistic sensibility. You'll naturally be drawn towards subjects that echo the things you want to make imagery about. If organic forms appeal most to you, then obviously things found on woodland and beach walks might make up a lot of your back catalogue. But don't neglect the possibilities of seemingly less appropriate objects. You could easily be set on a new path in your work by the chance find of a fragment of barbed wire or broken glass. There is beauty everywhere, and ugliness too—either, and both, will contribute to your work.

It's a good idea to keep all kinds of boxes and drawers of potential materials. Joseph Cornell's collections of collage materials, all carefully categorized and sorted into innumerable containers, took over his house. Surround yourself with things and imagery that will spark off ideas and help you make new connections.

Coracias spatulatus, 2011. This interior, a hot house in a botanical garden, has elements of both interior and exterior, but still works in a logical way. The nude stands firmly on the stair, and the shadows are consistent throughout. The scenario is believable, if odd.

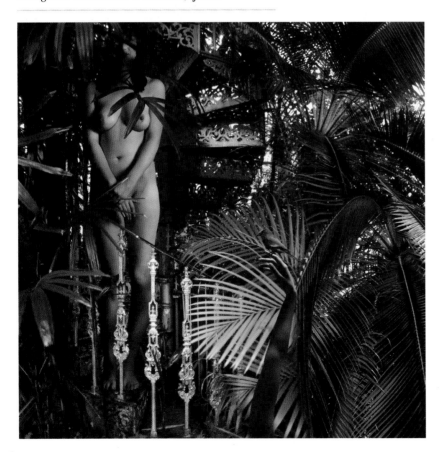

Keeping similar things together is helpful. The items could be related by anything at all. They might be made of the same material; my drawer of glass contains thermometers, light bulbs, hydrometers, broken mirrors, test tubes, prisms and lenses. Or the things might be linked by their method of production; engravings, daguerreotypes and ambrotypes, and handwritten manuscripts all have their boxes. Another drawer will contain water-related objects, anything from shells, fish bones and dried seaweed to a stuffed piranha. You might find lots of textures—fur, sand, porcelain, leather, paper—in the same color. Being tidy makes finding things easier. Taking out two or three unrelated drawers and sifting through the contents is an inspiration. My favorite boxes, though, are simply labeled "Still Life Stuff" and contain a complete miscellany of junk. Anything at all that catches my eye and doesn't belong anywhere else lives here, and the resultant chaos is fertilizer for the imagination.

Interiors

Enclosing your picture space within physical walls is not just an excellent way of framing and containing your composition. It will also create mood. You can suggest the safety of a tightly shut space or, more ominously, claustrophobia or imprisonment. You can deliver the freedom of green trees through an open door, or deny it through bars. Setting up tensions between such differing potential messages will add greatly to the emotional depth of your imagery.

You can make the space work in a logical fashion, or you can fracture reality and create new worlds. If you wish to deceive the eye into seeing a "real" space, be very aware of light directions and perspectives as you take your source photographs; you'll need to keep them consistent with whatever else you will add later.

Bay Tree, 2008. Making the light fall believably was the key to the success of this image. The bay tree itself was photographed in natural light, so adjustments had to be made to focus greater contrast and brightness to the top, where the chandelier's light would fall. The patch of light on the right hand wall suggests a door to the left; the bay tree therefore also had to have a lighter left and darker right side.

Remember to leave enough space for adding figures in any images you plan to use as a background–so many times I've had to add gravel or grass at the bottom of images, and it's remarkably difficult to make them believable.

A delight of digital montage is that you are never constrained to the literal; you can make the impossible seem possible, with surreal results. Like Coracias spatulatus, opposite, Bay Tree also plays with the idea of bringing the outside inside (or, possibly, vice versa), but has left the realms of possibility. Floating windowless houses with trees firmly rooted in water, growing by artificial light, are unlikely. However, by ensuring the light falls convincingly from the chandelier both upwards and downwards, and by making the water wash up against the walls, the eye might be persuaded by the invention.

Varying your viewpoint will change your picture's message completely. You can look through architecture

Town and Country, 2009. As Bay Tree does, this image confuses the interior/exterior divide. Showing a landscape both in front of and behind the wall leads the viewer to question whether the windows are seen from inside or outside the building. It also flattens the perspective (aided by keeping the far distant trees as sharp as the nearer) thus increasing the picture's abstract qualities.

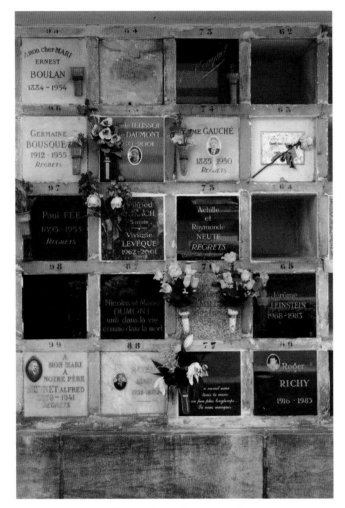

The columbarium in Père Lachaise, Paris, is an elegant quadrangle surrounded by walls of memorials, each of which is unique and telling. Artists' resting places show the tools of their trade; Isadora Duncan, the ballet dancer, has a pair of silk dancing shoes among her tributes. Many have decaying portrait photographs of exquisite beauty.

to landscape, or through landscape to architecture. By using windows and doors as frames, you can enclose either the setting or a building's interior.

Taking it outside

Clearly, traveling will build up an archive more quickly than anything else; the visual stimulation of new people and places cannot be equaled. Try to be *in* places. I am as guilty as anyone of rushing around taking photographs and not actually experiencing my surroundings, especially when under the pressure of time–but it is vital to pause and allow yourself time simply to breathe and look, listen and be moved. These moments contain the seeds of your next piece of work.

You will always take your best source photographs on trips to places that really interest you. Events such as air shows or carnivals, and places such as national parks and zoos are naturally good places to start, but the less obvious can yield surprises. The current boom in urbex–urban exploration–photography reflects artists' continuing fascination with the relic, with texture, decay and the accretions of time. Popular sites are often to be found online, but my favorite places are usually those I've chanced upon myself. Trespass laws are different around the world, and naturally I cannot encourage law-breaking, but fortunately here in Scotland, a right to roam exists. I won't damage things and while I have been sorely tempted to pinch a treasure here or there, I haven't–these places are sacred somehow, to the people who are still tangibly there in some way. As they say, take nothing but photographs, leave nothing but footprints.

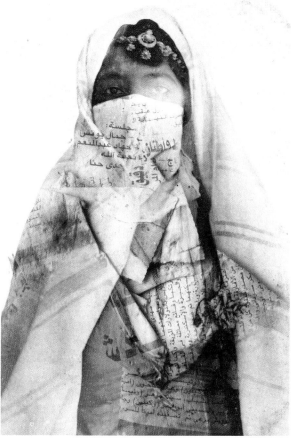

It was worth waiting for the light to stream through this ruined greenhouse. The shadows and reflections add layers of texture.

Femme voilée, 2008. A sheet of Egyptian newspaper, found on the banks of the Nile, is combined here with a nineteenth-century postcard image of a veiled woman.

Not all architecture has to be dilapidated and ruined to attract my attention. This gas tank in Dundee is very beautiful, given a good side light.

Under the Ice, 2002.

Public and private collections

There are enormous collections of material available to interested photographers, and it is delightful just how helpful people are if you ask. For example, a local hospital very kindly gave access to their state-of-the-art imaging department, whose x-ray, MRI and ultrasound imagery has been invaluable.

Often, generous antique shop-owners will let you photograph their stock. University departments and museums too are very helpful in allowing access to their collections, which can be surprisingly extensive and varied. Many publicly-owned museums are also happy to allow (non-flash) photography. As with anywhere, please always ask beforehand, and obtain any necessary permits. Be aware that most museums don't

When I was sourcing material for a set of illustrations about nanotechnology for New Scientist magazine, my local hospital very kindly allowed me access to their imaging department. The marvelous array of x-rays, MRI scans and CAT scans has fueled many a project since.

Car boot sales and junk shops have yielded many treasures. This collection of daguerreotypes and ambrotypes is a particular delight, and has been the starting point for many images.

allow tripods. Low light levels, a necessity for conservation, will mean long exposures and possible camera shake, and glass can give you problems with reflections. If you can't persuade someone to take the things you'd like to photograph out of the display case, get in as close to the glass as possible, wear black, raise the ISO setting on your camera and take several shots. A polarizing filter can help with unwanted reflections.

Keep a lookout in the local paper for events that might yield interesting source material. It's not just the large events such as marathons, carnivals and pageants that are fruitful; a small exhibition of local memorabilia can be a goldmine. Again, do ask permission before you photograph.

People are often very interested to know how you plan to use the pictures. Take along a few prints of your work to show them, or keep some examples on your phone. Sending a copy of the results is usually much appreciated too.

Found photographs

Ownership of an art object does not confer the right to reproduce it (see copyright, pp. 211–2). However, this will not be a problem with old photographs found in a junk shop. Often richly suggestive of other places and times, they can lead your imagination off into new realms.

Maureen Crosbie, a Scottish stained glass artist, was looking for new ways of using glass, and came upon some photographic negatives on an online auction site. When juxtaposed with delicately-patterned clear glass, mirror and judiciously-proportioned color, the results are sensitive to the age of the negatives, yet altogether new. Crosbie works in just the same way that the digital artist does; she has an idea, sources materials and makes formal arrangements with careful attention to balance of color, pattern and tone.

Tangiers, 2012.
This piece is based on a strangely-composed print found in a car boot sale. The addition of foliage from a Scottish greenhouse added heat and light to the sepia tones of the original image, left.

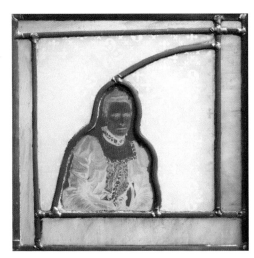

Ménage à Trois (one of three), by Maureen Crosbie, 2012. Reproduced courtesy of the artist.

Non-photographed input–scanning and filters

Scanners give a distinctive compression and interesting lighting effects to three-dimensional subjects. They can also produce greatly magnified images that would be difficult to achieve using normal or even macro lenses. It is interesting to build still lives directly onto a scanner bed. Building upwards from foreground to background inverts the usual way of working and gives sometimes unexpected results. The light will always be the same, of course; flat and frontal, and giving halo shadows if the subject has any depth, it is useful in making separate scans consistent. The depth of field is very shallow, so you will get a lovely softness to objects even a few millimetres above the glass surface. Leave the scanner lid open and the studio light off for a deep black background, or gently place white card over your arrangement for a lighter one.

While I personally avoid the use of filters for content, they can be useful to add texture. Do be careful that they do not add a repetitive, obvious pattern to your work, though–they should be used sparingly. It is much better to add interest with scanned material. Borders, for example, can be found by looking at the backs of old postcards, or in worn books, or by painting brushstroke effects yourself and photographing them. Each will be unique and tailored to the piece, rather than being a superficial afterthought.

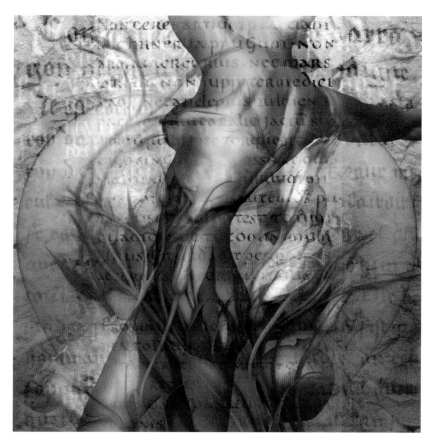

Eve, 1998. The lisianthus flowers in Eve were scanned, giving them a flattened, abstracted quality.

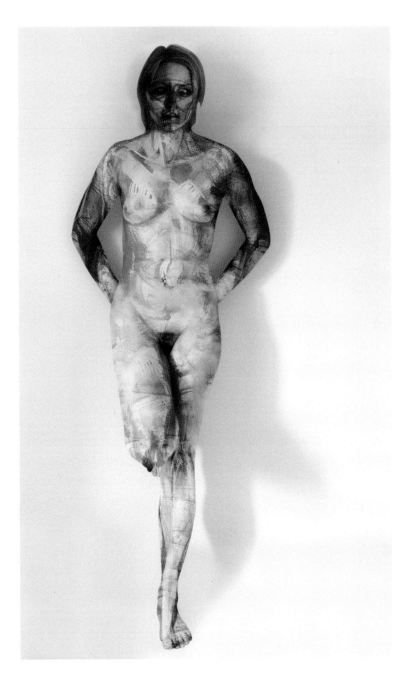

Using drawing and painting

Before I used a computer, I was convinced that digital programs couldn't achieve any kind of subtlety. Obviously there are things computers still can't do as well as the traditional media—and painting and drawing are, I feel, two of them. Things have improved dramatically in recent years, with graphics tablets and other pressure-sensitive methods of input, but digitally created drawings can still lack the facture of a "real" piece. Use computers for what they do brilliantly, things unachievable in any other way, and use the other media for what they do best.

Drawing was my favorite class when I was a student, and I still draw often. The results sometimes find their way into my work. They have particular textures to them, such as hatching, smudging or the paper they are drawn on, which enhance an image greatly. You also have the freedom to defy anatomy and the possible altogether, if you wish. It is a good idea to draw anyway, whether or not you plan to use the results in your finished pieces. Nothing sharpens your eye more, or reminds you better of the basic construction of an image.

A White Sheet of Paper, 2005. I made the pen drawing for this picture first. Inspired by the line drawings of Giacometti, it is black and white ink on brown paper. I then photographed the model in the same pose.

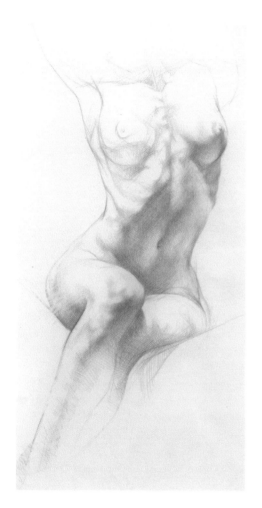

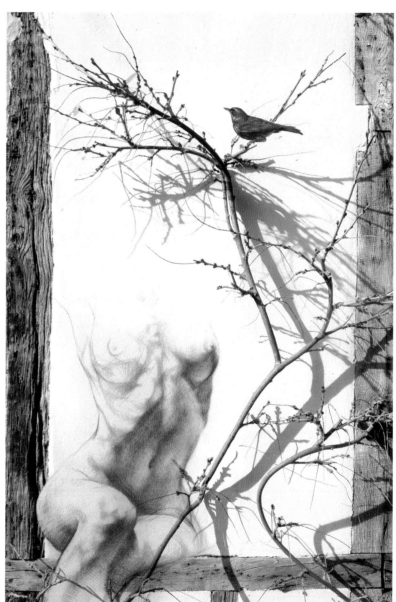

Drawing on the Wall, 2012. Colored pencils are perfect for hatched drawings; being relatively hard, they retain a good sharp point and let you build depth without losing definition. I increased the contrast in this one and used Multiply layer mode to integrate it with the background. The whole image was desaturated and a sepia tone added with Adjustment Layers.

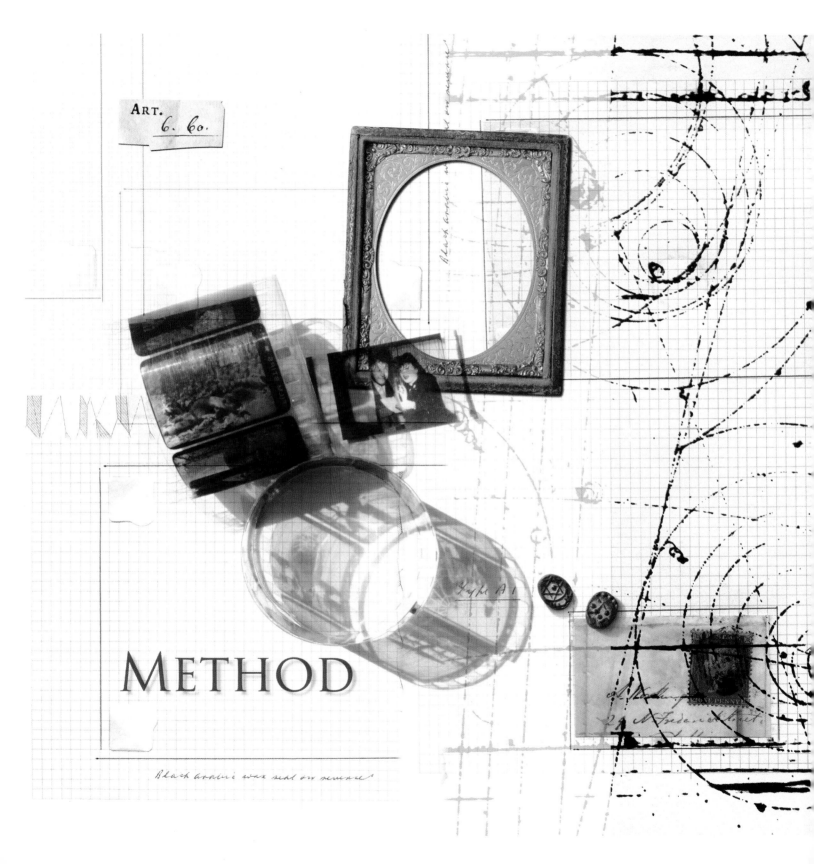

ART.
6. 60.

METHOD

Technique

Just how important is good technique and craft to the worth of an image? Once you have the basics, it is not as central as you might think. The amount of skill necessary will vary from one image to the next. Some pictures are assembled simply and speak directly, while others are much more complex and demand a high level of effort to pull them together. When the image communicates without it, you won't need advanced technique; it is only lacking if it obscures the message. As long as the picture does what it was intended to do, the technique and tools involved in making it become irrelevant. Don't worry about your skill levels, but about what you want to say. Your skills will develop along with your work, but technical expertise cannot hide paucity of content. The process should not dictate the direction your work takes. Accept that you will always be learning. Your creativity will not be limited by lack of expertise, or, indeed, by lack of equipment–it doesn't reside in the camera, the software or the computer. Your camera phone will produce images every bit as interesting and useful as a Hasselblad. Be led by your heart and your creativity, be confident, listen to yourself, feed your imagination and always keep your mind open.

When I work, I am watching the image develop rather than focusing on the mechanics. The process, with practice, becomes so intuitive that it ceases to interfere with the aesthetic decisions that are being made. So, we won't discuss technique so much as how to put across a message effectively. Technique is not generally important to the viewer, only to the practitioner. It is simply a means to an end. It is too easy to get bogged down in shortcuts and Adjustment Layers; the point of picture-making does not reside here, but in meaning and how to convey it. You won't need to be a

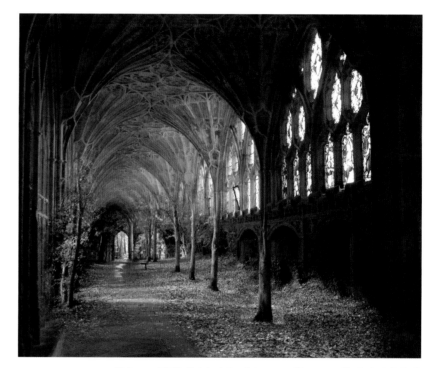

Cloisters, 2012. I visited the cloisters at Gloucester Cathedral (which, incidentally, appear as the corridors of Hogwarts in the first two Harry Potter films) just two days after a wonderful afternoon spent getting lost in the Forest of Dean. The two experiences, both uplifting and energizing, became entwined in my imagination. The picture had to work as a believable space, with consistent lighting effects and perspectives. This was a technically demanding piece that would not have been successful without careful attention to detail.

Crow, 2012. This is a very simple image (notwithstanding the rather elaborate path necessary to cut out the frame clamps). There are only three elements, each used in Normal layer mode at 100% opacity. Its strength lies not in any technical wizardry but in its symbolism and atmosphere.

Resolution and image quality

When determining the size of a file, the number of megabytes it contains, not its dimensions in inches or centimetres, is the important thing. Its resolution, measured in dpi or dots per inch, can be changed without altering its size. Just remember that the file size refers to the amount of information in it. If it's a small file, there isn't much information. You can indeed change it to a large file, but you won't be able to invent more information; it will get blurry. If it's a large file, you have a lot of information; you can make it smaller and lose some of it, if you like. A file say 72 dpi and 5×5 inches is about the same size, in megabytes and therefore information, as one at 300 dpi and one inch square; you can convert from one to the other and not change the file size, just the resolution. The lower resolution 72 dpi file will print out directly from Photoshop bigger and less sharply, and when placed in a desktop publishing program sit larger on the page but other than that, they're just the same. To sum up, a high resolution file has more information per inch than a low resolution one.

Screen and monitor resolution is 72 dpi, and digital jpegs are captured at this resolution. RAW files, on the other hand, are delivered at 240 dpi. Print resolution, for magazines and books, is generally 300 dpi. It's always a good idea to make the image as large as your source material will allow–if it needs to be used bigger, the information will be there and it won't become "soft". Better always to have a bit more information than you think is necessary; you can lose it later if you don't need it.

The best way to learn about resolution is to open a file and play with the Image Size dialogue box; look at the picture in Actual Pixels ratio (Command-1, or find it

Photoshop expert to make great imagery, just to have a good working knowledge of layers and their masks and modes, selection and opacity. Message, not method, is key. Having said that, the process is an interesting one. An outline of the basics follows.

in the View pull-down menu), and watch what happens to the image as you make the changes.

The amount of information you get in a file will also be affected by the quality of the saving format. I have my camera set to capture in RAW format. The file sizes are not unwieldy, so you'll still get a large number of pictures on your memory card. When a camera puts out RAW files, it saves the pictures in a less "lossy" format. It is not a usable file as it comes out of the camera. It is referred to as a digital negative, as it contains all the information needed to extract an image, and needs "developing". When converting a RAW file, you will have more options and therefore more possible information in the file than the camera-set, slightly lossy jpeg format.

For an image destined to be printed out without further processing, it is best to use RAW format, and save as a tiff. However, for montage work, I save converted RAW files as best quality jpegs; it saves a lot of space, as a jpeg file takes up roughly a quarter of the disk space in megabytes as the same file saved as a tiff. I defy anyone to see the difference once images are combined. You only notice deterioration in image quality if you save as a jpeg several times, when an accumulation of artifacts and loss of smoothness can build up. For montage work, when an image never appears alone but is combined with many others and generally "messed with", the extra quality of saving as tiffs might not be worth the larger file sizes it requires.

If your camera does not produce RAW files, or your software does not process them, don't worry. Jpeg format is more than adequate for all but the most demanding, largest-output jobs. Art photography does not demand such technical finesse. I take a lot of photographs—on a good day out, several hundred. Most of them are taken on spec, and will never be used. To process the RAW file of every one would mean I'd never get anything else done. So, for less important pictures for the archive, I often just go through the jpegs and save the best, particularly for mono images. They're always good enough. It's a trade-off, time versus image quality. It is probably best for you to try working both ways and see which suits your style of working.

Creating a background

Laying down a background, even if it should disappear by the time you've finished, will give a basic texture for the next layers to interact with. Get rid of that intimidating white space immediately! Rather than creating a new, empty file, I often open a photograph of a texture and start from there. Dragging a couple of similar files on top gives easily available alternatives, so that the initial image won't influence my thinking too much. Now, when the planned subject is added it immediately has something to work against and connections begin to form. I use the original file full size; imported images will automatically be adjusted to the resolution of the file in which you're working, and if necessary the whole can be adjusted for size and resolution once completed and flattened.

The proportions of the image will affect its impact. The versatility of Photoshop allows you to change them at any time as the picture develops. You can add space using Canvas Size or crop in to the parts that are looking most interesting. Remember that you need to save the file, close and reopen it before the history brush will work if you have changed the image's shape or size.

Selection

To make any part of your image active, it will need to be selected. To select all, choose Command-A. Remember this will only select all within the picture's edges; if there is information in the layer outside the boundary it will not be selected. To move this also, select the layer contents simply by making sure it is the active layer in the Layers palette.

Feathering any selection by one pixel or so will soften the edge. It is always a good idea to do this unless you specifically want a hard edge, as this will remove the "blocky" effect and help the integration of one part with another. The Marquee and Lasso tools can be preset with a feather distance in pixels, but you will need to go into the drop-down menu (**Select > Modify > Feather**) to feather selections made with the Magic Wand or Quick Selection tools. You can reposition a selection by dragging it from within the "marching ants" with a Marquee tool active.

Accurate selection is the key to making convincing montage. There are many selection tools available to you in Photoshop; below I discuss my own favorites.

The Marquee tool

Of all the ways that Photoshop offers, the Marquee tool is the simplest method of selecting. Using the rectangle or elliptical Marquee tool, click and drag out a selection. You can feather the selection beforehand by typing in a pixel value in the Options bar, or afterwards by using the drop-down menu. Holding down the Shift key will constrain the selection to a perfect square or circle.

Using the Magic Wand

To select the whole of an area of a more or less even color and tone, set the wand to a low tolerance–around 10 is a good start–in the tool options palette and click on the area that you wish to select. Pressing the Shift key while clicking will add to an existing selection. Increase the tool's tolerance to increase the range of color and tone added to the selection. If you want to select every pixel of a particular color or tonal range, click on one area of it and use **Select > Similar**. The tolerance of this similar selection varies with that of the wand. To eliminate a halo effect around a cut-out object, select the background, expand the selection by one pixel or so, feather by one to soften, invert the selection (Command + Shift + I), then add a layer mask; this will remove the outside edge of the object.

Selection using the pen tool in Paths

The advantages of a vector path over the Magic Wand are both greater accuracy and a smoother edge. You will also keep the path to reselect later, ensuring that future alterations will affect exactly the same area.

Edges that notionally move away from the viewer need to become gradually softer as they recede. A good way to achieve this effect uses Paths.

For this picture of broken eggshells, I wanted the shadows softer than the eggshell edges. I removed the softer selection from the shells layer and the harder selection from the shadows. Notice that I also faded the parts of the shadows furthest from the shells a little.

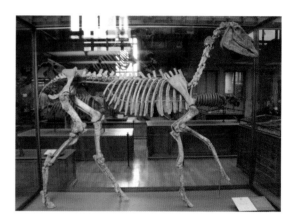

Draw a path and make a selection with a very small feather; I usually use .5 pixel, just enough to soften the "step" effect. Copy the object, and paste. Then make another selection using a wider feather, copy the object again, and paste. Turn off the background layer then, using Masks, remove the layer with the small feather towards the back of the object, and the layer with the wide feather from the front. You can do this with as many layers as you want, of course, to develop a convincing recession at the border. It is helpful to fill a layer with white below the object layers so you can see exactly the effect you are building. Finally, merge visible (without the white layer!) for a single object layer. For this doll head, I wanted sharp teeth and a soft neck.

There is only one way to remove a background as complex as this one, especially when photographed in monochrome. Paths may take a while to draw but the same accurate selection will then always be available to you.

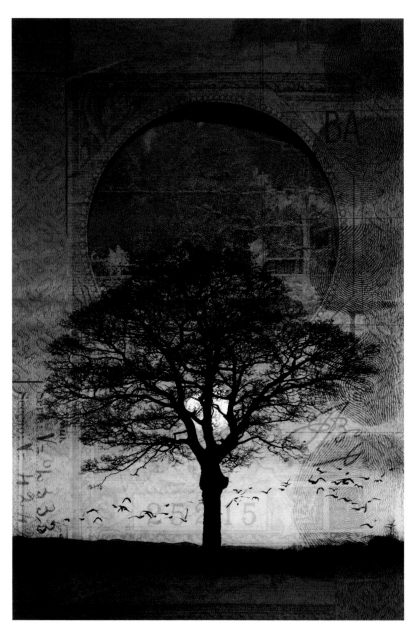

Winter Moon, 2008.

Avoiding selection

Instead of making complicated selections of, for example, a tree's branches against the sky, try allocating the layer a different mode. By using Multiply, or maybe Darken, you may well find you don't need to make the selection at all. For Winter Moon, removing all the sky from behind the tree would have been impossible; I simply used Multiply mode for that layer. Multiply adds all the contents of a layer even where it is not darker than the background, so any information in the sky registered. Increasing the contrast a little removed the sky altogether. The birds were added using Darken mode. Darken only shows those pixels that are darker than the substrate. You will achieve a smoother result using Multiply, but Darken is useful where a strong outline is required.

Evolution

The development of a picture is unstructured and intuitive from here on, as layer is added to layer in response to what is happening on screen. Pictures in progress are in flux, evanescent and growing simultaneously, and the best results happen when you stay flexible and alert. Experimentation with inversions, changing colors, opacity and modes, and so on begins to establish the "feel" of the new picture. You may not even plan the mood–it will develop just as with more traditional ways of making pictures, in a very instinctive and spontaneous way, reacting to the resonances set up by the interaction of the elements. Very often, the original substance of an image is rejected altogether as things more pertinent to the mood and shape of the piece are brought in. I'm not dictatorial over images; if something isn't working with the rest of the piece then it goes, and I'll find something else. I don't usually have

Another way of removing closely-toned sky from an image is to use Channels. The three colors making up the image—red, green and blue—each have a grayscale channel that can be edited separately by selecting just that channel. Select the Blue channel in an image, increase its contrast to the limit, and the sky will lighten and separate nicely from the tree.

You can also remove or alter one color range only from an image by using the Hue/Saturation dialog box. Here, the sky is knocked out by both lightening and desaturating just the cyans and blues (select the color range you want to affect in the Master drop-down menu). You can also use this method to remove color casts.

a final picture in mind when I begin something. Sometimes a title comes first. An interesting word or idea that can arrive apparently out of nowhere and begin to suggest colors, symbols or connections. These pictures aren't illustrations of a word; they seem to inform their own progress and reveal things as they develop.

When you're actually making a picture, you've already done a lot of the work. You've taken photographs or scans of the constituent elements, tidied them up and cut them away from their background if necessary. The choices that you have made about how these elements are shot and so on will obviously affect the picture, but the really creative part comes next, when you begin to make them coalesce into something more than the sum of their parts. This is where the skill lies—and therefore the problems! A lot of collage technique is about creating associations between unrelated parts, and coming up with something entirely new.

Traditional artistic media are much less flexible than digital montage. If you were to obliterate a month's work with oil paint, it would be gone; working digitally allows you to make such dramatic gestures, and if they don't work, undo them again. Photoshop allows decision-making both forwards and backwards in time. Set your History palette to create a new snapshot each time you save. Save whenever you arrive at a major decision point, then you can do as much work as you like and go back to a previous snapshot if you wish. This allows you to experiment without fear of destroying your previous efforts. I use the History palette a great deal. If I'm not

Experimenting will often result in series of linked images, all of which have arisen from a single jumping-off point. This series of five very simple portraits developed from the same monochrome shot.

sure whether a series of steps has really improved the piece, I can move backwards and forwards through the changes and make direct comparisons. You can set your own preferences as to how many steps are available. More steps will use more memory, so it is better to stick with an average number of steps–say, twenty or twenty-five–and save more often. Then you'll still be able to go further back in the image's snapshot history if you like, without sacrificing speed.

You can also Save and then Save As, giving you two identical files. These can then go off in different directions, so you don't have to choose between two possible avenues of exploration. This unique versatility probably encourages spontaneity and experiment more than any other feature of the digital medium.

If you have no shortage of memory, and the file size isn't getting too unwieldy, there is no need to remove the unseen parts of a layer–keep your options open. If you're happy that you won't need the excess in all of the layers, select all (Command-A) and choose Crop; this will keep the file size down. If you're only sure of one layer, apply any existing layer mask, select all, create a new layer mask and apply it. This will remove all parts of the layer outside the picture edges on that layer alone.

Shadows and light

Keeping shadows consistent across an image creates a feeling of believability. Conversely, experiment with irrational, illogical shadows for a more jarring, other-worldly effect. If you need to create a shadow for an object, don't just choose a drop shadow style. These don't allow for the shapes happening behind the object, or for subtleties of light direction and scatter. Much better to duplicate the object layer, fill the lower with a dark color, and apply Multiply or Overlay mode. You can then work into it with blurs and transform it to elongate and distort it. Study and draw shadows, watch how they move over surfaces and how they respond to them. They can be key to making an image "gel" and become believable. Remember that textures are often created by shadow, so do keep the light consistent across those too if you can.

If your source material was photographed in subdued or flat lighting conditions, you can change the direction and distribution of light across your image easily using layer modes or Adjustment Layers. The pair of images below shows the effects of both. The photograph of the farm outbuildings was taken on a fairly miserable day with low light levels. While these conditions reduce textural interest and image sharpness, they do result in usefully versatile source material. Shadows here are cast outside the barn, left, or inside it by first drawing a path around the doorway. (The path obviously couldn't be drawn along the grassy bottom edge; this area will need to be painted in later in layer masks.) Making a selection from the path, I added a Brightness/Contrast Adjustment Layer. This layer automatically showed only the selected area, hiding the rest in its mask. Turning up the contrast and brightness, or reducing them, threw light or shade onto the interior.

The figure and horse also needed adjustment when the light changed, of course. For the image at right I duplicated both and applied Screen mode to the new layers, hid all in masks and then painted in some fill-in light.

Inverting the selection and applying another Adjustment Layer allowed me to add the opposite effect to the outer wall and foreground. After deselecting I painted into the layer masks of both Adjustment Layers until the transition between light and dark looked good across the threshold.

It is also helpful sometimes to duplicate a layer and apply either Multiply, for shadows, or Screen mode. While this increases the file size, it can be more flexible than a simple Adjustment Layer; you can paint into the layer as well as its mask, increase or decrease its brightness or contrast without affecting other values, and blur it if necessary.

Combining textures

Photoshop's layer modes are the most exciting way of uniting the different elements of a picture. If one part is refusing to work well with the rest of the image, scrolling through the available modes may well solve the problem. Finding the right mode helps to emphasize visual links through the picture. Varying the layer's opacity, and even duplicating it and assigning different modes to each copy, also helps. A combination of these will eventually achieve a coherent whole.

You should try to be aware of relative focus when using several textures. If one is significantly sharper than others, not only will it leap out at you, it will make the rest look soft. Using blur and sharpening is often vital when fine-tuning a piece. Unintentional inconsistencies in sharpness across an image are rectified easily with filters. For example, if you have reduced the size of an element radically, making it over-sharp, applying a slight blur will knock it back into the picture plane. Sharpening will bring parts of an image that might have been enlarged a little too much, rendering them soft,

back into focus. The Noise filter can also be very helpful to blend two images with different levels of sharpness; adding noise at a low level, maybe four or five percent, will help to give a soft part of an image the appearance of crispness. It is usually better to soften the sharper than to sharpen the softer as over-sharpening can cause unwelcome artifacts and graininess.

Translucency

A major advantage of digital montage over traditional forms of collage is its ability to make elements translucent. I used to layer sheets of the thinnest papers with wallpaper paste, watching them merge and interact, only to be disappointed as the glue dried and all but the topmost disappeared. In the digital realm, this is no longer a problem; even riveted steel plates can be made

Daphne, versions I-V, 2012. The only variable across these five versions is the mode applied to the nude's layer. I decided that Difference mode, far right, worked best for Daphne.

insubstantial and transparent, and every layer can have its effect. Most layer modes allow the background some influence—as they build, so does the nuance and subtlety of the piece. You can also simply lower the opacity of a layer to allow those below to show through. Further, it can be useful to place several layers into a group and apply layer modes to the entire group. This way, you can have a Normal mode layer, for example, completely obscure the underlying parts within the group, and also have it interact with the background. All this allows you not only to blend layers, but also to create an impression of depth and light in the image.

Cloning

The clone tool is not just for retouching—it is often invaluable for painting across large areas of a piece. When cloning, keep choosing new places to sample from, or a repeating pattern will be obvious. Establish the groundwork by using a larger brush at 100% opacity to start with. Finer details can be added with a finer brush and, if necessary, lower opacity to blend, later. Find lines and tones already in the image and follow them across to the new area. Always do this at as high a magnification as possible, checking periodically the overall impression (Command-1 will show you the image at actual pixels size; Command-0 will return it to full screen).

FACING PAGE

Shatter, 2012. You can use the translucency of many layer modes to make the subject itself appear transparent. It was surprisingly complicated in the case of this dragonfly, which was photographed against a white background. I cut it out using a path and began to experiment with layer modes. This final version has four different modes applied to six layers: two Overlay, one Hard Light, two Multiply, and a Normal. The order, opacity and contrast of each layer was adjusted, and layer masks edited further until it all worked together. The Normal mode layer appears only in the thorax and abdomen, where I did not want the glass to show through. The background has just two layers; the beautiful blue cathedral glass was not broken, so I overlaid a smashed piece of clear glass.

The clone tool can be set to sample just the layer in which you are working (Current Layer), that layer and the ones below it (Current and Below) or All Layers by choosing from the menu under Sample, in the tool bar. Here, I am cloning only the current, ammonite, layer with a large, soft brush at 100% opacity.

Developing your image

An element can be included symbolically or simply because it's the right shape. Don't get hung up on why you're adding something. If you want to add it, that's reason enough. Fine art is not the same as illustration—you don't necessarily have to make your message immediately obvious. Let the viewer interpret the picture. Suggestion is more powerful than insistence.

Sometimes a picture can be close to finished, contain all the elements you wanted to include and be organized and structured, and yet still lack "spark". Don't be constrained to the digital medium to arrive at a finished picture. In this example, Ten Pins went through several stages, came out of the computer and was brought back in before I was happy with the result. First, I photographed several arrangements of an old anatomical model, the paper kind with open-out flaps and lift-up tabs.

I made a collage of these together with a nude, but was dissatisfied with it—flat and uninteresting, it had no real focus.

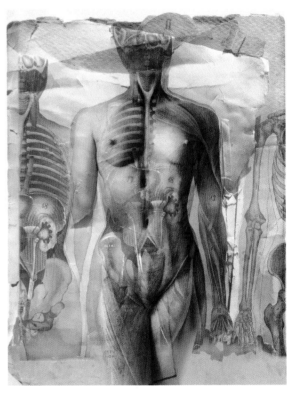

I printed out the digital montage and laid the print on a board. I then added pins and laced cotton thread between them. I ensured that the angles of the thread were similar to those of the lines within the printed image; they echo the shoulders, groin and verticals. The pins and thread brought the picture into sharp focus, and added depth by casting angular shadows. The assemblage was then photographed in strong natural light, as all the original source material had been,

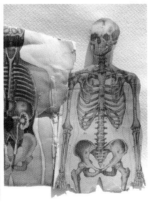

making sure its direction was consistent with that of the elements within the collage.

Next, I cropped the image. The head and the paper creases at the top were superfluous, and a tighter crop to both sides helped to focus attention on the main figure. Finally, a sepia tone removed the pink and peach colors, which I thought weak and insipid. I added a little contrast with an Adjustment Layer, and arrived at the finished picture, Ten Pins.

Ten Pins, 2012.

Practice

I didn't train to be a digital artist. We didn't even have a computer in our department at art college when I was there, which shows how long ago that was. I just taught myself, by deciding what I wanted to do and trying to do it. Happy accidents can teach you as much as, if not more than, careful poring over a tutorial. The technique is best picked up by simply using the program. If you start making a picture and come across a specific problem the manual will naturally be useful, but it's better not to get bogged down with it to start with. Playing is always the best way of learning. If you get the basics down—selection, layers and masks are the only vital things—the rest can follow. After all, the ideas are the most important part of any picture.

Don't let the program determine the piece. Use it over and over until the shortcuts and the controls are so natural that you don't have to think about them any more—they can make you very conscious of the "how" rather than the "what" of the image. The best possible way to develop your skills and most importantly your own voice is simply to sit down and do it, a lot. Complete familiarity with your program lets technical problems recede in importance and the real business of communication happen. Some people like to listen to music while they're working. For me, it influences my mood too much—a little like listening to thrash metal while driving, it can interfere with my natural pace!

I try not to rationalize too much. I like to watch an image develop and feel my way, let it change and not worry about where it is going. When I dictate its direction, it can often get stale and rigid. It's better, at least for me, to let the creative process itself have an influence, and to let small surprises and accidents happen. If turning a layer off makes the picture suddenly different, and better, I'll delete it, and carry on along this new direction. Always dump things that aren't working, however attached you are to them—they can always be saved as a separate file and used later in something else. Work is never wasted when it is part of an ongoing development, either of an image or of your work as a whole. It is one of the joys of digital that you have such freedom.

Do remember to take proper breaks every forty minutes or so (major headaches will ensue otherwise)—five minutes looking into the distance is enough to let your eyes relax. Most importantly, have fun!

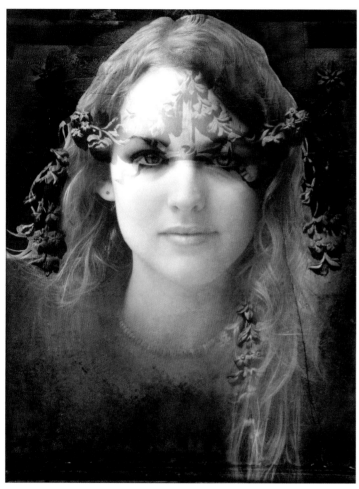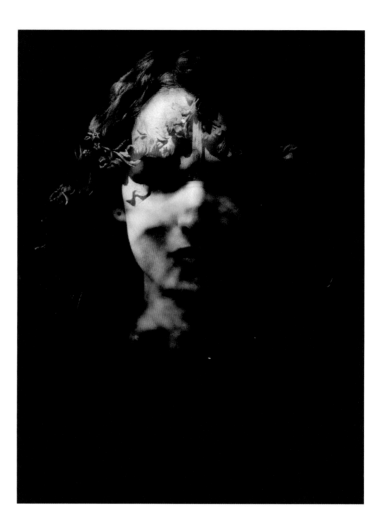

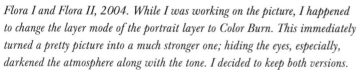
*Flora I and Flora II, 2004. While I was working on the picture, I happened
to change the layer mode of the portrait layer to Color Burn. This immediately
turned a pretty picture into a much stronger one; hiding the eyes, especially,
darkened the atmosphere along with the tone. I decided to keep both versions.*

Saving it and final touches

It sounds obvious but it's very easy to become so involved with an image you forget to save it periodically. The crash-free program still eludes us, sadly. Losing hours of work is very demoralizing, especially if you have a deadline looming.

The image is now finished, barring some minor touching up; to do this, first flatten your image. I always save the layered version first and then save the flattened file separately; this enables you to make further changes to the image later if you have more ideas. The final job is to go over the whole file at a high magnification to pick up any small imperfections with the clone tool. There's a lot less of this to do if you're using a digital camera, but if you have scanned in slides or used a flatbed scanner there are likely to be bits and pieces of lint or dust that will need to be removed. I always try to do this at the scanning stage, but one or two always get past!

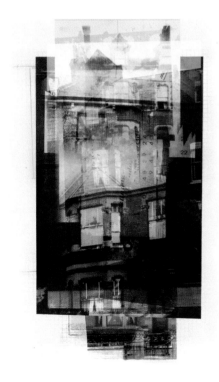

City I, II, III, V and VI, 2011. Remember, if you like both a saved version and a newer one, you can Save As a new file and develop both. These pictures are all versions of one original image.

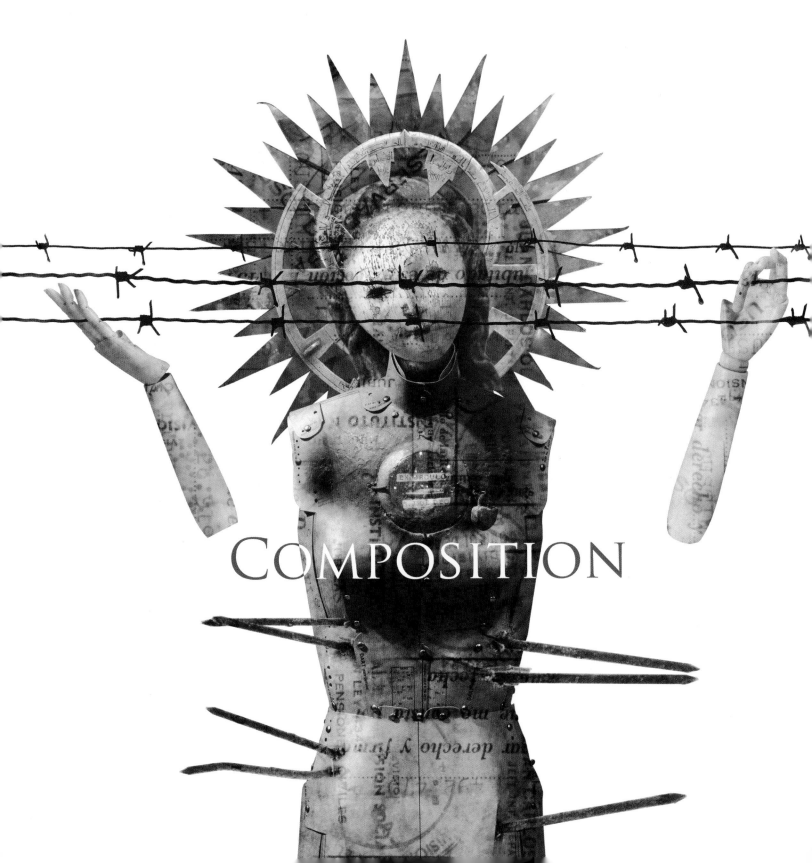

COMPOSITION

All creative effort attempts to capture, codify and convey the most elusive things in life. Thoughts, emotions, fears, all so ephemeral and intangible, are nonetheless communicable through good art. Poetry achieves this in a small space of time, while a novel, a film or an opera has longer. In these times of constant sensory input, to the point of overload, a picture has to appeal to something in the viewer–their intellect, or their heart–immediately. You need to have an audience's attention before they will explore and contemplate the piece. Composition is the best means you have of creating an image with impact.

There are no rules when it comes to composing an image. This section suggests some of the ways that composition will affect your picture and how you might use it to reveal your ideas, but it is by no means either exhaustive or absolute. There are ways to unify your montage and make it a complete and integrated picture. There are ways to suggest mood, direct the viewer's eye or create space. This chapter, and the following chapter on color, will outline these, but you will develop your own, with experimentation. Treat this guide is a starting point, and then follow wherever your art takes you.

Three of the commonest aspect ratios, or proportions, of cameras' digital output.

Proportion

When creating a new file, the first thing you will decide is what proportion and size it will be. This is not irreversible; you can change it at any time by cropping or expanding the canvas size. It will definitely influence the growth of your image, however, and needs consideration.

Digital cameras produce files of differing proportions. 35mm film has an aspect ratio of 2:3, and some cameras, like my own, adhere to this ratio; it is a close approximation of the eye's own visual range. Others give a less elongated image of 4:3 (the old standard ratio of televisions and computer monitors), or a widescreen ratio of 16:9. You can change the proportions of a file at any time, most simply by cropping. This will remove information outside the selection, while the remaining image will be unaltered. (Resizing and unchecking the Constrain Proportions box in Image Size will also alter the proportion, but will expand or compress the contents too.) You can also add more space, on any or all of the sides, in Canvas Size (**Image** > **Canvas Size**...). The new space will be the color of the lower swatch in your Color Picker by default, and you can choose any color. Changing the picture's aspect ratio like this can alter the dynamics of your picture completely and give a it very new feel. You're never restricted to a picture's original proportions. Images often develop in a different direction from that anticipated, so keep this freedom in mind.

A square format is very interesting to work with. It is a natural shape to choose for symmetrical compositions, especially those whose overall movement is circular. Square format film cameras tended to be large format and of the best quality, and square photographs

were associated with large negatives, high detail and technical excellence. More recently, though, a different type of square format photography is in vogue. First Polaroid, and now Diana and Holga cameras, made the square format fun and friendly; cheap plastic lenses create distinctive distortion and vignetting. The latter two cameras use film, but you can buy plastic lenses for your digital camera to achieve the same effects. You can also apply these effects as a filter.

I like to work with squares. Cropping a photograph down to a square shape will reduce the size of your finished image, so I shoot series of photographs and stitch them together. The shape has its challenges. It can look staid and it can also be difficult to set up interesting diagonals within a square to throw it off balance. Persevere, however, and you'll make an unusual image.

We're very used to widescreen format television and cinema. Elongated shapes are elegant, dynamic and look spacious–the eye travels across the image, making the format perfect for landscape. Attention is concentrated more firmly on the subject, as the eye is not given space to wander off and extraneous sky or foreground is eliminated. At their most extreme, long formats tend towards abstraction; our eyesight is not naturally limited so radically to the letter-box shape, which therefore points up the artificiality of the piece. Interestingly, more radical crops reverse the spacious feel of the widescreen format, and can start to suggest restriction, limitation and even claustrophobia. Have a look at the work of Josef Koudelka, whose use of these shapes is exemplary. You might also like to try tall verticals, which share the dynamism of the landscape format to create a strong visual lift.

You need not be limited to a square or rectangle, of course. You can easily make your image circular, triangular or any other shape. Make a new layer at the top of the stack, fill it with white, and then cut the shape you want out of it. (If the picture is to float on black or any other color, fill the mask with that, of course.) Irregular edges, of torn paper, fabric or brushstrokes for example, can be of any shape at all and will also be an effective border.

Geometry

Basic geometry is behind the construction of every successful composition, whether consciously or not. Geometry can help you send subliminal messages–qualities such as tranquility, dynamism, unease or solidity, even aspiration can all be suggested using the simplest of shapes.

Medieval architects built their cathedrals using complex and rhythmic permutations of squares and circles. The most perfect shapes, the square represented the material world–the four corners of the Earth–and the circle stood for the spiritual world, for Heaven. The shapes clearly have deep psychological effects on the brain, for these ancient echoes persist. They have been thoroughly researched and put to work by artists and designers ever since to hugely varying ends. In modern experience, perhaps the most obvious use of subconscious, even subliminal, suggestion of this sort is in branding. Think of all those round and oval logos.

FACING PAGE
Guitarra IV, 2010. For the Guitarra festival in Cordoba, Spain, I decided to make a series of circular images. The outline serves to highlight the relationships between the curves of body and guitar, and helps to unify them. The anatomical engravings stress that these images are about structure and form.

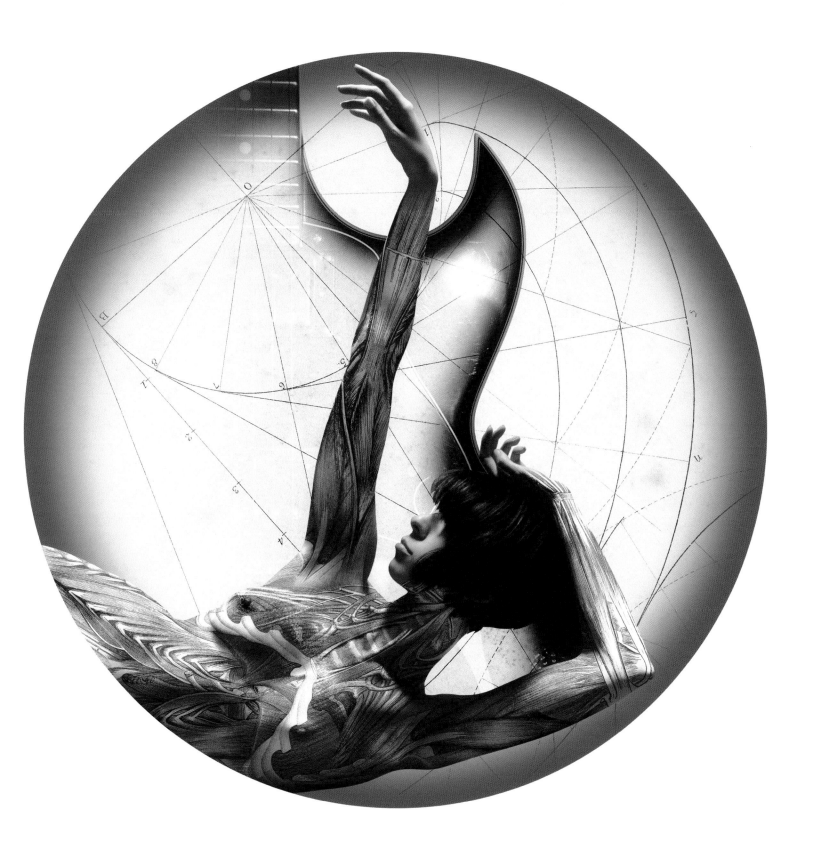

Nestling, 2011. A nest is the definition of security and comfort.

appearing only in some crystal forms and one or two plant and insect markings and structures. It is essentially a shape of human construction, and as such is a very potent expression of the order placed on the world by us. Rigid and structured, a square or rectangle has a forthright solidity useful in giving an image order. It signals conformity, conservatism and dependability.

Warning roadsigns and labeling show that the triangle has more dynamic, even dangerous, connotations. The diagonals create a movement across the surface that doesn't return you to your starting point; you are abruptly redirected along a new diagonal. The perfectly smooth transitions of curves are replaced by definite stops at the angles. As the solid two-dimensional shape with the smallest possible number of straight sides, the triangle has the most acute internal angles and so the most extreme changes of direction. It cannot be a coincidence that the converging lines of receding perspective create triangles in two-dimensional renditions of space; the impression of movement, of a recession through space, that they give is understood at a very fundamental level by the brain. Further, inverting a triangle places it at its most vertiginous and unstable, suggesting impending movement–falling–and a dynamism that can be invaluable in creating a striking picture.

Adobe's logo combines the psychological suggestion of both the square and the triangle. Within a (suggested) square, signifying that the product is utterly dependable, a reversed capital A makes a triangle for energy and invention. Combining messages creates subtlety. Try throwing a circle off-center, or lining up a series of inverted triangles; the contradictions set up can be really visually exciting. Turning a square through 45 degrees creates diagonals, which will effectively destabilize it and set up new rhythms. Changing the shape of the whole canvas can completely change its mood. Cropping a rectangle into a square will

Companies such as Esso, BP and Toyota are sending out a holistic, positive, and caring corporate image. These companies, their logos are telling us, are reliable, concerned and trustworthy. Following a circle in a composition, your eye travels smoothly and safely in an uninterrupted sweep before being returned to the beginning. Curves as a whole have soothing, gentle properties, and the circle is the perfect expression of them. From the atom to the planet, the sphere is nature's most complete, stable and balanced structure, and its two-dimensional form shares these qualities.

Four- and three-sided figures have different connotations. Used when imparting information clearly and efficiently, squares and rectangles are highly functional. The square or cube almost never occurs in nature,

Genealogy, 1999. This picture, made for a book about numerology, required an atmosphere of logical progression. The triangle creates a dynamic but grounded balance.

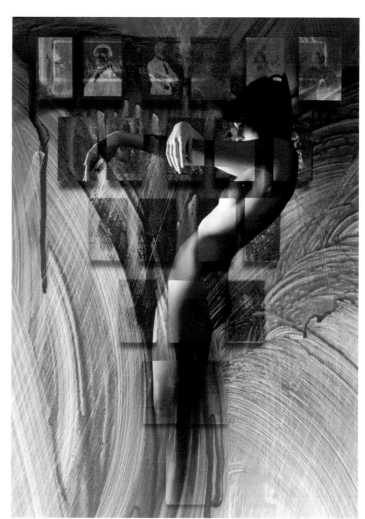

Family, 2012. The inherent instability of an inverted triangle is used here to increase the feeling of movement—not just the travel of the eye around the image, but apparent or implied movement within it. Putting all the weight, the darker tones, at the top combined with the figure's impossible lean also makes the image's balance more precarious.

Voyage, 2011. The ship will leave the safety of the circle to embark on a journey into the outward-facing triangle. Notice the echoes of the triangle within the ship, which links the two elements.

Eve, 2003. The square picture shape contains the circle perfectly and helps the eye travel round it uninterrupted. The circles and arcs used here aren't all concentric, however. Placing a few asymmetrically or with differing centers prevents the "bull's eye" effect from becoming too pronounced.

impose an order and balance which is interestingly subverted by its being an unusual picture shape. (See Proportion, p. 121.)

The psychological resonances of the various basic shapes can be used in your work to reinforce your message. For Eve, a picture about the beginning of life, the natural shape to choose was the circle. Echoing the shape of an egg, the circle was set up by the clock face and reinforced by placing the compass inside it. The baby (a wax model from a museum) is kept within positive, enclosing curves, suggestive of the mother's nurturing role.

A very symmetrical picture like this can become too static. To give the composition both movement and a stable foundation, a triangle was then created with the light streaming through the woman's fingers towards the lower corners. These diagonals pick up both the Roman numerals on the clock face behind and the crosshairs of the compass, helping to link all these elements together.

Finally, it is useful to understand the classic of picture composition, the Golden Section or Golden Mean. This proportion, roughly 8:13, can be found by positioning a point on a line such that the ratio of the smaller line to the larger is the same as that of the larger to the whole. It is constructed mathematically by the Fibonacci sequence, a series of numbers beginning by definition with 0 and 1, in which each number is the sum of the previous two, making the series begin 0, 1, 1, 2, 3, 5, 8, 13, 21, 34, 55, 89, 144, 233 and so on. As it progresses the ratio of each number to the previous gets closer to the Golden Ratio of approximately 13/8 or 1.618. The ratio is shown in a Golden Rectangle, which can be divided into a square and a smaller rectangle of the same shape, or proportion, as the larger.

The Golden Section has been explored so thoroughly since it was first constructed by Euclid that it can now look old-fashioned, even dull, but it has long been thought the "ideal" proportion. Many natural forms, such as the growth patterns of ferns, or the helix of a nautilus shell in which it is developed into a logarithmic spiral, show this proportion and this attracted natural philosophers and artists to it as an expression of divinely created perfection of form. Renaissance masters such as Piero della Francesca used it repeatedly in the astonishingly complex geometrical constructions underlying their paintings. Perhaps because of its "natural rightness", or perhaps because having seen it so often before it is deep in our subconscious, it very often creeps uninvited into a picture simply because it looks "right".

The "rule of thirds", by which points of interest are positioned on the intersections of an imagined tic tac toe grid, may be a useful place to start with composition, but it will not keep you interested for long. Much better to push things further and think about how the geometry of your image can do more than make

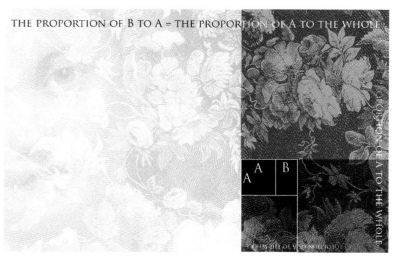

THE PROPORTION OF B TO A = THE PROPORTION OF A TO THE WHOLE

The Golden Section.

The World Turns, 2002. The Earth is placed on the Golden Mean vertically, but thrown so far to the right that it is destabilized. Pushing the focus of the composition right off to the edge gives the image the intended feeling of travel, while balancing the moons and sine-wave patterns around it with a vertical symmetry maintains control and stops the picture from becoming too chaotic.

a pleasing balance. Using very pure forms of basic geometrical shapes in pictures can give a feeling of logic, and hence of believability, to the most fantastical composition. The impossible can look almost possible if you pay careful attention to details of light direction, the relative sharpness of the elements and so on. Clear geometry reduces an image's apparent chaos and gives it a firm framework, a "skeleton". It can also breathe emotion into your work.

Gestalt theory

The secret of successful digital montage is to make the whole greater than the sum of its parts. There are many ways to do this. In this section, we'll look at the potential of the lines of your composition to integrate its elements into new relationships.

To make your imagined world convince the viewer, and so to deliver its message as effectively as possible, the picture must work as a unified whole. If its separate parts are too easily identified and classified by the person "reading" it, it will never be more than the series of elements within it. The viewer may become sidetracked into simply cataloguing–that's a tree, that's an eye–rather than seeing the picture in its entirety. It must become more than an assemblage of disparate parts. Connections have to be struck up between those parts, uniting them and making something completely new.

Composition is a vital means of achieving this. First, the choice of the elements themselves creates obvious connections. By selecting things for your picture that relate to one another on some level you are beginning to start up a relationship between them. The link can be an evident one–a profile and an x-ray of a skull have an immediate association. They could have shape or color

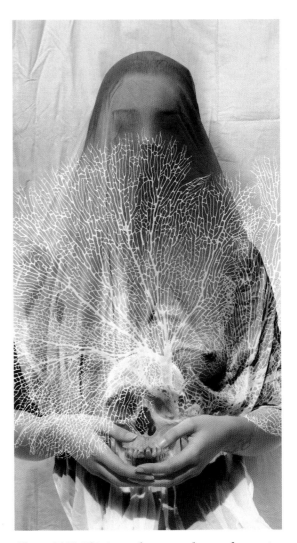

Maria, 2012. This image shows several ways of connecting parts of an image together. The link between head and skull is reinforced by their similar frontal aspect; the drapery and sea fan are connected by the echoing flow of their lines; the skull and sea fan share the similarity and continuity of the fan's lines with and from the cranium.

in common—an ear and a shell are very different and yet they are linked by form (and, indeed, poetically). Or the relationship can be a subtle one. Visually linking a Victorian family photograph album with a modern portrait tells of a genetic history, a link through time between people. Connections can also be contained within the objects themselves. A key and a lock, a dog and a bone have an obvious narrative connection. In a rebus or pictogram puzzle, objects' names sound like something else, or are part of another word—visual punning. A picture of a deer (a hart) and a snapped twig could mean heartbreak. Edwardian swains sent long and beautiful letters composed entirely of rebuses to their loved ones. This more literal approach to allusion can have viewers puzzling over an image for hours. This appeals more to the intellect than to the imagination, maybe! Your choices may be made intellectually, emotionally or even sometimes seemingly at random. The reasons for them may even only become apparent once the image is complete.

Once you have your elements, you need to make them work together. Their placement, color and tone relative to each other are all important in creating a new entity. By fusing them together, you can create a gestalt, or a whole greater than the sum of its parts. According to gestalt theory, now a well-researched area of psychology, there are four main ways in which the brain tends to link objects together. These can be exploited by the digital artist to encourage parts of a picture to meld into something altogether new.

Proximity

Personalized number plates rely on this principle to deceive the viewer. The closer objects are to each other, the stronger the implied relationship between them. A 1 and a 3 can easily be read as a single character B by closing the distance between them. This can of course be a nuisance when it happens unintentionally, resulting in lamp-posts growing out of the top of people's heads.

134515

Similarity

The number plate also shows the effect of similarity of form—the 4 and 5 can be seen as an A and S. The similarity can be one of shape, texture or color. Anything will help to establish a link. Changing the hue of an element, for example, can associate it with others. Try assigning Luminosity mode to its layer. It will retain its tonal values, but assume the hue of the underlying layers, linking it to them. Repetition is the extreme form of similarity, and can make a powerful statement. Multiples of almost identical objects create rhythm. Andy Warhol's screen prints set up echoes and repetitions that make each print in a series inescapably belong to the next. Similarity is a motivator for many of my images. While "looks like" clearly does not equate to "is like", it does make an immediate connection between things that leads to contemplation and encourages imaginative leaps, as well as having pictorial advantages.

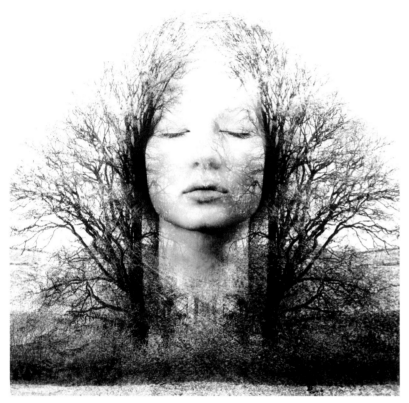

*A Tranced Woman, 2006. The trees are easily read as
hair because of their similarity of texture. The branches
also move into the portrait, stressing their likeness to veins.*

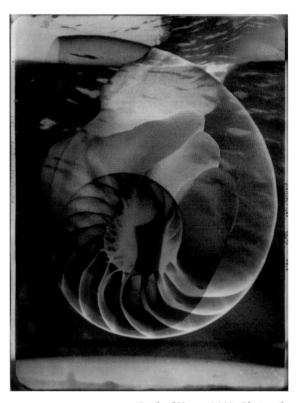

*Birth of Venus, 2002. Placing the
nude inside the shell, as Botticelli did in his
original Birth of Venus, inescapably links the two.*

Continuity

Placing objects together makes it easier to see them as associated than as separate elements. Aligning curves or lines so that they appear continuous fools the mind into reading a connection between them. In A Tranced Woman, the curves of the branches echo and extend the curves in the face, showing that backgrounds, as well as more obvious subjects, can provide a quiet link across an image that operates almost subliminally.

Closure

The brain tends to fill in gaps to create a perception of stable shapes, or to make recognizable shapes out of unrecognizable ones. It wants to assign a reading of what it is seeing to something within its experience. If you're making a picture of something outside that experience, it will do everything it can to help you make it believable.

By using a combination of these techniques–and there are clear overlaps between them–the viewer can

be persuaded that they are not looking at a picture of a body and a shell, but a new synthesis. It doesn't have to be a conscious thing. More likely, you'll simply move something about until it looks right, and only then will you notice that its curves echo others, or its pattern is similar. Play around with the image. Use those facilities of Photoshop which give you such freedom compositionally. A combination of things—scaling objects so that they fit with others, changing their color or saturation, fading them out with a layer mask or by varying the layer's opacity or mode—will eventually result in a unified whole.

The brain naturally creates order out of chaos. The connections it makes can work on other levels than the purely visual. A picture can have emotional depth, or a complexity of reference, by the use of a combination of well-chosen elements and these compositional methods. And remember to allow for mystery. Layers of meaning can co-exist in a picture, to be interpreted in different ways by each new pair of eyes. Allowing the viewer to find them for themselves makes their resonances all the stronger.

A useful way of finding connections for your work is to assemble folders of otherwise unrelated similarly shaped or colored objects. Making these collections is just like collecting the materials for a traditional collage; simply placing them together in front of you starts the creative process. You have the added delight of being able to include things you could never have used before for reasons of scale, or ownership, or even just because they have one too many dimensions. When you place a tachograph diagram, an apple, and the moon together, you immediately begin to weave stories around them, and the differences of scale are all to the good. Their unifying factor—their shape of course, in this example, but it could as easily be that they are all means of transport, or a glorious shade of cobalt, or triplets,

anything—will help you make a satisfying visual entity while encouraging inventive thinking.

Symmetry and asymmetry

Symmetry has deep resonances in the human psyche. We each have, more or less, a symmetrical body and a symmetrical face; excessive deviation from this is seen as unattractive, even worrying. Across all peoples and cultures, and throughout history, those faces regarded as most beautiful are exceptionally symmetrical. It seems to be a fundamental human preference, probably explained by its suggestion of genetic fitness. As a result, symmetry is associated with calm, balance, strength, peace, a general feeling of well-being. It can also inspire confidence, and demonstrate power. From ancient Egypt, Greece and the Mayan and Aztec civilizations, to Imperial China and Victorian Britain, splendidly symmetrical architecture, both religious and secular, has proclaimed authority. Islamic architecture, in particular, also has a wonderfully calming, spiritual quality.

Throughout history, artists too have used these deep-seated associations to great advantage. Ancient Egyptian sculptors depicted their ordered, peaceful world in highly stylized symmetrical terms. Inspired by this, from the earliest kouros carved in Ancient Greece, classical composition has been about balance, harmony and equal oppositions of forces. Early severe symmetry and rigidity developed into a more sinuous dynamism, but it retained an essential balance that still resonates powerfully with a modern audience.

There are so many influences on ways of seeing, of course, and there is a great deal of art with other priorities. Much oriental art, inspired by the natural world,

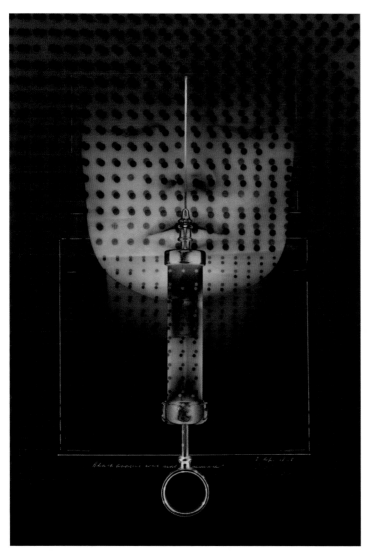

Botox, 2007. A very symmetrical and frontal composition gives the figure a power that would have been diluted by off-setting it.

developed an entirely different language of composition and new ways of creating balance. It was here that the power of asymmetry was first explored. Expressive, full of movement and surprise, the Japanese print, for example, is essentially dynamic. By throwing the picture off-balance, a mood of excitement, expectation, even insecurity is created.

Photography has been another pervasive and refreshing influence on compositional style. Its way of capturing life's randomness and chaos, of cropping, of looking past foregrounds to the subject, of creating out-of-focus areas, has profoundly changed the way pictures are structured. The Impressionists, working at the time photography developed, used it and its lessons to make wholly original compositions. Degas took many photographs, and was influenced by these and by the Japanese prints that were then arriving in Europe to experiment with very asymmetrical and, at the time, daring and provocative, work. Off-balance, with the main subject pushed to an edge or even cropped, and looking over shoulders into the picture space, his work has a new kind of realism.

Modern artists can bring all the aesthetic sensibilities of their forebears to the most cutting-edge technology to make altogether new forms of beauty. Macoto Murayama (see also p. 67) uses both symmetry and asymmetry just as nature does. Most natural forms have at least one axis of symmetry, and Murayama uses this in his beautiful floral pieces to create perfectly balanced, perfectly elegant forms. While, at first glance, they appear mirrored, they are never simply duplicated from one side to the other; look closely, and you'll find subtle differences of curve or angle. All the nuances of natural variation are reproduced to ensure these images have enormous vitality.

*Spider lily - i -w, 2008, by
Macoto Murayama. Image courtesy
the artist and Frantic Gallery.*

*Japanese lily - v -w, 2007, by Macoto Murayama. Murayama also
explores the fluidity of the asymmetrical. The dynamism of living,
growing things is miraculously retained; scrupulous attention to detail,
measurement and analysis has not quashed, but brought out the flower's
organic vibrancy. Image courtesy the artist and Frantic Gallery.*

This is a less balanced version of the picture, with an apparently fleeting glimpse of the man suggesting movement or transition.

The pair of images above shows how symmetry and asymmetry can affect a composition. Père Lachaise is a composite of images from the famous Parisian cemetery. One can get a real sense of the people commemorated here from the beautiful statuary, inscriptions and even photographs, and this picture is about finding the character behind the memorial. The background is an old print found in a junk-shop; the leaves echo the cemetery's many trees, and its sepia tones suit the subject well. Its distressed edges are reminiscent of the atmosphere of age and weathering at Père Lachaise. The portrait is from a memorial in the cemetery's famous Colombarium. Many of the monuments are painted, and have weathered into beautiful textures; this star was cut into a metal door.

When the entire picture is rotated 90° counterclockwise (remembering to rotate the portrait layer 90° back!) the whole feel of the image is changed.

Moving the star off-centre has made its diagonals more dynamic; their alignment with the corners of the picture is stronger and the man now seems to be moving across the picture rather than standing in it.

Notice too how the star and portrait layers now needed to be nudged upwards a fraction. Even when a horizontal line appears to cross the middle of a picture, it is always more "comfortable" with slightly more space below it then above. Of course, if discomfort is your aim, go ahead—all compositional rules are there to be broken if it gets the message across!

If you want to give your picture strength, power and a classical elegance, try making it—or areas within it—symmetrical. If you're aiming for a vibrant, organic image full of movement and dynamism, throw it off-balance. As with all these compositional guidelines, there really are no rules, just different ways of achieving an atmosphere.

Ram, 2010. Pictures that are too rigidly symmetrical or overly balanced can become static, even dull. As Murayama has shown, introducing subtle differences will enliven the image. A found plastic moulding has inherent flaws that make it more visually interesting than a perfect shape.

Complexity

Images can vary in complexity from the simplest combination of two images to the most elaborate confections. Considering the context in which your image will be seen may well help you decide upon the degree of complexity needed. If your piece will be fighting for attention as a poster, for example, or a book cover, impact is essential and simplicity will help the main drive of

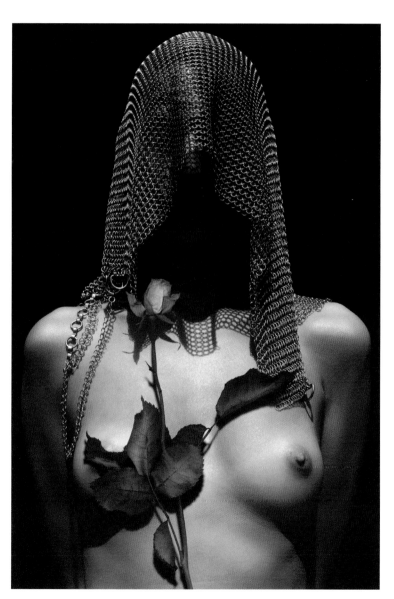

Monument, 2010. This could be a straightforward photograph (the rose was, in fact, added later). With only three elements and no background or color, this is about as simple as it gets.

Corridors, 2012. This image is about the corridors of the mind, and how their workings are influenced by one's genetic and environmental history. The recesses of the psyche are overlaid with a series of MRI scans, in which the body has been replaced with images of windows—windows to the soul, which also suggest the influence of environment. The woman looks into the dark, the unknown.

the message get through with only a fleeting glance. If, however, the image will be viewed at leisure—in a book, maybe, or an exhibition—you can add greater depths to be explored without losing your audience.

There is power in simplicity. Your message may be complicated, but delivering it simply is often more effective. Advertisers have always known this. From the very first "Buy this, it does you good" slogans to today's more psychologically aware, but no less succinct, offerings, they have kept it short and sweet. It is a valuable lesson. Simplification increases focus. Pare your image down to its essence to give it maximum impact. This is more difficult than it sounds; every element—color, pattern, tonal balance and so on—is just as important in a two-layer composition as in a magnum opus. With fewer things to juggle, the spotlight is thrown on the ones remaining, so they have to be right.

Color can complicate a picture. If you find that your image is becoming overworked or jumbled—as can easily happen when many layers work together— try desaturating by dropping an Adjustment Layer at

the top of the stack. This will make your tonal balances easier to read and may well help you find the problem— you might even decide to leave it there.

As George Orwell said, never use a long word where a short one will do. Concision is important for montage too. Building an image will increase its depth and evolve its meaning. Once you have that meaning, however, take it back to that. Remove anything that isn't helping people to understand it. I have a terrible habit of overcomplicating things; I used to stuff texture into everything, simply because I liked this or that effect. Now, I see that it can distract, and detract, from the central thrust of the image. You have to sacrifice the small for the whole, sometimes.

The image below, Corridors, is a case in point. I made the first version in 2003, having just bought several Victorian photo albums. I wanted to get as many references to genetics and the interior workings of the head into the picture as possible; there are two sets of MRI scans, both a photograph and an x-ray of a skull, portraits… altogether too much. I took another look

FACING PAGE

A Tribute to the Madness of Beethoven, 2009, by Kris Kuksi. The extraordinary constructions of Kris Kuksi are alive with seemingly endless detail, yet never become chaotic. The pieces are united by the elimination of color and intricate interweaving of gesture and form. He makes broadly symmetrical frameworks, which then dissolve into smaller and smaller asymmetries. He uses scale beautifully, building outwards and inwards from larger central figures to give an almost fractal-like sense of infinite repetition and complexity. For more by Kuksi, see Myth, p. 72. Image courtesy the artist.

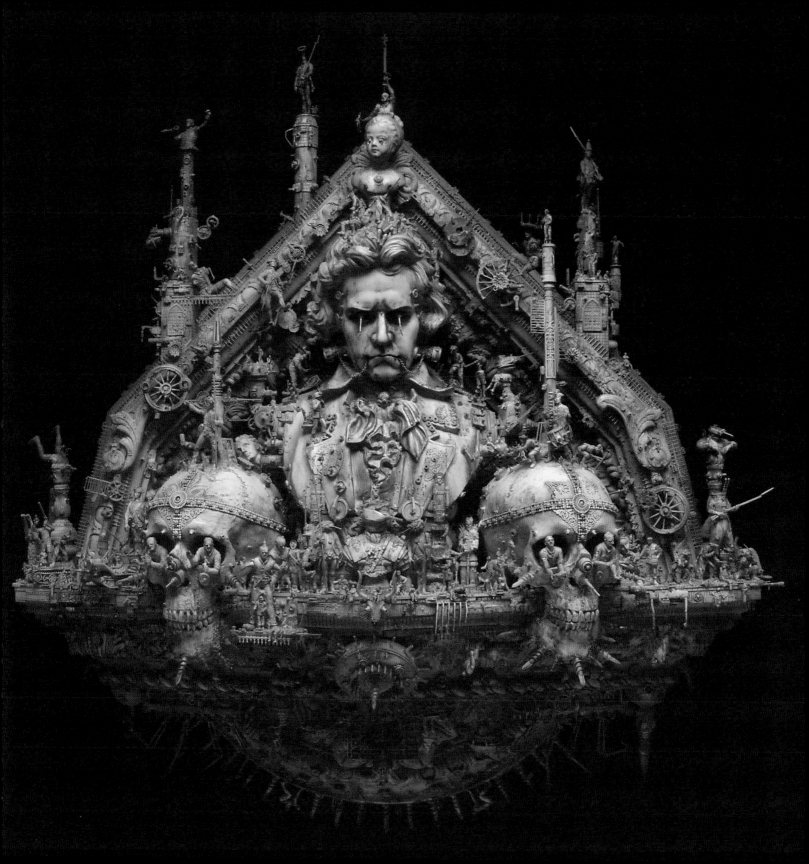

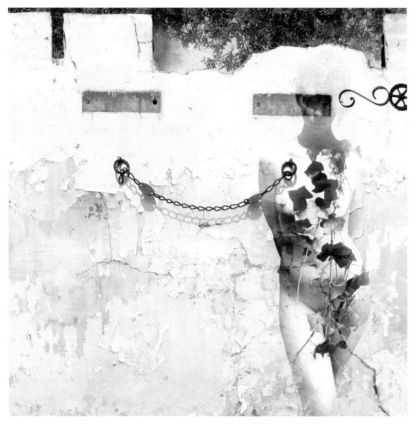

Ivy Wall, 2012.
Allowing plenty of
clear space around
small detail gives it
room to breathe.

pattern or texture together will also give density of information and a delightful confusion of space. Matisse used his local toiles de Jouy to magnificent effect. He juxtaposed riotously colorful and richly patterned bolts of cloth in his interiors and still life paintings, using them to break up space and make the viewer's eye dance rhythmically across the painting's surface.

Try not to overpower the viewer with indiscriminate minutiae across the whole surface. Give the detail some order, as Kris Kuksi does–symmetry, maybe, or a unity of color. Make sure that however much there is in an image, it all needs to be there.

Many images strike a balance between areas of detail and clean space. Kuksi achieves this balance against the background of his constructions; they work beautifully as concentrated and ordered detail against the space in which they sit. Focus on areas of intricacy by contrasting them with calmer passages, and they will be all the stronger for it.

Focal point

The focal point, the place where the eye is immediately drawn on first viewing, will give your image its initial impact, stress its subject, and establish an immediate link with the viewer. It may be inevitable–a portrait's eyes will always be the first place you look–or it may be less obvious. With complex pieces, it will need to be considered carefully to guide the viewer towards an understanding of the narrative. You can engineer it to help tell a story, or to give precedence to the key parts of a composition. It establishes the area of primary interest in your image.

Just as when looking at another person, a lot is learned from this first glance. Too much highly detailed information right across a picture can cause

at it, removed the clutter and finished up with a much more coherent picture.

Complexity need not descend into complication, however. More can be more. There is joy in embracing the bountiful. The viewer will delight in discovering tiny detail in more complex images. Careful control of the relationships between objects, tones and colors will avoid the chaos and confusion of an overstuffed picture.

A picture's complexity does not just lie in the number of elements combined. Moving areas of color,

clutter and confusion unless a focal point arrests the attention. Choose where you want people to look first and keep the main focus there; exploration of the rest of the picture will come once communication has been established. The viewer can be persuaded to look wherever you wish in an image. There are several ways of doing this.

Focus and detail

Keeping part of the image pin sharp, and throwing the rest out of focus, will immediately direct the eye. The clearest, most accessible areas of an image will take precedence over softer or darker passages. The focus doesn't always have to be on the obvious, of course; fashion photography, for example, often makes very effective use of blurring of the subject itself.

Centrality

Placing the area of greatest interest squarely in the middle of a picture will naturally give it pride of place. It may be obvious, but that doesn't reduce the power of such a direct, forthright appeal for attention. Pairing centrality with symmetry will further emphasize the importance of the main subject. The composition doesn't have to become rigid or static; use color or secondary rhythms of line within the image to keep things fluid and interesting.

Implied lines

Linear perspective is often used to help the eye travel through an image. Converging rooftops, for example, or receding lines of trees, will lead the eye off into the distance or to an object placed at the point of convergence. Less directly, the brain will make connections

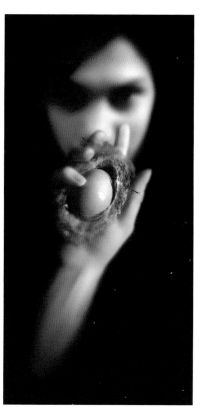

Cuckoo, 2006. A pair with Never Tell (in the Perspective section, p. 141), Cuckoo uses blurring to reduce the impact of the face. A direct stare is so strong it would otherwise have overridden the main narrative element here—the nest with its oversized egg.

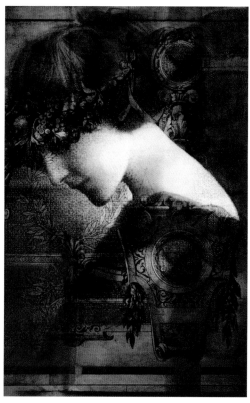

Anastasia, 2009. Here, the primary subject is out of focus. The face remains the focal point, however, by virtue of its brightness against the background.

between lines that are close enough and similar enough in direction to each other to appear contiguous (see Gestalt, p. 128), and will follow those. You can set up other connections that will have the same effect as linear ones. Use similar colors or tone to create a path through a picture.

Contrast

Contrasting or very bright color is instantly eye-catching. Colors opposite each other on a color wheel–red and green, blue and orange, yellow and purple–are complementary, and give the greatest contrast with each other. Striking contrast immediately attracts attention. A highly saturated area, too, will pull the eye away from more muted parts of the image. Contrast of tone works similarly to color contrast–the greater it is, the more it will draw the focus of the image. Contrast naturally reduces with distance (see Perspective, p. 141) resulting in parts of the image becoming softer, calmer and less distinct. Working against these with brighter, more solid areas will bring the latter forward into center stage.

Trajectory, 2012. You can use other, more literal, visual devices too. A pointing finger, arrows and eye-lines are clear directives. Triangles have a dynamic effect, and attention will move along the diagonals towards the apex. This piece employs several of these methods to establish a focal point. The lines of direction here are not only implied by the model's pose, but literal, and the model's gaze carries on the movement towards the hand. Compare this image with Guitarra (p. 122), which has the same pose but with a relaxed hand and a curvier setting.

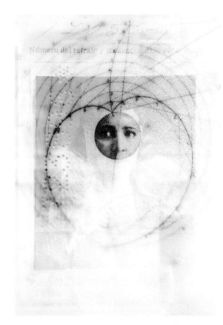

1723896, 2008. The face in this image is given priority by virtue of its greater contrast and darker tone. The central placement of the portrait, potentially static, is enlivened by the addition of dynamic curves and concentric circles.

Achieving perspective

Digital compositions live in a wonderful hinterland of suggestion and possibility. The setting, or environment, along with every other aspect of the picture, may be more or less explicit. Sometimes you may want to create a completely believable space, with logical progression of depth. You may also want to explore the less literal, more allusive, possibilities of the medium. Whatever your intention, all your compositions will benefit from the use of visual effects to persuade the viewer of depth, distance or simply separation between the constituent elements.

A portrait, for example, may be set in a perfectly rational landscape or interior, that could be described with a map or floor plan. You will need to exploit all the available methods of persuasion to convince the viewer of the truth of your invention. Roman artists first employed *trompe l'œil*, or "fooling the eye", to great effect in fresco architectural decoration. Real gardens within villas were surrounded by painted ones, whose apparent recession was achieved by sophisticated and lively use of perspective. There was a revival of these techniques in Renaissance Italy where "doorways", actually simply moldings on a wall, looked out onto infinite landscapes, or portraits in real frames would be surrounded by other, painted ones. These techniques will also give your digital composition the feeling of depth. The use of perspective can create astoundingly realistic impressions of space.

Alternatively, you might be aiming for an atmosphere, the implication of surroundings more or less real, which may tell of the subject's nature or circumstance rather than their physical situation. Here, the implication of depth will establish the relative importance of the parts, and give shape and definition to your picture. While the image may not work in a logical fashion, using elements of setting will establish a mood.

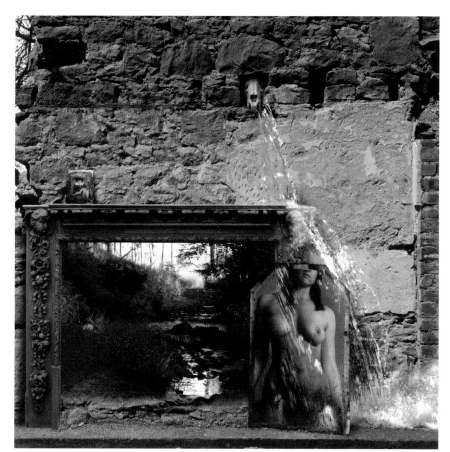

Wall, 2010. This image looks at first glance like a straightforward photograph. The light is consistent throughout the piece, and the detail of the trees at top left convinces the eye that one is indeed looking through the carved surround to a receding landscape. It is only when one realizes that the figure reflected in the mirror is not there that unease sets in. Use of apparent realism can create an unsettling picture that will make the viewer stop and think about what they're seeing.

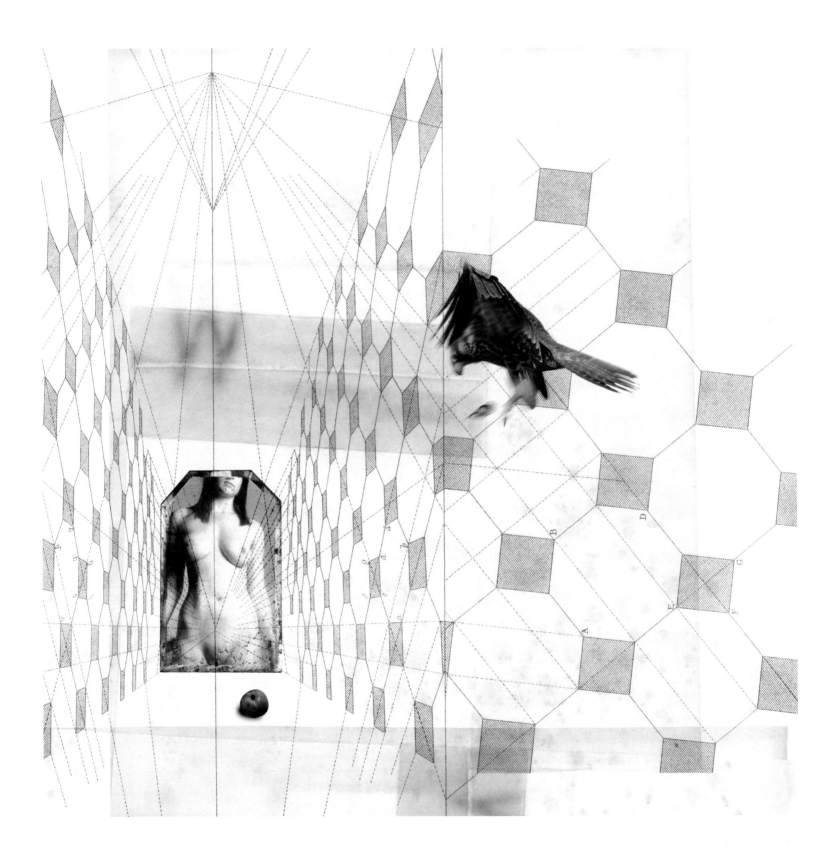

Some images live entirely on the paper plane and are arrangements of form of a wholly abstract nature. Even these will often use effects of perspective to create focus and direct the eye within the piece.

There are three main ways of achieving the illusion of space in your work. Linear perspective is possibly the most obvious—by using line and scale, receding into the apparent distance, you will create a powerful impression of depth. Aerial perspective is less easily defined. Color and tone can be manipulated to expand boundaries even where there is no literal subject to work with. Finally, by varying the focus of your elements, you will create distance between them and concentrate the attention on the most important parts of your composition.

Linear perspective

Paolo Uccello and Piero della Francesca both worked on the perfection of linear perspective in Florence in the fifteenth century. That Renaissance Florence was the setting is no surprise; the city produced magnificent sculptors (no less than Michelangelo and Donatello) and its painters were similarly concerned with weight, solidity and depth. Achieving believable space within a picture was almost an obsession with many of them.

The vanishing point is the simplest expression of their theories. All elements in a space, defined in a linear fashion, will recede to a point in the notional distance along (equally notional!) straight lines. The linear progressions will dictate the reduction of scale of the elements. This is most easily seen, of course, when dealing with structures that have straight edges; buildings demonstrate the principle beautifully. Then there can be more than one vanishing point along a horizon.

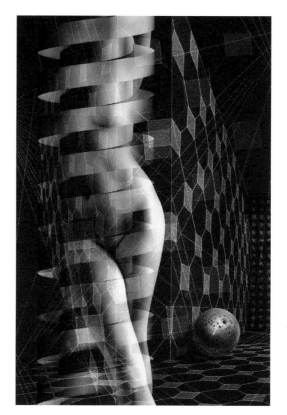

FACING PAGE

Falco peregrinus, 2011. Again, the reflected figure is absent, but this time there is no attempt to fool the viewer into believing in a constructed space. This is an imagined land. The perspective lines here are actual, rather than implied (in the "real" landscape, they are implied, in an "actual" space). They bring movement to the image, and connect the various elements visually while setting up a rhythm of pattern across the surface.

Perspective, 2006. The addition of the ball was the key to making space in this image. Its lighting is consistent with that of the figure, and it casts a shadow against the "wall" beside it, making them both seem solid and positioning them in relation to each other.

By using two or more you can create almost vertiginous impressions of whirling panoramas or dizzying heights and depths.

Tricks of perspective can create an impression of space beyond the possible. M.C. Escher's famous etchings of illusory spaces and architectural impossibilities are perfect examples of how playing with line can convince the viewer that you have more than just two dimensions available. He then subverts the illusion; once he has you seeing three dimensions, he neatly shows that what you "see" cannot exist, and returns you to the two dimensions he's working within. He sets up depth in his work, only to collapse it again.

Aerial perspective

Venice was the colorist city to Florence's sculptural. Here, such masters as Titian and Bellini made soft-edged, nebulous, luxurious and richly colored paintings. Solid flesh, architecture and landscape alike dissolve into color of a richness and subtlety only made possible by the recent invention of oil paints in Germany. Surely the uniquely ethereal nature of the city itself, floating precariously in its lagoon amid shifting reflections and refractions, was the inspiration.

In these colorist paintings, the artists developed the second method of conveying distance in a picture: aerial perspective. As objects get further away from the viewer, they become less saturated in hue, and their color becomes bluer. The shorter red and yellow wavelengths of light are absorbed and the remaining blue wavelengths give distant objects their apparent cool cast. By combining the resulting cool hues with desaturation, you can give pictures convincing depth.

This very simple example, Shepherd, shows the effects of aerial perspective on a landscape. Three main areas—foreground, middle distance and background—are

Shifting the color of the hills from warm ochres to cool blues, along with softening them with a Gaussian blur, sends them off into the distance.

clearly defined. The landscape becomes progressively lighter and bluer as it moves into the distance. Constructed from four photographs–the tree with foreground, the shepherd, sheep and mountainscape–this shows that scenes can be brought together using elements from different sources by paying attention to aerial perspective.

Focus

The mountains in the shepherd image also show the third way of moving things into the distance–softening focus. In landscapes such as this, softness in the distance will be caused by mist, haze or cloud; even on the sunniest day, far-off features will usually seem indistinct. This also applies to smaller, closer subjects. Notice how the depth of field narrows the closer you move towards your subject. This separates the subject from the background, and focuses attention in the places you choose. When dropping the background into an image, it is useful to mimic this effect. Generally, your main point of interest will be in sharpest focus; by blurring less important elements, you will draw attention to the subject.

Naturally, you may want to dislocate your image, and underscore its very unreality... in which case, break all these rules!

Never Tell, 2012. The blurring of the face sends it back into the distance, and keeps attention on the locket in the foreground.

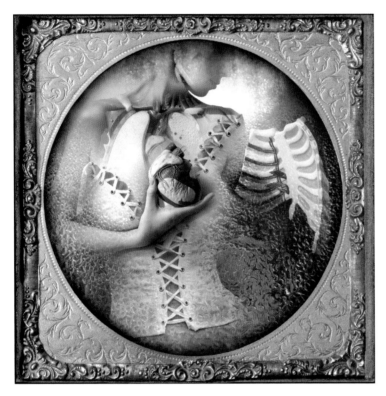

Two Hearts, 2012. Victorian daguerreotypes and ambrotypes were presented in beautiful box frames. The metal or glass plate is encased behind protective glass and a metal slip in a velvet-lined hinged case. While I have never seen a circular aperture, ovals are common. For this piece I altered an oval to a circle in which to fit the ribcage. Placing a shadow under the frame separates it slightly from the image and gives a better illusion of a real frame.

Framing

Frames are not simply decorative means of hanging pictures on walls; they also augment their contents greatly. By incorporating a frame within the work itself, you can suggest depth and unify a composition.

There are so many ways visually to enclose a composition, and contain the movements set up within it. You can be quite literal–by making a border round your image, you will bounce the travel of the eye back into your picture. A frame can establish an implicit foreground against which you can set up distance. Keeping the frame sharp and increasing softening as the perspective recedes will immediately create space. You can also work with the shapes, colors or textures in your frame to set up echoes within the piece. Circular or arched frames are beautiful things; finding visual links with them inside the image will set up swirling, energizing movements.

The shadow in Two Hearts, left, demonstrates another way of framing a picture–vignetting. Diana and Holga film cameras make nicely vignetted 120 format negatives, complete with accidental light leaks and focus anomalies, and filters are available to replicate these effects. You will, however, have better control over the vignette if you make it yourself, using either a Multiply layer or an Adjustment Layer. Applying different opacities and blurs will ensure you achieve exactly the results you want.

Rough edges are a natural result of some chemical printing techniques, like cyanotype and liquid emulsion. There's a hand-made feel to borders like this. They can easily be added using various filters but it is much better to scan real paint edges and use those. You'll get a different result every time, and can fit its scale to the piece on which you're working. Polaroid printing is another chemical photography process that

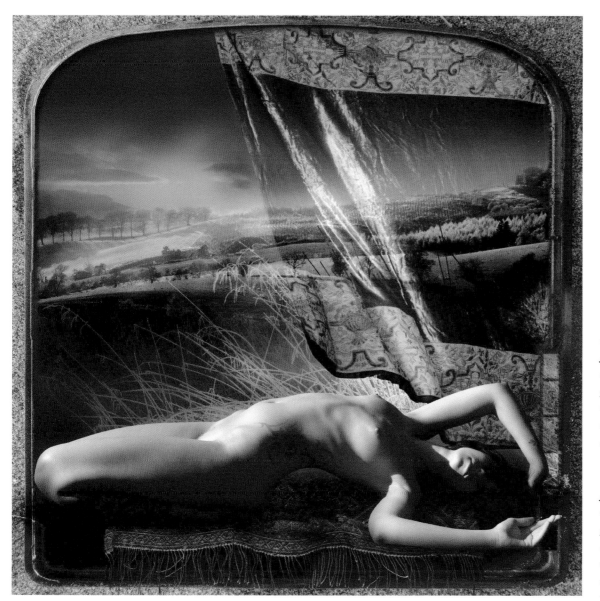

Danaë, 2010. Here, the figure's framing is illogical and unrealistic. A small pressed tin plate frames a view and contains the nude along with a translucent curtain that apparently, yet impossibly, hangs from it. The carpet under the girl floats above the grass, giving an otherworldly air to the piece. The frame here sends the landscape far into the distance, and echoes the soft arch of the body.

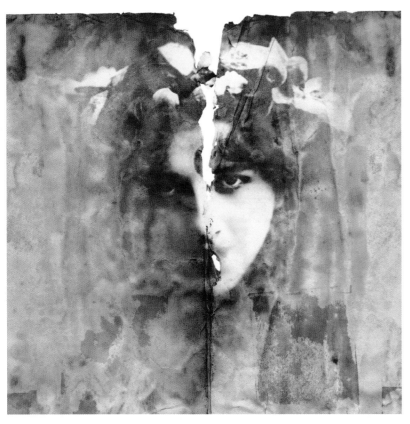

Shroud, 1998. The top border is an intrinsic part of this image, as it comprises the ragged edge of the folded sheet of paper in the background.

leaves very distinctive patterns on the edges of prints. Importing them will give your image a painterly feel. Be careful not to overdo it, however. I've seen whole books printed with elaborately textured edges to every print, and it rapidly becomes tiresome. As a rule of thumb, better only to use effects like this when they're integral to the image and not just decoration added on afterwards.

Interiors will enclose your image in another way. Walls limit the eye's travel, and the whole feeling of the setting is necessarily constrained, bound by the dimensions of the room—whether real or not. You may also make use of doors and windows to make a frame within a frame, and look out of the space into another.

I'm a great advocate of allowing the unconscious mind free rein when image-making. Theories are fascinating, and well worth studying; they'll give you a solid foundation on which to build your fantasies. When you're actually making a picture, however, overanalysis and careful planning can be counterproductive. A picture that is finished in your mind before you start can become a stale thing, lacking in vitality. Too much control can squeeze out the happy accident, that marvelous moment of serendipity when something happens to surprise you, to make you explore further, to excite your eye and mind. So, try applying these suggestions and, if they don't work, throw them out and do something new.

FACING PAGE
Frames, 2012. Try photographing actual picture frames. You don't have to use them around the edge, of course.

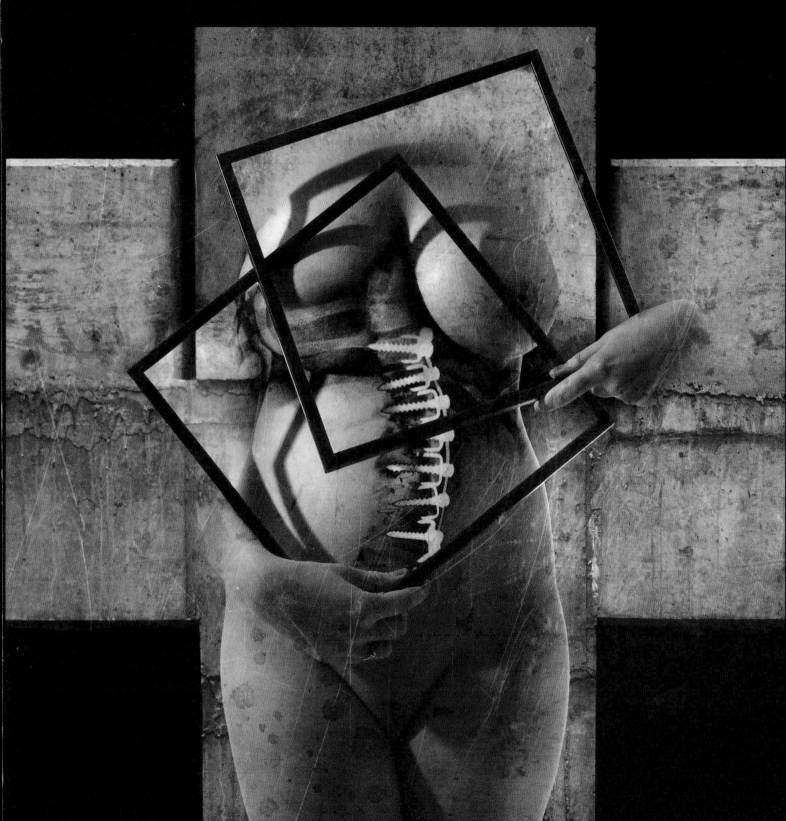

COLOR

Color is an integral part of your composition. An essential aspect of the way we perceive the world, it is everywhere yet remains essentially indefinable. How do you explain a color, other than by reference to or comparison with another? You can experience it, and imagine it, even dream it, but to someone who has never seen it, it is unknowable. Color is uniquely visual, and the essence of so much art. You can use it to stir feelings, to conjure space, to beautify and unite your work. Even removing it has equally strong significance.

This section will not discuss color theory, which is a huge and complex subject in itself. Just as with composition, it is simply a practical guide. It will give you somewhere to start when using color as part of the creative process. Take off on your own study of the enormous emotional and expressive potential of color.

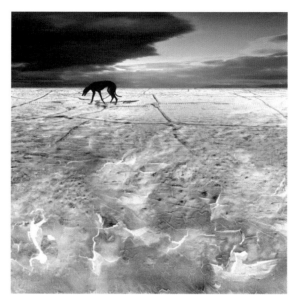

Outside, 1999. The blues used here denote distance and chill, giving a feeling of isolation.

Color and space

Use color to create space, and give your picture distance. Bright, warm colors will attract attention, while cool hues recede into the distance.

Color temperatures are universally understood. That blue, green and violet are cool colors, and red, yellow and orange warm is undisputed, no matter who you ask. Unlike many of the moods associated with hues, thermal associations are so deeply rooted in our collective psyche because they are integral to the natural world around us. The connection of red and orange with fire, yellow with the sun, blue with water is ancient. We are so convinced that blue light is cold, reflected off snow and ice, that in a room where the ambient light is changed to blue we'll turn up the heating, even when the temperature remains the same. Our physical responses to color are closely linked with the emotional ones, and are common to everyone. Cultural

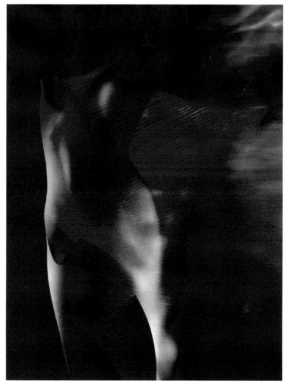

Miyake, 2005. Hot reds turn the fabric into flames.

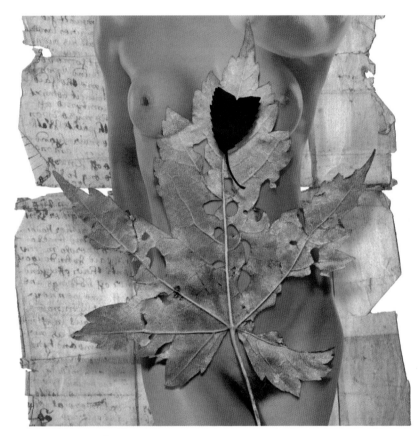

Heart, 1998. Red can leap off the page. I kept the heart-shaped leaf small, and a cool, dark red so it stays on the same plane as the leaf below it.

contrast it has. All these effects will make parts of your picture recede. To bring an object closer, use colors at their full punch, warm their hues and turn up the contrast. Reds are the most "advancing" colors. Jumping out at the viewer, they will need careful use if you want to keep the image unified.

Each of the colors shades off into the next in the spectrum, of course, and as they do, the perceived temperature changes. As yellow becomes blue, via green, its temperature drops. The addition of blue to any color will lower its visual warmth, so it is possible to find cool reds, those with a violet or magenta tint. Similarly, the warmer blues tend to be those with a percentage of yellow–cobalt, for example. Blue elements can be brought forward in an image by using a warm color cast, and red ones sent further back with a cool one.

Do remember to keep it simple. Strong or subtle, an image can become muddled and busy if it is crowded with indiscriminate color. Many painters first learn to harmonize their palette by restricting themselves to just three or four tubes of paint. A small selection of earth colors–for example, a yellow ochre, light red and Prussian blue–ensures that any combination of these will work together. More colors are added as you become more adept at seeing and working with them. In digital manipulation, color is controlled in less direct ways, and all the colors are always available and variable. If an element is not fitting in with its surroundings, changing its hue may well help. Photoshop allows us to add or change color in many different ways, quickly and accurately. The effects can be seen non-destructively as you move the sliders in the palettes, allowing experimentation impossible in paint.

These are just a few of the many ways to do this. Firstly, you can change the overall hue of a selection by using the Hue/Saturation palette (**Image** > **Adjust** > **Hue/Saturation** or Command-U). Here, you can

influences don't affect our perception of red as a warm color, and there is no mythological or historical reason why blue should be cool; the connections are pre-cultural, prehistoric.

A color's temperature will suggest its distance. Aerial perspective describes the effect of distance on color's hue, saturation and contrast. It gives those soft, cool blues and grays on horizons, colors inextricably linked with distance in our minds. The further away from the eye an object is, the cooler and the less saturated–or concentrated–its colors appear, and the less

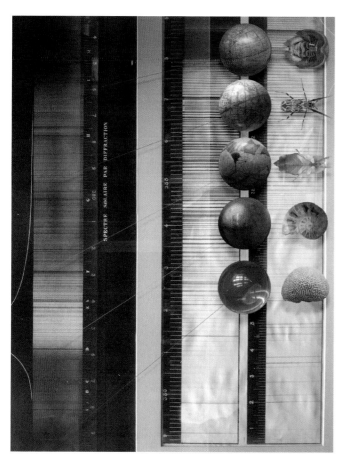

Colour, 2002. Use as many colors as you like within an image, but pay attention to their proportions. Here, all the colors of the rainbow are offset by large areas of neutrals.

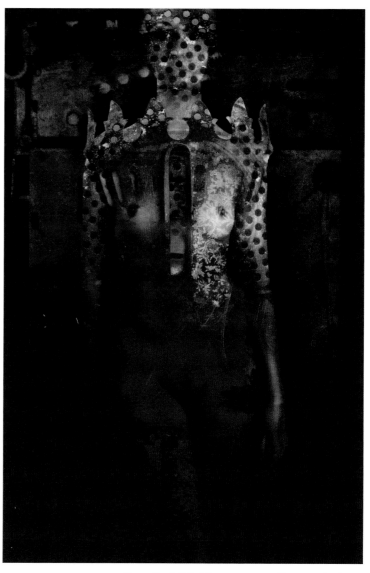

Butterfly, 2012. The proportion of hot to cool colors is important, as shown in this image. The cold blue and green is all the more vibrant for being concentrated in a very small area.

Extinction Event, 2004. This image was constructed using Exclusion layer modes to achieve a balance of complementary colors. By starting off with a warm copper background and overlaying monochrome images in Exclusion mode, the blues and grays were sure to be a good balance with the hotter areas. Experiment with Difference mode too, for a more dramatic effect.

move the color (hue) through the whole spectrum or, by using the drop-down menu beside Edit, change just the reds, blues, greens and so on. You can also adjust the saturation—the percentage of pure color—to make the color more or less strong.

For more precise changes, try the Color Balance palette (**Image** > **Adjust** > **Color Balance**, or Command-B). Here, you can remove a color cast from, say, the highlights without affecting the midtones or shadows.

Replace Color (**Image** > **Adjust** > **Replace Color**) is a useful way of altering one particular color without affecting the others. If you want a gray to be bluer, but don't want a blue cast across the rest of the spectrum, use the eyedropper to select the gray (the fuzziness slider controls the tolerance of the selection) and then change the hue of just that color.

Adding a new layer, assigning it Color mode, and then painting into it will give you color changes that haven't permanently affected the underlying layers. Paint as many new colors as you like into this color mode layer, which can then be masked, or reduced in opacity, for fine-tuning. Try changing the mode to Hue for subtle variations.

Adjustment Layers are very helpful in controlling aerial perspective. They can alter contrast, lightness, saturation and many other variables across an entire piece without either permanently affecting the layers below them, or needing work on each of those layers. They don't increase file size, and can be subtly controlled both at the creation stage and later, by painting in a layer mask. Find them under **Layer** > **New Adjustment Layer**; you have many choices, the most useful for color control being Color Balance, Hue/Saturation and Selective Color. You can apply layer modes to these just the same as to any other layer, giving you even more variables to play with.

Finally, remember how layer modes themselves can change the colors of the layer. Experiment with Difference and Exclusion modes for dramatic effects. Luminosity mode is very useful for unifying a layer with those beneath by effectively removing the color contrast with its surroundings, reducing its distance from them.

Color and mood

The colors you choose will profoundly affect how people react to your pictures. You can persuade your audience to feel excitement or calm, happiness or sadness, even peace in response to them. Choose your colors carefully, and they will increase the emotional depth of your imagery. There's no more powerful way of getting your message across than color control.

Everyone who uses color is using its emotional power. Every painter, graphic designer, fashionista, decorator, gardener and advertiser controls color to communicate with us on a very deep level. Color changes mood. We are all susceptible to its effects, consciously or otherwise—fast-food restaurants paint their walls red to keep us moving, while dentists paint theirs green to calm us down. They are exploiting certain universal responses to color—physical, measurable responses, such as changes in heart-rate or adrenalin output—that can be exploited by the digital artist too.

These deep responses must at least in part be explained by the colors of nature. The blue haze of a far horizon encourages an association with space, heaven, the infinite; a red berry can be temptingly ripe or dangerously poisonous. But color's influence is not straightforward. Color associations are not the same for everyone. What may be a bright, strong, happy color for one may be loud and oppressive for another. While the basic effects that it has on the psyche may be

Love Birds by Fiona Watson, 2012. This joyous riot of color is no random cacophony, but a carefully orchestrated visual poem. Linked throughout by the unexpected rich reds—the opposite of nature's usual background—the birds' relatively small areas of contrasting colors makes them sing out, vibrant and vivid. Image courtesy the artist.

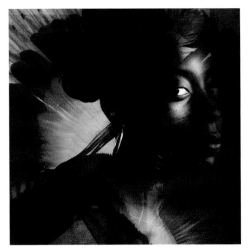

The Diviner, 2006.

Habitat, 2009.

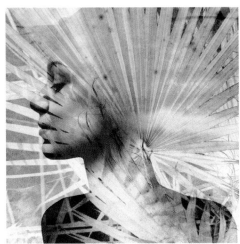

Asha I, 2005.

well-documented, there is still an essentially individual response, based on preference, experience and culture, which ensures that we are not so simply manipulated. Our individuality, along with the context in which the color is placed, ensures color's tremendous subtlety of effect. The possibilities are infinite. Here are some of the associations–positive and negative–you might use when conveying your message.

Red inspires excitement, is full of vitality, heat. It quickens the pulse and sets the heart racing. The Indian color of marriage and the Chinese color of luck, red is celebratory, romantic, passionate. Blood red, fire engine red, Ferrari red–red is dangerous too. In nature, it alerts to the poisonous or the foul-tasting as well as the ripe. Attention-grabbing, rich, glowing and decadent, it can be aggressive, even oppressive.

Orange tends to be thought of as an extension of yellow. It shares its bright cheerfulness and warming glow. Positive and uplifting, orange tints the saffron

robes of Buddhist monks. In Britain, its associations aren't as deeply embedded as those of the primaries, possibly because the word itself didn't actually appear in the English language until the fruit was imported into Britain in the fourteenth century, and only became a color description later. Until then, orange was simply, in Old English, *geoluhread*, or "red-brown".

Yellow: joyful, bright and summery, the color of sunshine has few negative associations. It brings to mind warmth, happiness, spring flowers and new leaves, youth and light. It is the color of intellect to blue's spirit and red's flesh. For the artist, it can be difficult to work with. It is the only color that is most saturated when at its lightest. Darkening it changes it to orange and then brown. Tonal differences, and so shape, can therefore be hard to define.

A highly ambivalent color, green is associated with the natural cycle of life and death. Both the Green Man and the Ancient Egyptian god Osiris encapsulate the

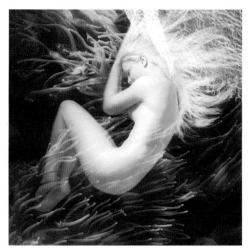

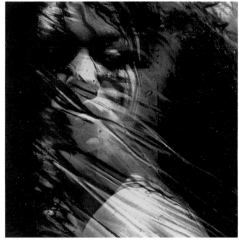

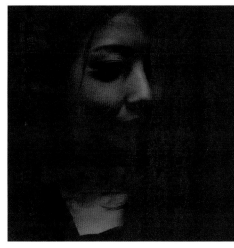

Deeper, 2009.

K, 2010.

Testimony, 2012.

color's dichotomy: green-faced, they are gods of vegetation–life itself–and also of death. Green is the color of nature, a fresh, springtime color of clear certainty and restfulness. It is also the color of putrefaction and poison, envy and jealousy.

The color of summer skies, the deep blue sea, heaven itself, blue instills feelings of well-being, calm and the infinite. Blue is contemplative, the color of silence. It is a lifting, ascending, receding color that can create space and distance in your pictures. The negative associations–cold, melancholy and loneliness–are extremes of the positive ones of cool, contemplation and solitude. Blue is the color of peace.

A combination of physical, masculine red, and spiritual, feminine blue, purple has been called "psychologically oscillating". It can ooze sophistication, sumptuousness and confidence, an Imperial color of Byzantine richness, or it can seem decadent, ostentatious and even crude. Psychologists associate purple with internalization, suggesting depth of emotion; it can be spiritual or, in excess, depressive.

Combining color

Using color is a fascinating business. As soon as one color is juxtaposed with another the values and impact of both are altered. Experimenting is absolutely the best way to investigate this. Play with combinations of colors of similar saturation, or strength, and widely differing hue. Try building a picture with a lot of differently colored elements on separate layers. Turn them all off, then add them one by one–watch how each new color affects the whole. Then change the colors in each layer using Color Balance or Hue/Saturation to see how altering a hue changes the overall effect. Highly saturated color demands careful attention. As Fiona Watson demonstrates in Love Birds, discord is prevented by balance of their proportions, turning potential conflict

into exciting brilliance. Lower saturations are elegant and contemplative, and are nicely heightened by one or two spots of a brighter hue (see The Moth's Ball, left).

Using similar colors at varying saturation across an image will create focus–the greater the color's strength, the more the eye will be drawn towards it. You can build movement across a picture, even narrative, by manipulating the concentrations of richer color. In your experimental color montage, drop a Hue/Saturation Adjustment Layer over the top at -100 saturation; paint into its layer mask to reduce its effect. As the color returns to areas of your image, watch how the balance and focal point changes.

Further, any bright color will give a neutral gray beside it the appearance of its opposite hue; color can even create color when it is not there. Complementary colors and their potential balances and dissonances are the subject of the next chapter.

Color gamuts

Digital images are created and worked into in RGB (red, green, and blue) mode. Your screen uses just these three colors of light combined to create all the colors

you see. Monitors and screens use RGB mode, so publishing to the internet will need no conversion. Inkjet printers also work with RGB files. It is only when publishing images in books, magazines and other print that your image's mode will become an issue. Printers make separations from images in CMYK (cyan, magenta, yellow and black) mode, which has a slightly different color range, or gamut, from RGB. It is a larger gamut, and good for spot colors, as defined by the Pantone system. Digital collages, however, are always imported (cameras and scanners all work in RGB) and usually worked on (many layer modes behave differently in CMYK) in RGB. They will need converting to CMYK to output to printers' separations, and when you do this, colors out of gamut for CMYK will change. When converting, the program does a good job of interpreting the nearest color available, but pictures can go muddy, and deep reds can look brown. Light and bright greens and blues recede and become grayer. If you plan to publish your image, don't just keep working and worry about it later–good alternatives are easier when you have layer modes at your disposal.

The colors in this wheel, left, represent the available RGB colors; the grayed-out areas in the screengrab, right, show which of these are out of gamut when converted to CMYK. These are, fortunately, pure, saturated colors, which will rarely appear in your montage. To see the RGB colors' true values, look for a color wheel online. It will be in RGB mode, unlike this illustration, which has necessarily been converted to CMYK for print.

FACING PAGE
The Moth's Ball by Fiona Watson, 2012. Compare this seductive piece with Love Birds (p. 155). They share the symmetry, the movement of the creatures, the vignetting to enclose the dynamic. Here, however, the colors are cool, delicate and calm–the quiet is subtly enlivened by tiny accents of hot red and viridian. The heat of the day has passed into the cool of night. Image courtesy the artist.

The grayed-out areas of this image are out of CMYK gamut. As the file used to print this was converted to CMYK, of course, these areas cannot be shown in their original RGB colors.

When you're using the Color Picker, you'll get an exclamation point beside the color if it's out of CMYK gamut, and below it in a tiny box the nearest viable alternative.

There's a very useful gamut warning facility in Photoshop, Command-Option-Y, which will gray out anything that CMYK conversion will alter. It's the blood-reds and paler greens and blues that can be the biggest nuisance, but all of the more saturated colors are vulnerable. If you're having trouble achieving your desired color range, try converting the whole document to CMYK mode (without flattening it, of course) to experiment. Layer modes will work differently but you may well find a solution to your problem by adding Hue/Saturation and Brightness/Contrast Adjustment Layers.

Color contrast

The most arresting color combinations are often of complementaries. These color pairs sit opposite each other on a classic color wheel; if you invert one, you will have the other. Complementary pairs consist of one primary color and the combination of the other two primaries, a secondary color. The color pairs are:

- The primary red and the combination of the other two primaries, green
- The primary yellow and the combination of the other two primaries, purple
- The primary blue and the combination of the other two primaries, orange

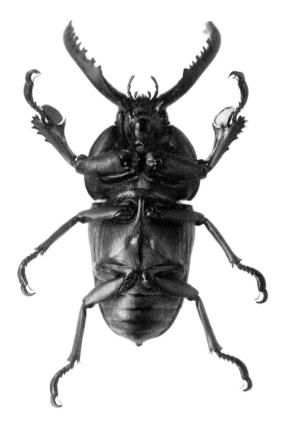

Look to nature for superb examples of color contrast, such as this exquisite beetle. The shimmering viridian of its legs shades into a deep red on its forelegs, while the purple abdomen has yellow hairs. The complementary primaries appear in tiny amounts, which subtly accent and enliven the overall color scheme.

Combining two complementary colors of paint produces black. In the RGB color space, combining a color and its complement produces white. The RGB pairs are, interestingly, also different–red pairs with cyan, green with magenta, and blue with yellow. This doesn't change the basic discussion, however, about the effects of colors and their complements, and finding

combinations that will produce the most effective contrasts and the brightest, most exciting imagery.

When two complementary colors are used together, they will both appear brighter and more saturated. A red ladybird perched on a green leaf looks all the redder, and more poisonous to predators, by contrast. Red warning road signs also benefit from

the color's clarity against a predominantly green land-scape to make themselves noticed. Using color like this requires a degree of care, as vibrancy can easily turn into jarring discordance. To help the colors work together, be aware of their proportions and their relative temperatures and saturation.

You will vary the effects of complementary colors radically by adjusting the proportions of each hue. A very small splash of an opposing hue will sing out of an image and bring the focus to it. A more even spread of color, as in Crewe Hall (right), mutes the effect a little. It allows even the most vibrant contrasts to settle into working together in harmony. Another unifying factor here is that the color temperatures are similar. Both hues are at the cooler, bluer end of their range, which prevents the contrast from being too strident. Finally, they are not highly saturated. Wide ranges, indeed whole spectra, of colors can live happily together if they are all of the same intensity, high or low. High saturation across an image, as seen in Rosamond Purcell's beautiful picture of dice, works perfectly to bounce the colors off each other and create a vivid synthesis. Any one of these hues at a lower strength would have become gray and muddy.

Crewe Hall, 2008. I used a classic combination of red and its complement, green, here. By creating a spiral of red moving up the image, color alone has created a shape and movement within the composition.

FACING PAGE

Dice and Deity, 2007, by Rosamond Purcell, from Dice: Deception, Fate and Rotten Luck, *by Ricky Jay and Rosamond Purcell, The Quantuck Lane Press 2003. These exquisitely juicy colors make a set of decaying celluloid dice look positively edible. Image courtesy the artist.*

Augenblick, 2005. You can also contrast a color with desaturated or monochrome areas. While not strictly a color contrast, it is another way of using color to create a focal point. Using a small amount of a color against neutrals will make it appear more vibrant, and draw the eye. Notice that neutrals will seem to take on a subtle hue of the color's opposite. This optical illusion has caused the grays near the splash of red here to appear greenish.

The absence of color— monochrome, sepia and color tints

Monochrome imagery has always had a classic feel. Well before the invention of photography, painters often made monochrome studies, either as an end in themselves or better to see the composition they were building; distractions of color removed, the structure of a piece is easier to see. In Japanese *suibokuga*, or ink paintings, the subject is reduced to its essence to capture its soul; these are figurative abstracts, one step removed from reality by relying entirely on shades of gray for expression. Grisailles, paintings constructed wholly in tones of gray or brown, use the ability of monochrome to imitate sculpture in *trompe l'oeil* decorative schemes. As the influence of photography spread, monochrome became forever associated with the formal studio portrait, and its feeling of gravitas continues to the present day.

Highly saturated colors are exciting, creating tension and strong reactions, but if overdone a picture can become gratingly aggressive. You can restore calmness, weight and even sincerity to an image by desaturating it. The addition of a color tone can then enhance a mood and unify the image. Any color can be used to advantage, and will give your image a different feel. Sepia toning does of course also have antique connotations, reminding one of old family photographs and Victorian landscapes, and is a traditional preference.

I have a particular fondness for monochrome. I trained in sculpture (a very long time ago) and have always found relative tonal values vital to the work. There has been the enormous influence of monochrome photography too. The less color, the more the

bones of the composition show. I love color photographs of monochromatic subjects. They have both textural complexity and a subtlety of color that you do not immediately notice. Removing color from your image to a greater or lesser degree will place the emphasis on other aspects of the picture; texture and tone will become central. Lowering the saturation can give it mystery, sophistication and elegance. If the color is not important to the image, it's always worth trying a monochrome version. I very often drop a desaturate layer over a picture just to see what it looks like, and it's surprising how often I leave it there.

Rather than simply desaturating the color layer or layers, which will remove all color information permanently and reduce your options, create a Hue/Saturation Adjustment Layer and apply -100 Saturation. You will then have the option of bringing back the color later if you want to. It also allows you to alter the opacity of this adjustment layer, to create subdued and subtle effects. Try moving the adjustment layer up and down the layer stack, too–it can be very interesting to have some layers monochrome for the rest to work against. You may need to increase the contrast a little when removing hue; I usually add a Brightness/Contrast Adjustment Layer at the same time.

To add a sepia or other tone, make another Adjustment Layer, Color Balance. With this you can add any cast you like to the image. Most helpfully, the program shows you the effect before you apply it, so you can achieve exactly the hue you want. This can help to draw an image together–if various parts are not coalescing happily, it may be that the color balance is wrong. Removing the offending hues will help bring back harmony to an image. It will also take the picture another remove from reality, making it immediately more allusive.

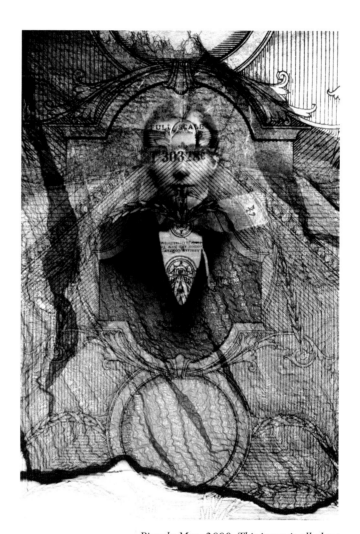

Pianola Man, 2008. This image is all about pattern and texture, and the removal of color concentrates the attention upon them. The Edwardian portrait, with its formal clothing and serious demeanor, links back to the earliest photographic portraits.

The color here isn't doing anything interesting for the image. The green hues are actually distracting from the shapes of the flowers by giving the leaves too much prominence. I added a Hue/Saturation layer and moved the Saturation slider to -100, removing the color altogether; then I added a Color Balance layer, and gave it values of +28 Red, -36 Yellow in the midtone range. The opacity of this layer was then reduced until I liked the resulting sepia tone. Finally, a Brightness/Contrast layer of Contrast +15 brought up the flowers.

Making an image monochrome may even change its subject. In this color shot, top, the contrast of the bright gorse bushes with the rusty corrugated iron takes precedence in the image. With the hue removed, the rhythms and textures of the garage doors become central.

FACING PAGE
Tribu, 2012. The full color version of this picture wasn't working; the colors were jangling and leaving the feather headdress, in particular, looking disjointed. I desaturated completely with a Hue/Saturation Adjustment Layer and added a sepia tone, but this was now too dull. By creating a group from these two layers, and reducing its opacity a little, a hint of the original color was regained. Finally, adding a layer mask to the group allowed me to paint back in the fish scale colors on the chest and neck. The result is a lot more unified.

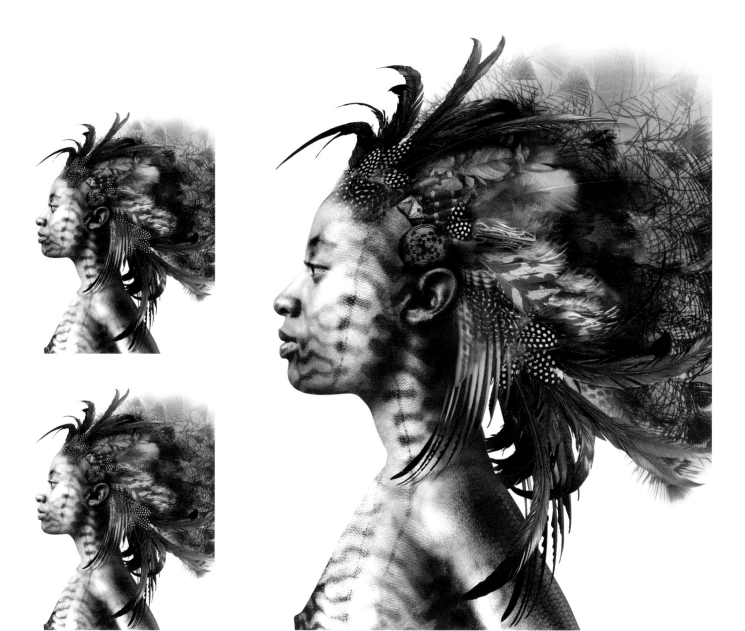

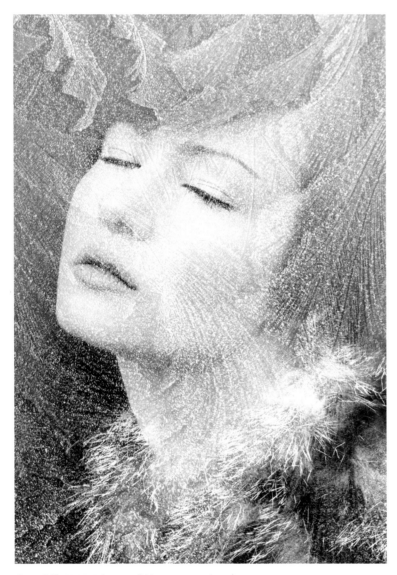

*Snowfall, 2005. The muted blue-grays in this piece are
recessive, allowing the soft pinks and reds to come forward.*

As we have seen, lower saturation of colors also
creates distance in an image. The softer, quieter colors
of a far landscape have linked desaturation with space
in our minds. Use this effect of aerial perspective to
send elements further back in your composition. Bluer,
cooler hues will recede more than warm ones, so use
them to give a picture depth. There are other tricks that
will enhance the effect–try soft blurring, a lighter over-
all tone and slightly lower contrast (see Composition:
Perspective, p. 141).

Texture

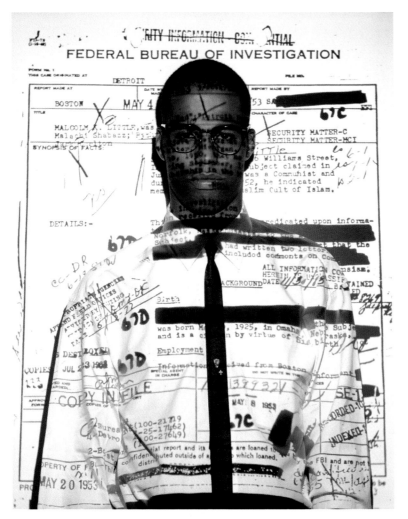

Malcolm X Fashion Story, New York City, 1992, by Albert Watson.
The FBI documents projected onto the model lend both graphic
interest and a narrative. Malcolm X was under surveillance, and
placing these genuine documents directly over the model with his
direct and challenging gaze gives a powerful feeling of oppression.
This was no ordinary fashion shoot. Image courtesy the artist.

Finding textures

Texture brings immediacy, a direct physical connection, to an image. When it is made entirely within a program, digital art can sometimes look too clean, artificial and lacking in character. It needs real texture to breathe life into it. I like oldness in such a new medium; it gives an image "soul". Pictures that are too surgically crisp and flawless can lose their bite, for me. I love "messy", damaged-looking, textured images with clues as to their making, their evolution or their history. There is a reality and a truth in using worn, genuine objects that have been loved and have decayed, which carry the marks of a past and tell a story; they bring life with them. They give veracity to computer art that can otherwise be too distant from real experience. The presence of the old within the new technology links the images to the past and to humanity.

Layering photographs is the best way of getting texture into your work. Anything you notice–old walls, skips, posters peeling off hoardings, tree-trunks, wind-blown sand, textiles, rust–all will add grit and grain. By importing textures and using layer modes, the picture will develop depth, both visually and of meaning.

Text creates beautifully intricate textures, and has the bonus of meaning, whether decipherable or not. I delight in handwriting in all languages. Grandmothers, pen friends or simply online auctions will turn up old letters and postcards, book inscriptions, and other family ephemera that will add real history to a picture. Type-set pieces are also beautiful, especially older examples printed on rag papers. I've found some very special old Cyrillic and Hebrew books whose deeply imprinted text leaves braille-like bump maps on the versos of pages. The text and numerals on old banknotes come along with exquisite engraving and delicate color. The older and more destroyed the notes are, the better they look–as

Old, damaged banknotes are fair game for collage work. I use a scalpel to cut them accurately along engraved lines, or tear them for softer edges. The resulting assemblages, when photographed, are good bases for building upon, incorporating worn, creased paper textures and delicate traceries of line to a piece.

Red and Blue, 2009. This is not actually a simple still life photograph, as the beetles were added later for their colors. The banknotes were indeed cut up, however.

they are printed on cotton paper, they can take a lot of mistreatment before being replaced, and as a bonus the wrecked ones are much cheaper than pristine examples.

For a much more modern feel, graffiti often has a beautiful spontaneity and speed of line, and gives images an urban kick. The less legible, the better–I like the writing to register as form rather than to be read. Graffiti looks particularly good in black and white: separate tags are less distinguishable and overlapping words merge into a riot of swirling gestures. You might also try using the Type tool to create typography within Photoshop or Illustrator. This will necessarily give much crisper and cleaner letterforms, but they can be broken down and integrated with your image by raster-izing and blurring, or applying layer modes or styles.

Engravings can be found everywhere, and have a distinctive texture that adds a great deal to an image. Imagery in old books is usually in the public domain

and so can happily be used in your work. (Note that copyright law varies considerably around the world; please see Permissions and copyright issues, pp. 211–2.) The banknotes' engraving tends to be of pattern and especially borders, while other sources will have landscape, portraiture or more–all grist to your mill. The facture–texture created by their making–of the engravings has a similar effect to including your own drawing or painting in your work. It is evidence of the hand and a direct reference to the image-making process.

Reflections and refractions

Water is the consummate photographic prop. Condensation or rain spatter, the sheet or spray of a waterfall, the still surface of a lake or a turbulent sea–all will give completely different results. Add water's refractive and reflective possibilities and its versatility is endless.

Mirrors are also wonderful to work with, both when taking shots and also, photographed for their innate texture, when making montages. Old, foxed, silver-backed mirrors are the best. They decay and oxidize beautifully, letting some areas reflect and some transmit light, and blooming with their own subtle spectra of color. Beveled edges add further interesting distortions, and help to frame your composition (see

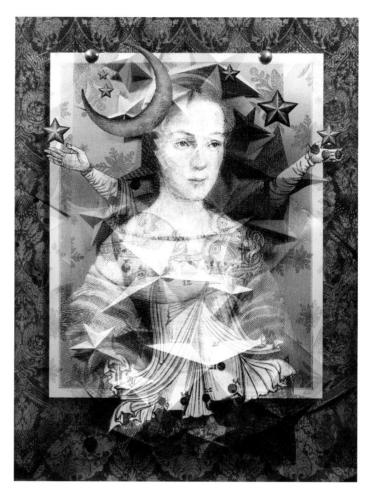

Andromeda, 2004. A junk shop find of a beautiful book entitled Sciences et Lettres au Moyen Age et a l'Epoque de la Renaissance, *published in Paris in 1877, is a treasure trove of steel engravings. From maps to portraits, medieval lettering to astronomical diagrams, its illustrations have inspired and contributed to several pieces. Here, a portrait of Claude de France and a figure of the Andromeda constellation have been combined with the book's endpapers.*

FACING PAGE
Columba livia, 2011. This image is full color, but I have brought the saturation right down. The graffiti, which was brightly colored (and on three different walls), now sits within the composition and reads as pure shape.

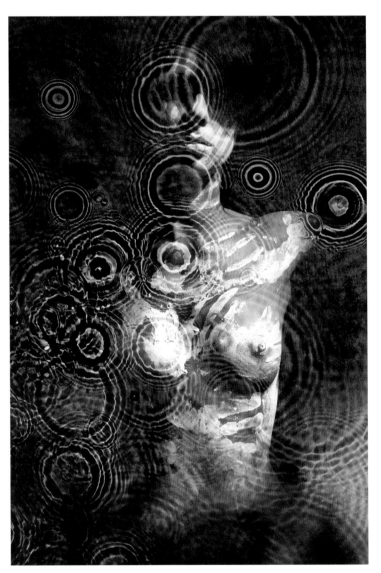

The Telepath, 2005. I found this aged, dappled mirror on a shopfront in Paris. The unfocused reflections of the street add another layer of texture over its mottled silver. The soft cool tones work well with the warmer oxidized metal plate underneath.

Underwater, 2010. A shallow fountain in a sun-drenched courtyard in Córdoba had a perfectly clean white surface under the water, against which the shadows of ripples moved. The space between the water's surface and the echoing shadows implies enough depth for a figure.

Mirror, p. 203, and Two Mirrors, p. 85). Take photographs of things reflected in them for immediate texture and atmosphere, or photograph the mirrors themselves and add their texture to your work later.

So many things are reflective, and will give depth and layers to your image. I always tried to avoid reflections in plate glass windows until I saw the work of Eugène Atget, which maximizes their potential. Street perspectives, superimposed upon rows of mannequins or hardware, place his shop fronts firmly in Paris and give them context; they add information without adding confusion, and the aerial perspective creates depth. Sometimes, delightfully, you will also find his tripod, and even the photographer himself.

Look for reflective surfaces—metal, glass, an animal's eye: anything smooth enough to deliver a readable reflection—and see how they can distort and reinvent your subject. For her book *Landscapes of the Passing Strange: Reflections from Shakespeare*, Rosamond Purcell made a series of delicately ethereal, scintillating images of reflections in old mercury-glass jars. She finds finespun traceries, nacreous color reminiscent of ancient Roman glass, shimmering metamorphoses of form. These are landscapes of the mind.

Pattern

Pattern is almost macro texture, or an ordered, rhythmic version of it. Pattern sets up movement across your image and reads as arrangements of form rather than object. Cemetery, overleaf, has a regular grid as a basis of its composition, with a central axis of symmetry. Each grave marker or space is different, so the pattern is disrupted, but the underlying structure gives the image stability. (The translucent figure, balanced on one foot and looking away, subverts that stability.)

Awake your Faith, 2011, by Rosamond Purcell, from Landscapes of the Passing Strange*, W.W. Norton & Co., 2010. Suggestive of butterfly wings and quicksilver fish, the sculpture is transformed into the slippery evanescence of pure light. Image courtesy the artist.*

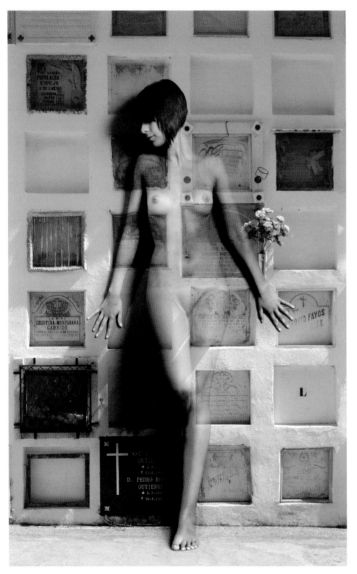

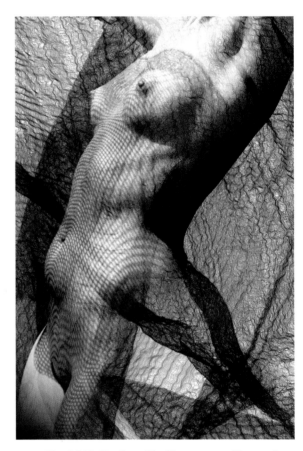

*Net, 2010. Textiles will add pattern too. You can drape
your model while shooting, or later. For this piece, the
model held a piece of netting up between herself and
the sun, creating patterns of shadow that emphasize the
curves of her body. The muslin was added digitally.*

*Cemetery, 2010. This image works, I think, because the figure is not simply
placed over the background—the square grave markers are gently distorted
by her presence. The repetition of squares has a similar effect on the picture
as the symmetry, imparting a rhythm and adding visual coherence.*

Microscope to telescope— playing with scale

From scanning electron microscope (SEM) imagery to Landsat images and beyond, natural textures obey the laws of physics and so display remarkably similar characteristics. The Kamchatka coastline, seen from 200 miles away, can look so like a photomicrograph of a capillary system or a neural network. Fractal branching can be modeled at any scale and indeed is theoretically infinite. So often, you will see radiating veins in a leaf, or a pattern of clouds, or a crystalline structure, and think "that looks just like…". Visual echoes like these are found in hugely differing contexts, and they can be invaluable in creating connections. Use them to relate one element to another, to make rhythm and rhyme in your images.

Using texture

As you layer texture, make sure that it has the right degree of focus. If it is too soft, the texture may send the object to which it is applied further back in the composition. Too sharp, and it will be granular-looking and "float"–it will not be assimilated into the piece. The latter is a more common problem, but fortunately one that is easily solved with a carefully adjusted gaussian blur. Sharpening may not be helpful if the texture is too soft. Try using a mode like Overlay or Hard Light to bring more contrast to the layer, or scale it down.

Finally, if a texture is being applied to a contoured surface, try to mold it to fit. If you place an image of cracked glaze over a figure, for example, bend the cracks a little in sympathy with the curves of the body. The glaze will then stop being a layer on top and begin

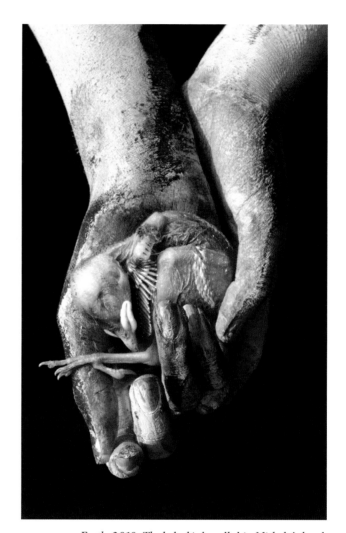

Earth, 2010. The baby bird cradled in Michala's hands was actually tiny, a mere inch or so long. Removing color points up similarities of texture between the painted hands and the bird, and connects them. Despite their disparity of scale, which is logically obvious, disbelief is suspended.

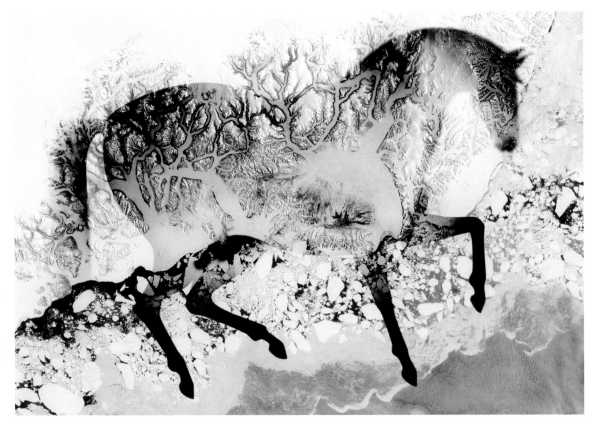

Icehorse, 2007. The frozen dendritic patterns in this image could be a macro shot or a frozen lakeside. They are, in fact, the coast of Greenland, photographed from a Landsat satellite, courtesy of NASA.

to settle on to the surface of the body. Take a look at Cemetery, page 176–the strict horizontals and verticals are slightly softened and warped by the body in front of them. It's not a huge distortion, just a gentle modeling that helps the two layers relate to each other and become a unified whole. The Smudge tool, used at an opacity of around 50%, is usually the best way to make such small changes.

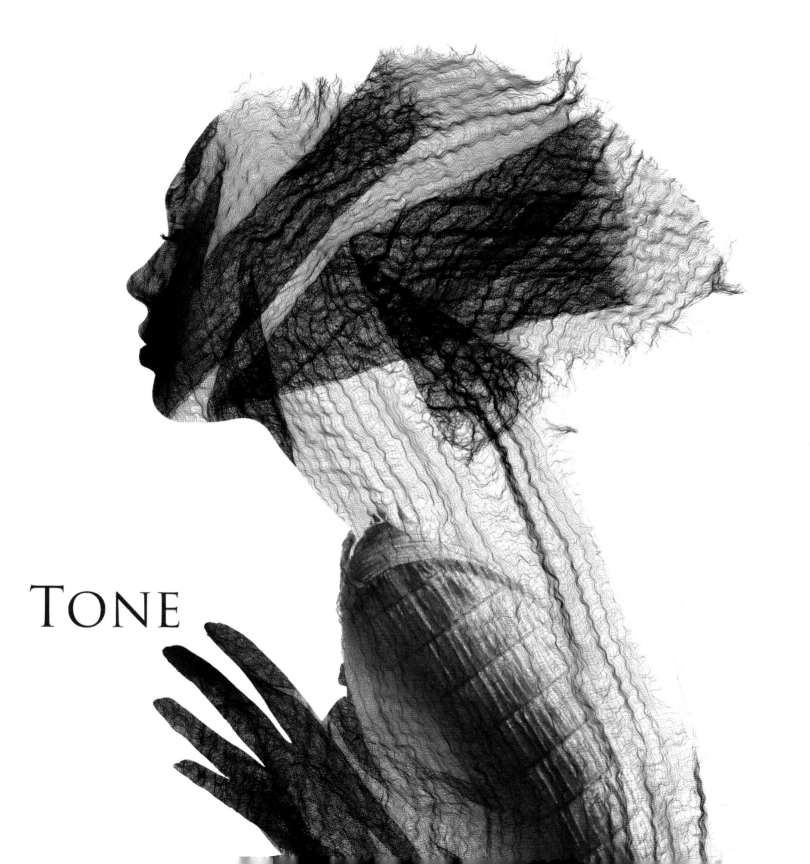

TONE

PREVIOUS PAGE
Net, 2012. Removing the background altogether puts the focus squarely on the figure and its gesture. This image is a combination of just three source photographs—the profile and arm belong to a model, the hand is my own, and the scanned muslin links them together.

A bright mood, dark foreboding, light of heart, a dark look… language shows how deeply entrenched are our ideas about tone. Relative brightness and darkness is one of the key mood-inducing qualities of an image. It can be a subtle thing; having the focal point of an image gently lighter and more contrasty will attract attention to it even without the viewer being aware of it. It can also be the first thing you notice, and even the subject of the image itself.

A child's fear of the dark is a reversion to our most primitive core. To prehistoric man, darkness must have been terrifying indeed. He was a prey animal, sharing even his sanctuaries with the saber-toothed cat. The discovery of fire and the ability to frighten away the predator was the beginning of our control over the environment. A love of brightness, and its attendant warmth and security, is still so deeply bedded in the most instinctive part of us that it always evokes the same positive response.

Authors have long used the weather and time of day to create mood in their work. The brooding, thundery storm cloud, or lengthening shadows at nightfall herald mystery, uncertainty, malfeasance, the unknown. Only when the situation is resolved does the sun come out and everyone can relax. Artists use tone in the same way to change the emotional climate in their imagery. Whether it is a literal reference to dark clouds or caves, or simply a gathering crepuscular gloom, deepening the shadows in your piece will certainly increase the mystery and disquiet. Clear, fresh, bright spaces will lighten and brighten the mood with the tone.

High- and low-key images

Changing the lightness or darkness across an image has an immediate effect on its impact. Any picture can be made higher or lower key by the addition of a Screen or Multiply mode layer, or an Adjustment Layer (Levels, Curves or Brightness and Contrast will all do the trick—try them all to see the effects they have), or you may simply have photographed a gull on a white wall in the snow. Whether your image starts out bright or dark or becomes that way, the psychological effects will be the same.

High-key images are very light in tone overall, and tend to be low in contrast. Shadows are soft, and texture muted. A high key is often used in portraiture as it is flattering, soft and gentle, and easy on skin texture. Bright in tone, it is bright in mood too; it conveys positivity and happiness.

Low-key images, on the other hand, are dark, moody, atmospheric and powerful. They are dominated by shadows, and strong highlights are very restricted in area, if they have any at all. You can achieve interesting effects by using brightly lit source material in a low-key image; you will retain the shadows and textures of the original, while adding tone and depth. Personally, I often favor inky shadows and darkness visible—not just because of deteriorating eyesight, but largely due to the influence of our long, dark Scottish winters.

Innocent, 2006. The smiling portrait naturally lent itself to a high-key treatment. With a scan of a taped and faded fax as a background, I superimposed the two portraits in Overlay mode and blurred the larger for a soft effect.

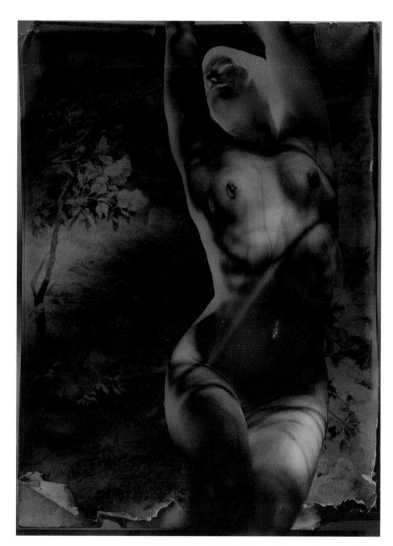

Moonlight, 2005. This nude was shot in sunlight. By using it in a low-key image, the patterns of shadows across the body can be read in a different way.

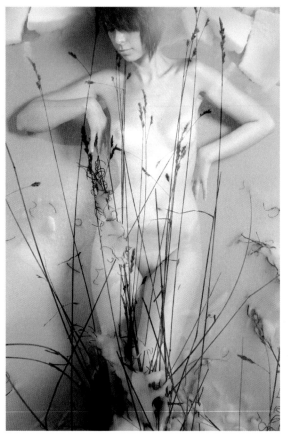

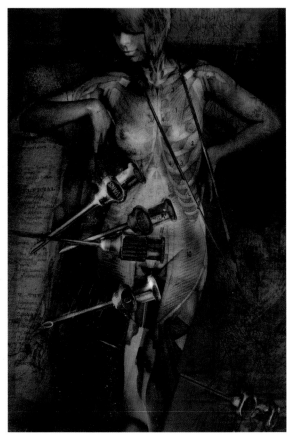

Hyperborea (left) and Iloprost, both 2010. This pair of images shows how the mood of a piece is radically altered by changing its overall tonal values. I made Hyperborea, the snow scene, first. The gentle expression on the model's face inspired a winter idyll. As soon as the nude was placed into the darker environment, the darker ideas came, and the needles and anatomies emerged.

FACING PAGE

Hands of the World 1978 by Touhami Ennadre. Ennadre is a master of the low-key image. His works glow out of the deepest, most velvety black. His photographs, of hands and bodies, night clubs, abbattoirs, a birthing room or a cave, can be unnerving, even startling. He does not shy away from the darkest aspects of life, and indeed death. The images operate in a delicious space between sensuality and pain, horror and fascination, being and not-being. They make you look closely, then sometimes recoil. However they impact you, they are always beautiful. Image courtesy the artist.

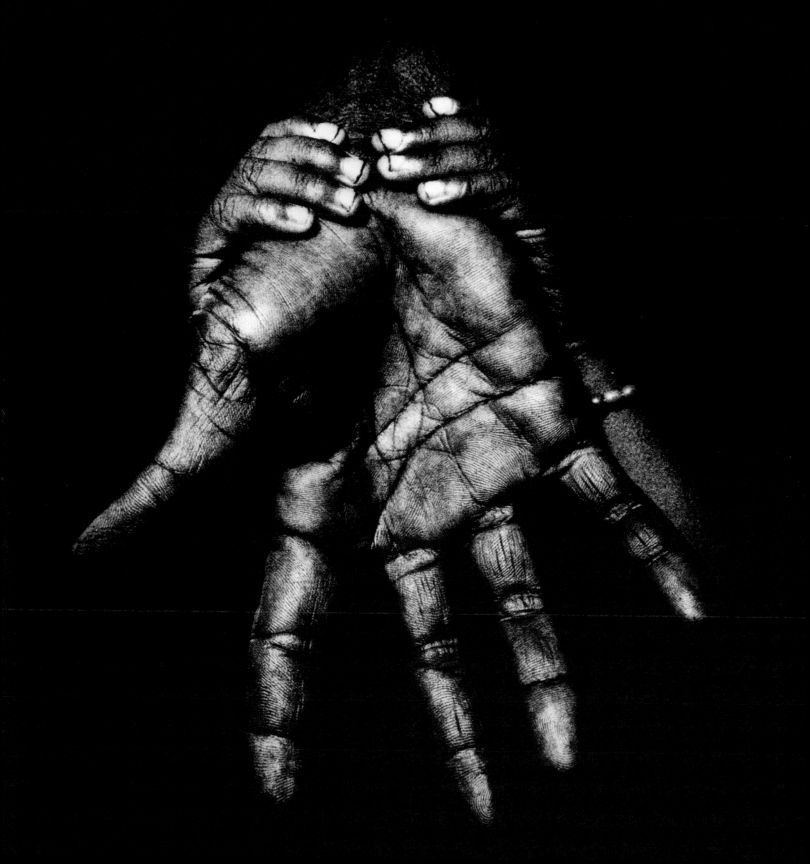

The greater contrast, or range of tones, of the central rosette of this plant–along with the converging lines– makes it the clear focal point of the image.

Tonal contrast

Manipulating contrast is an effective way of placing focus where you want it in an image. Greater contrast draws attention, while softer, closer tones are calmer and more recessive.

Getting contrast levels right is a very important part of assimilating an element into a montage. Too even in tone and a layer will recede, too much contrast and it will jump out of the picture. There are many ways of adjusting contrast. To affect an entire image, use an Adjustment Layer–you can paint out parts you don't need in its mask. To affect only one layer, use **Image** > **Adjustments**. Curves and Levels are easy and imme- diate ways of changing contrast and tone, but I find that Brightness/Contrast is more flexible. You can adjust one without the other; while you may want to give an element more contrast, for example, you may not also want to change its brightness.

For small adjustments to contrast in a single layer, try using the Clone tool. By choosing the clone point and clicking again without moving the cursor, you will clone identically in Normal mode. However, by

If you desaturate a color image, you may well need to raise the contrast to maintain form. Here, removing the color contrast leaves the picture completely flat and dull. Increasing the tonal contrast brings life back to it. Note that adding this much contrast will give a grainy quality to the picture.

changing the mode of the tool, you can make image adjustments. Keep the opacity low to start with, and choose a soft brush so you won't have an obvious edge; build the effect gradually. Setting the tool to Overlay mode will give you greater contrast, Screen will lighten a little, and Multiply will darken. This is often easier than making a selection, as you can watch the changes as they develop rather than having to predict where you want to apply them.

Texture and form become more pronounced as contrast increases. Stronger shadows and highlights create depth and sculptural solidity. Taken to the extreme, though, increasing contrast flattens the image out again; removing the grayscale transitions between tones results in graphic, posterized effects. If the background is pure black or white, you will achieve a silhouette, with the image reduced to an outline.

To bring out the detail in the horse's eye, I used the clone tool at 20% opacity, first in Screen mode to lighten the deep shadow and then in Overlay mode to increase the contrast and show the detail.

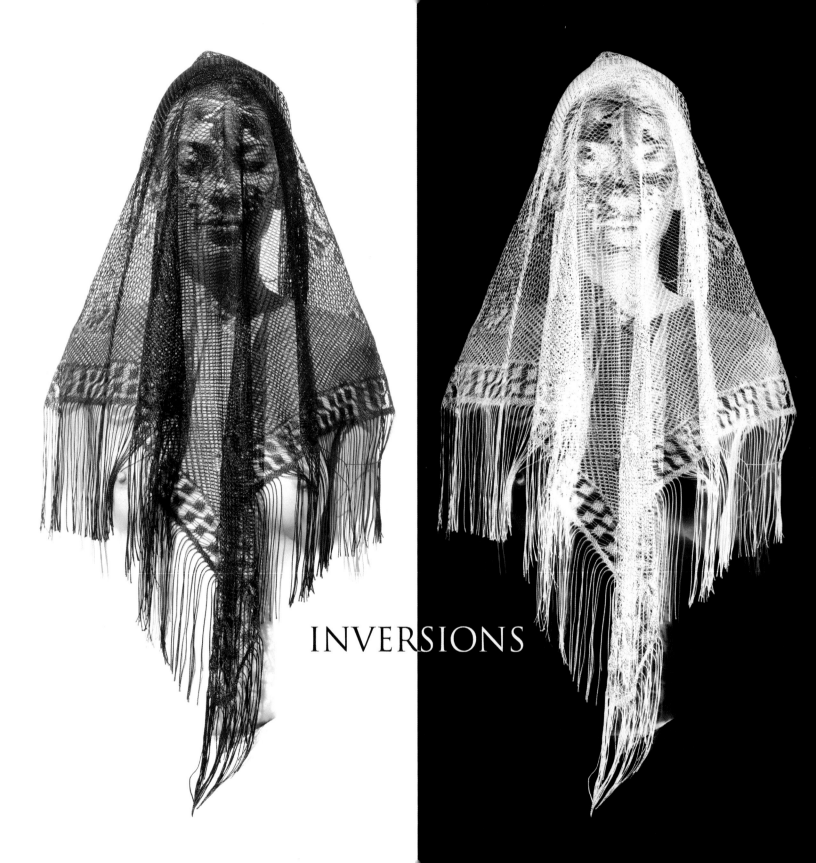

INVERSIONS

This avenue of experimentation will come very naturally to anyone who has worked and played in a darkroom. Traditional photographic practice will clearly make one highly conscious of the interplay of positive and negative. There is a great deal of expressive possibility in exploring different forms of inversions.

Color and tone inversions

Inversion can be of color, or of tone, or both. Command-I will invert the whole of the selection, both its color and its tone. You can then fade this inversion by choosing **Fade > Invert** from the Edit menu to give you many more options.

By applying a fade to an inversion, you will no longer be able simply to invert it back to its original state. An Invert Adjustment Layer, however, will make inversions non-destructively. You can apply any of the layer modes to the Adjustment Layer, and may well surprise

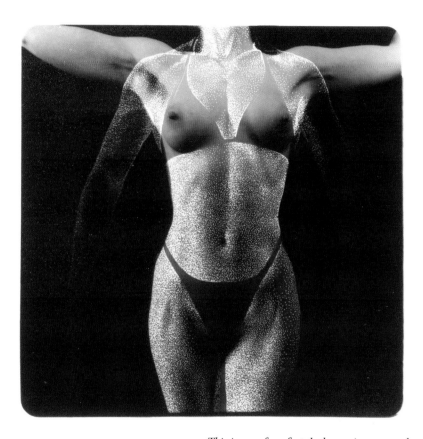

*Incantation, 1998. This is an example of inverting just the hues of a selection. After inverting, choosing **Edit > Fade Invert** and **Color mode** gave these peculiar effects. The doll's head became an unnatural and queasy green instead of the expected pinks and reds.*

This is one of my first darkroom images, made at college in 1992. As a printing exercise we made photograms by placing objects directly upon photographic, light-sensitive paper and exposing them to light under an enlarger. Having photocopied one of my stipple drawings onto acetate, I placed it on the paper and projected a nude over it to come up with this, a clear precursor to later layering experiments.

This image was inverted using an Invert Adjustment Layer.

The right hand side of this image has an Invert Adjustment Layer over it in Color mode.

The right hand side of this image has an Invert Adjustment Layer over it in Luminosity mode, which inverts the tone—the dark shadows become light—while leaving the hues the same. The flowers and leaves retain their reds and greens.

yourself by experimenting with these. By applying Hue, or Color, for example, you will invert only the color. Shadows will remain darker, and highlights lighter, but red will become green, blue will change to orange, and so on. The color will register as the direct opposite of the original on a color wheel.

Inversion of tone in a monochrome image results in the classic negative. In a color piece, you can achieve this by applying Luminosity mode to your Invert Adjustment Layer. The color will stay the same, but the highlights will become shadow and vice versa. I feel this affects the balance of a picture much more than color inversion; the weight of a composition is substantially shifted by moving the darks in particular. Further experimentation using the difference and exclusion layer modes will yield exciting results.

By cutting up positive and negative prints of the same image and pasting them together, one can create interesting new combinations. In the photocopy collage overleaf, the picture has also been sprayed with thin white ink to add another texture to the dark areas, and tape and drawn lines finish the assemblage. This early picture is another obvious forerunner to the digital montages that came later.

FACING PAGE
2 in 3, 2003. Old negatives themselves can find their way into finished pieces. Two mono negatives of nudes were scanned uncut and Luminosity mode applied to give them the golden hues of the background. Three separate blank negatives were then scanned overlapping on a flat-bed scanner, inverted and, in a layer above the nudes, given Difference mode. By cutting out the two nude negatives using the three blanks' outline, the unification of the two layers is complete.

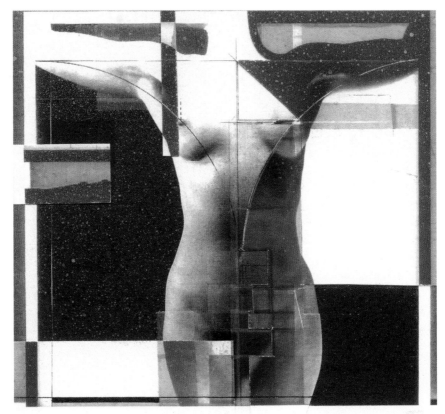

*Back when I was working
in the darkroom, I also
experimented with
photocopies and laser
prints. They each add a
distinctive texture to the
copies. The imperfections
that photocopying adds
are well-known and very
recognizable, and laser prints
have a ridged look as the
toner is laid down in lines.*

FACING PAGE
*Femi, 2008. I find inversions work particularly
well with mono source material. A beautiful vintage
postcard of a Dahomey woman's scarified back was
overlaid with a photograph of a frozen cigarette packet
to add texture and color. Abstractions were created
by adding an Invert Adjustment Layer and painting
into its layer mask. Here, the inversion emphasizes the
symmetry of the pose by suggesting a reflection.*

Shells I and II, 2003. Colors can bring a picture together in many ways. Using a similar color can blend an element, while using its opposite will highlight it. Compare these two versions of Shells. In Shells II, the original's color inversion is retained only in the shell itself. The blues are opposing but compatible colors to the underlying russets, making an alternative harmony.

FACING PAGE

Negative, 2011. The inversions can also carry through to the subject itself. Here, a sculpture mold, found in a museum café, is the physical inverse of the finished cast. The background is also an inversion, of a sunlit white-washed wall.

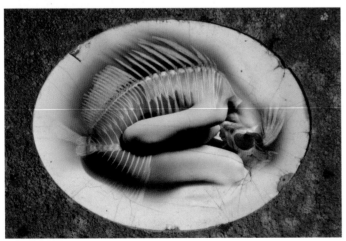
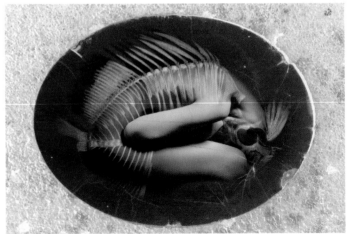

Butterfly Fish I and II, 2012. Try inverting only one layer of an image. Here, just the background is inverted. When white, the porcelain tile (found on a gravestone in Père Lachaise cemetery, Paris) looks very like a plate, with the nude served up as an appetizer. If inverted, the dark oval encloses and protects the figure and gives a far calmer result. Which you prefer, of course, I leave to you.

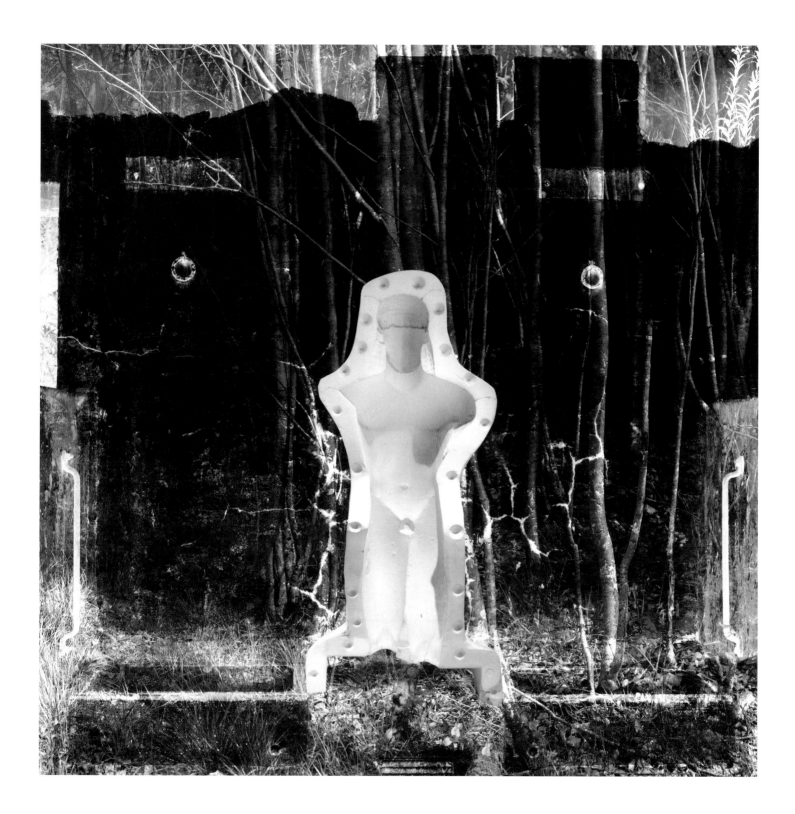

Solarization

Again looking back to the darkroom, solarization is a partial inversion of tone caused by over-exposure during either the development of a negative or the exposure of a print. First discovered very early in photography's history, it was not much used for expressive purposes until Lee Miller turned the light on in a famous darkroom accident in 1929, whereupon it was pounced on by Man Ray. Solarization emphasizes contour and has an elegantly delineated quality all its own. The darkroom method is very unpredictable, but Photoshop can give you a good approximation of the effect which is far more controllable. Duplicate the image layer and apply the High Pass filter (found under Other, at the bottom of the preset filter list) at a radius of around 15 pixels, and apply Overlay mode and 50% opacity. This exaggerates contrast and accentuates the edges of tone. Create a Curves Adjustment Layer above it; instead of the more usual sine wave pattern, make an inverted V with its apex in the middle of the graph. Experiment with this new curve shape; tiny adjustments will make big changes to your image.

Orientation

I often find it easier to work on a picture if the light within it comes from the same direction as the light source in the studio. This will not make a difference when you have finished the piece, but it helps to show up inconsistencies or problems that might otherwise be harder to spot. You can always flip the entire picture later if you like (as long as it doesn't contain orientation-dependent imagery such as text, naturally). Flipping the whole image can also be a valuable check of

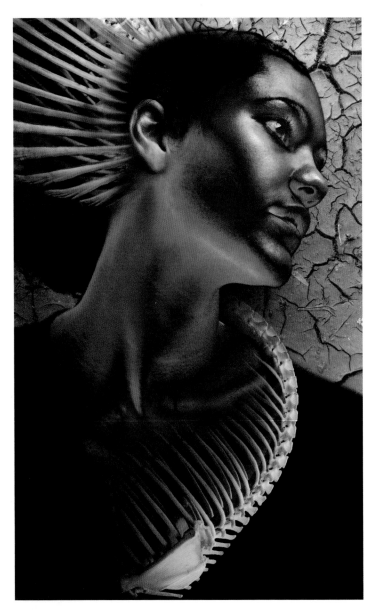

Bronze, 2007. Applying solarization effects can result in a pleasing metallic quality.

*Finally, try inverting orientation. Duplicating and flipping all or parts of your image will start up symmetries and patterns. If you apply any of the layer modes (barring Dissolve or Luminosity) to the uppermost layer, you will read both layers together. Moving a horizontally-flipped layer laterally in relation to the other will always give bilateral symmetries—reflections—across the exact center of the combined pair. Like Rorschach blots, mirrored images are easily read as something else, and have huge potential for suggestion. For these simple inversion experiments, I started with an image in which the nude is a negative. I applied Darken mode to a horizontal flip (top right) and dropped an Invert Adjustment Layer over the top. For the vertical flip (bottom left) the upper layer was also Darken mode; I inverted the flattened image and applied **Invert > Fade Invert: Luminosity**, which reverted the figure's tones back to their original values and darkened the background, while retaining the warm hues. The two layers needed moving apart a little to create the space between the figures. As every art teacher will tell you, it is important to be aware of negative space—the areas between masses can tell as strongly as the masses themselves in a composition.*

composition, revealing imbalances to which you may have grown accustomed. It may even result in a better composition of itself–in the West, we read from left to right, a tendency so engrained that movement in this direction can feel more natural and comfortable.

Swimmer, 2012.
I duplicated an image I
had made, Swimmer, and
flipped it vertically. By
applying Lighten mode
to this second layer, I had
a pair of reflected figures
floating in a dark sea.
Adding the "water"–
actually a photograph of
a reflective plastic sheet–
finished the piece.

DISTORTIONS

The camera lies, all the time. Lens distortions can be more or less radical. At their strongest, fish-eye lenses create extreme wide-angle images, even hemispherical panoramas, in which no line is straight and horizons loop across the picture. Long lenses squash and flatten apparent depth. Shooting through or into distorting surfaces will subvert reality further. Even your source photographs can be radically manipulated.

André Kertész made a seminal series of distorted nudes in the 1930s. He shot into convex, concave and wavy mirrors, finding extraordinary etiolations, swellings and three-headed women there. By cropping out the carnival mirrors' edges, Kertész summons up an uneasy hallucinogenic quality. These dream-like, surreal forms have a lot in common with sculpture: monochromatic and monolithic, they recall Henry Moore's massive female figures.

Cow, 2010. This is a straightforward photograph. I found an old paper anatomical model of a cow, and used grass as a background. I placed a sheet of glass in front and angled it until natural light passed through. Then, I poured water over the glass, and shot with a fast shutter speed to capture the effects of the ripples.

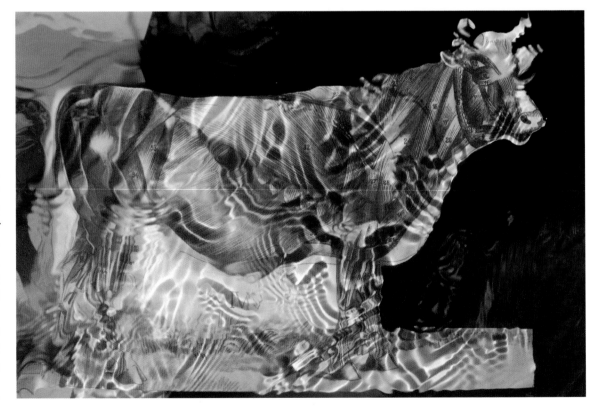

Photographers also take advantage of the dark-room to create print distortions. Tilting or curling the paper under the enlarger will produce fascinating effects similar to old funhouse mirror reflections: stretching, compressing or completely reinventing form. You can achieve similar results using Transform, especially Warp (note that Warp, in particular, will reduce the sharpness of your image considerably).

Irregular glass sheets, bottles, lenses and spheres alter the passage of light through them. Crystal balls are wonderful objects to play with. Anything you place behind them will look flipped and curved, so you can have sections of land or seascape upside down, or bent architectural lines or figures fitted neatly inside.

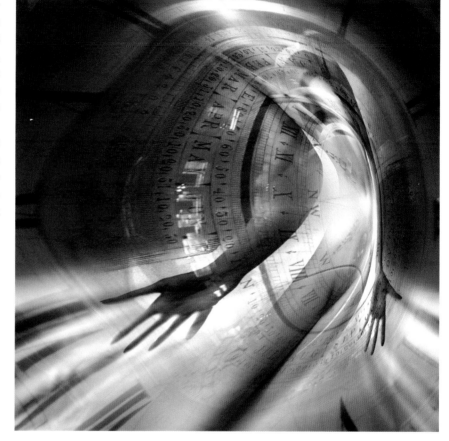

Eve, 2012. For this version of Eve, I warped the entire image to place more emphasis on the hand and give the piece movement.

Notice how the landscape seen through this castle's arrow slit is inverted in the glass ball, and inverted back in the bubbles within it. The straight sides of the slit are, rather pleasingly, curved into arrowheads.

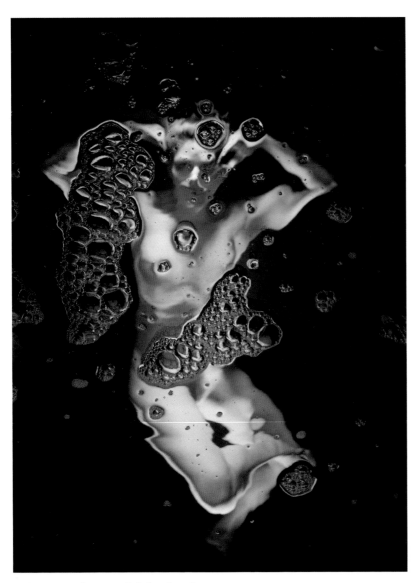

WS-20 1998 by Brian Oglesbee, from Aquatique,
Insight Editions 2007. Image courtesy the artist.

Water has endless potential for photographic experimentation. You can work with reflections off its surface and refractions seen through it. Focusing on the surface of the water will reveal a different set of transmutations from those seen when focusing on an object within it. The surface itself can be disrupted–chaotically, by wind or rain, or its own travel, or rhythmically, by wave, droplet or ripple. It shows in the purest form the forces of physics and all of nature, and offers limitless possibilities.

Brian Oglesbee makes the most extraordinary images of nudes in water. His photographs are not manipulated at all. Astonishingly, they are unretouched shots. While many look as if they were made outdoors in ponds or streams, they are in fact all made in his studio. He makes complicated setups involving fans, vegetation and water tanks large enough to accommodate his model. Using 4×5 sheet film, he makes large-format negatives of such detail that every bubble contains a new image within it. His work is completely original and utterly beautiful.

DEVELOPING YOUR IMAGE

Developing style

Style is an elusive quality to pin down. It is not easily described, but is instantly recognizable. It develops constantly. It evolves. Generally not chosen or even aimed at, it is something you cannot escape, because it is a result of who you are. This book explains my development, but your own will, of course, be yours alone and take you on a unique journey.

I make the pictures I do because I love life drawing. There is a particular delight in the perfect line of a neck or wrist that cannot be explained logically. The nude has always been my primary subject. While studying photography I began to work into the prints, and the images gradually became less descriptive and more allusive; the reality of photography melded with the surreality of mixed media and collage techniques. The images became more complex and complete than life studies. I needed to take them further, and before Photoshop existed was trying to blend the nude with its surroundings. It was only when the digital age dawned (for me, in 1997) that I found my perfect medium. You may well have learned Photoshop at school, so it will always have been a part of your visual lexicon but this shouldn't prevent you from experimenting with other media, either to use in your digital imagery or for its own sake. There is a great deal to be learned from drawing and painting—and it's a joy.

Layering is a constant preoccupation, which explains much of my personal style and even my choice of medium. Urban living, in particular, presents us with a constant barrage of information, stratum upon stratum of buildings, walls, posters, graffiti, peeling paint, shadows and reflections. We absorb so much without even being aware of it. Digital collage is the perfect medium to convey this multiplicity of modern vision. I delight in layering the nude, in particular, with clay,

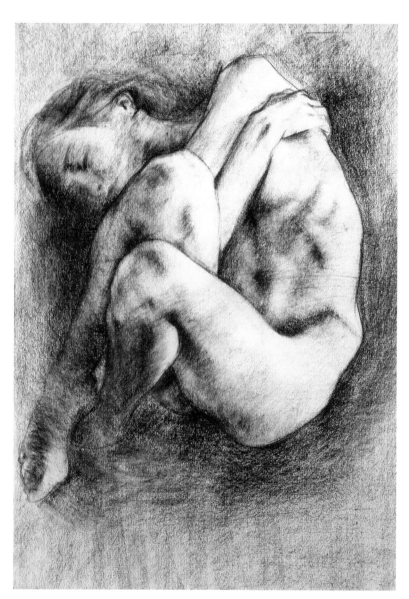

A life drawing, made in charcoal. The texture of charcoal on paper is something you cannot fake with filters—for the strokes to follow the contours of the figure and explain the form, you need to draw it.

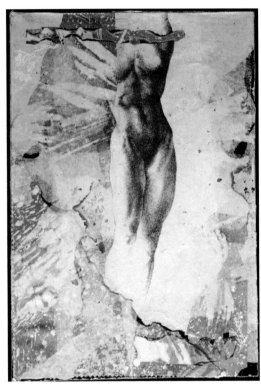

Access to a darkroom changed the way I worked completely. Although the nudes were all monochrome or, as here, sepia toned, color could be introduced with paint or collage. For this image, the snowy ground was photographed on Ilford HP5 black and white film, which goes through the standard color C41 process; the prints usually have a color cast, in this case magenta. It was a short step from here to making Photoshop montages.

This is typical of my early collage efforts. I overlaid papers and textiles onto hardboard, gluing them with wallpaper paste. I often set fire to edges, as I liked the echoes with the sepia tones of the drawing. Once the collage was dry, the nude was drawn in ink with a Rotring pen.

paint, latex, gauze or muslin. Such coverings blend the body with the environment while leaving it unclothed. Photographs of glass with both reflected and transmitted light, diaphanous drapes, translucent plastic sheeting, things wet or seen through water; like that early Atget shop front, all these layers offer visual complexity and depth of both information and meaning.

Your own style will develop naturally; there is no need to force it. When I was a child, I copied Paleolithic horses from the Lascaux caves in charcoal, drawings by Leonardo and Michelangelo, paintings by Stanley Spencer and van Gogh, and even made a Minoan snake goddess out of Plasticine. Later, I drew from Herb Ritts' nudes. With no voice of my own as yet, I was trying on others' for size. This is a very useful exercise. It teaches you not only what you like and, if you're lucky, why, but also manual dexterity and concentrated looking. The lessons sank in, and are assimilated into my own practice even now. While cross-hatching techniques, for example, are no longer relevant to my work, the focus on masses and shadow still is. Your every creative endeavor will

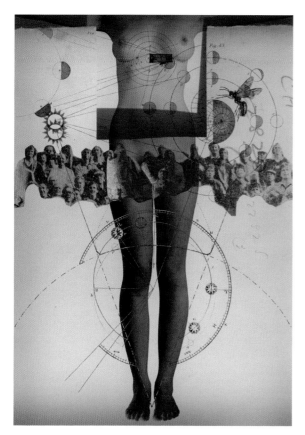

Fig. 43 (Observatory), 2012. My work still bears traces of this development. Scanned or photographed cut edges, scribbles and allusions to the paper plane are all references to the image's two-dimensionality.

expand your range, sharpen your eye and further your progress. Trust that while you may admire someone's work, and emulate it to some degree, your own life, loves and experiences will take over and you will be off down your own road. Concentrate on your message, be honest and direct, and let the style take care of itself.

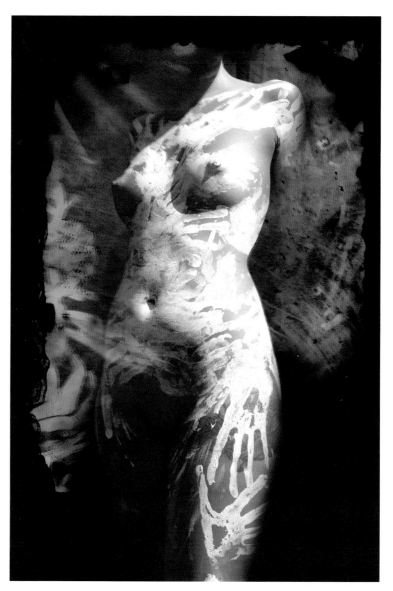

Mirror, 2010. The body, layered with paint, is reflected in a mirror also bearing handprints. This later piece shows how much more painterly the work has become.

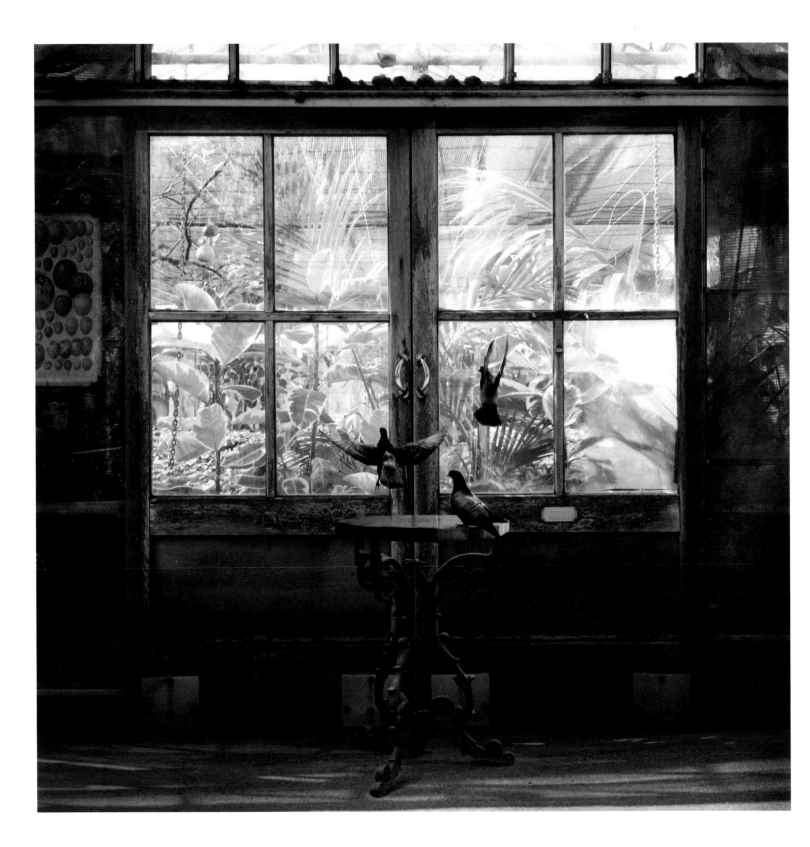

When is a picture finished?

It can be surprisingly hard to know when to stop. I sometimes leave a layered file on my desktop for months, looking at it occasionally, waiting for a final idea or element to add–or, indeed, subtract–that will bring it all together and give it cohesion. This is the equivalent of a painter putting work on an easel and looking at it sideways for months until the time is right to move on.

Uncertainty usually means that there's something wrong that you can't put your finger on. A trick that the painter and other artists in traditional media might use is to turn the image upside down to examine the composition. Your eye can grow accustomed to the shape of a piece while working, and you will sometimes need a fresh perspective. What looks satisfactory might well reveal unnoticed flaws when viewed from a new angle. Rather than rotate a large layered file, select all and copy merged, then make a new file, and move that about. You can also try flipping it horizontally (painters use a mirror for this) for a different viewpoint.

FACING PAGE
Interior, 2012. It is often best to title a picture when it's finished, unless the title itself was the inspiration. You can be fanciful, informative or simply descriptive. Even "Untitled" means something–maybe that you are not leading the viewer, or that it is one of a series, that it is self-explanatory, that it just doesn't need a title. Possible titles for this might be "Locked Out," "Edinburgh Botanics" or "Interior". I went for the latter, as it is actually an exterior and I wanted to exploit the confusion between interior and exterior clues within the image.

If you're still unsure about whether the image is finished, it may simply mean that you're tired. Attention to detail is vital to ensure the flow of an image, but if you're down to changes that you aren't sure are an improvement, and are toggling backwards and forwards between history states uncertain about whether it's better or not, it's a good time to stop. Fiddling with tiny detail that doesn't affect the thrust of the picture means either that you are finished for the day and need a cup of tea, or that you have finished the picture. Looking at it again in the morning will tell you which.

Struggling for ideas?

No one is spared artist's block; it can happen at the most inconvenient times, and can be difficult to resolve. The best thing to do? Just start! It doesn't matter if you don't know what you're going to make, or what you want to talk about, or what is going to be in your picture. That all changes while you're working anyway. If you just start playing with things, you'll suddenly see a connection and you'll be off. And don't worry about whether what you're doing is any good–there's no need to place pressure on yourself. If it doesn't work, never mind, just move on to the next one.

When creating a new file, fill the inhibiting expanse of white straight away–it doesn't matter what you use, you can change it later. Working into something is much easier than starting from scratch. While a picture is developing, its atmosphere, composition and even subject will change (in your personal work–of course–you may well have less latitude with a commercial brief), so don't worry if you have no clear message in mind initially. The very act of compiling a picture will suggest new meanings, which you can then work towards.

Whether you use it for quick doodles of poses for photo shoots, somewhere to collect clippings or just for sketches of the dogs, keeping a notebook will help you gather your ideas and your thoughts.

I love car boot sales and flea markets. You can pretty much guarantee that you'll be able to afford anything you like. They are huge toy boxes full of the most random collections of completely unrelated things.
Just seeing them together starts you thinking. This is a particularly good day's haul.

Most of art is simple hard work. To make good art, you'll need to make a fair bit of bad stuff first. Don't let this dissuade you. Whatever you produce, you're learning—which is far more valuable than any single image. It's not all work, though. There are those moments of delicious clarity, those lucid flashes when you are more receptive and more awake. They can be encouraged, if not demanded.

Everyone needs input, brain food. For me, it's museums, traveling, photography books, junk yards… you will have your own launch pads. Nothing comes from nowhere. If the well is running dry, get outside, look hard, photograph everything and recharge. If you're not facing a looming deadline, a day doing something completely different can get the creative juices flowing again: walking the hills, browsing antique shops, whatever you find most relaxing and interesting, can work wonders. This is dusting and restocking your ideas bank.

Everything is about art, and art is about everything! Everything you see and do, and everything you're feeling. Whatever you're doing, really look at things. All creative people, scientists and artists alike, learn from observation. Ideas can spring up from anywhere. Conversation, cinema, drives in the country, arguments, exhibitions, opera. Reading a novel or a poem, shopping, anything, no matter how mundane, can trigger connections in your mind and set you off on a new idea.

Keep a sketchbook. All art students do, and it's a good habit to keep. I don't sketch out finished pieces, but I do keep notes of ideas for poses, props, locations and so on. I also maintain tear folders, and whenever I see anything I like in a magazine or newspaper, I'll put it there. They have developed into an interesting jumble of colors, poses, textures—anything that might trigger a new image or help one along. A folder of screenshots of online imagery serves the same purpose. Try always to

carry a camera with you. The smaller digital ones are so good for this, slipping into a pocket much more easily than an SLR and letting you capture the unexpected. Use it as a digital sketchbook. I have been known to spot a beautiful fish in a supermarket that has sparked off a new image. Don't miss a possible picture, wherever you are. Take ideas from the world around you, get them into your computer and make them your own.

Another interesting exercise is to revisit your old work. By saving everything as a layered file as well as a flattened tiff, you can go back to it later. When I'm stuck for ideas, I sometimes look at a piece I made years before, and re-see it. I might have new source material and I'll surely have a different outlook from that day in the past. Looking back is a useful thing to do. You'll see what you would do differently this time. Actually do it– work into that old layered file and make it better. You will come up with another version, and often this will develop into something entirely new.

If your brain is stubbornly refusing to co-operate, you could try ambushing it. Tell yourself you're not going to work today, you'll just archive this shoot or photograph that new acquisition. You may well start working without even noticing. Housekeeping jobs like scanning, drawing paths around objects that will need to be separated from their backgrounds, or retouching new material can begin the thinking process. If you're under pressure of time, try doing the small tasks first. Opening a new file and gathering together elements from your archive might start the flow. Very often this collecting together of the things you'll need helps you to see relationships between them and gives you ideas. It works in much the same way as in traditional collage. Laying out lots of elements on the floor and just playing is a good way of finding new correlations.

Try a different medium. Maybe get out your pencils or paints, or make an old-style paper and glue collage.

Even the inexhaustible and unstoppable Picasso moved between disciplines. It can free you up from a well-used way of thinking, and encourage a new approach.

Working with someone else is not easy in this medium, but collaborating on a shoot, for example, can be very inspiring. Just talking about art with a like-minded friend will set things in motion. Being an artist can feel an isolating occupation, particularly when compared with music or theater, for example–but sharing your work with others and giving and receiving feedback is invaluable in keeping the creative juices flowing. At the very beginning of my digital journey, I was lucky to meet Sandy Gardner, another digital illustrator and a marvelous correspondent. Our dialogue was, I feel sure, useful to us both. We share an artistic history, having both experimented with traditional collage before finding our perfect medium, and we share an aesthetic too. Online blogs and websites mean that geography is no longer an issue when finding a creative conspirator.

If all else fails, stop! There is no forcing inspiration. You will need a rest sometimes, to recharge, regroup and let new ideas form. Go hiking, watch a great film or take a holiday. All these things will relax you and give your mind time to start making new connections. Allow yourself the space to rebuild your stock of personal metaphor and message. With a little time, you will wake up one morning ready to head off in a new direction.

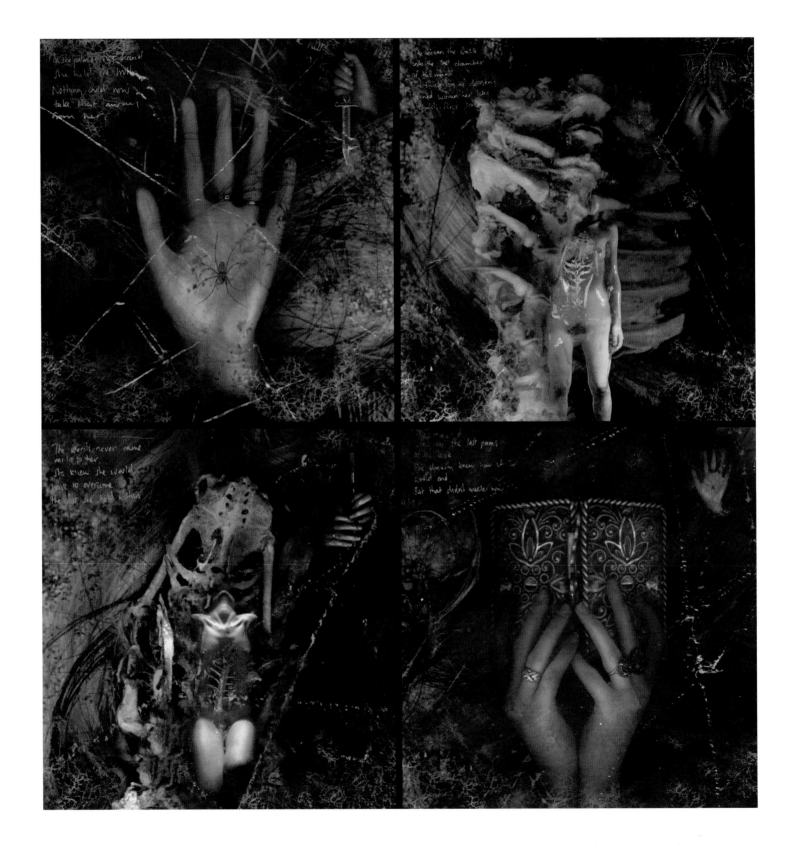

Diamond, 2007. This image arrived in my head more or less intact the day after watching the rather brutal Blood Diamond.

FACING PAGE

Igneous Obsession, by Sandy Gardner. Lectures by and conversation with other artists on the same wavelength will be enormously helpful. This beautiful piece was inspired by a Dave McKean lecture. Image courtesy of the artist.

THE FINISHED IMAGE

Archiving

Please, always keep back-ups of your work. Hard drives do break, and months of work could be lost. Computer repair shops spend large amounts of time, and customers' money, trying to recover information from defunct drives, and it's not always possible. As back-up media is now so cheap, it's not worth the risk.

There was a time when a whole office would back their work up every night to a two gigabyte hard drive, which seemed inexhaustible. Things have changed: programs and systems take up more room and, most importantly for the digital artist, cameras produce much larger files. Fortunately, back-up media has changed too, being much larger and more affordable. You no longer need to edit your photo shoots too severely. Keep as many different versions of a shot as you feel are successful. It is impossible to know at the time which of the slight variations of composition or color will be the most useful in a later image.

It is very helpful to keep close records of your growing collection of files. There are several programs that will help you do this, or you could simply start up an indexed book and note down the contents of each CD or DVD as you make it. Having the contents of a DVD marked on its cover will also save you rummaging through stacks of anonymous disks in search of a photo you took three years ago.

Keep a back-up of your back-ups!

Besides having a hard copy archive in the form of DVDs, I also keep a pair of one terabyte (1,000 gigabyte) external hard drives. These are identical, so if one should break or become corrupted, no information will be lost. I back up the day's work each evening to both, and keep a folder on my desktop of all files to be written to DVD. You may also want to back up online to a remote server for additional security.

Large external hard drives allow you to keep files in growing collections, of course, which makes it much easier to find what you're looking for. All the pictures of an octopus, for example, will be in Fauna > Marine > Invertebrate, or all syringes in Instruments > Medical.

Getting your work "out there"

First, make yourself a website. They really are invaluable, not just for unsolicited contacts, but also for pointing clients towards–it saves so much in printing expenses and DVDs. Join Facebook, Twitter, Flickr, everything you can to broadcast yourself and your skills. Behance is a very good online portfolio site that will carry your work and allow people to get in contact with you directly. It is worthwhile putting together some carefully chosen themed sets of work to show here, and tag them so that interested parties can find them easily.

This screenshot shows how I keep my external hard drives organized.

When approaching potential new clients, do a bit of legwork and get a contact name first. I don't use a hard copy portfolio any more but send out DVDs. This is much cheaper, obviously, and it doesn't matter if you don't get it back (which you won't). I used to buy lots of copies of my publications and send out samples, but it's just too expensive. I tailor the DVDs to the client, and always include a small selection of personal and unpublished pieces to give an idea of the scope of the work. If you're doing this remember to send only low resolution copies.

As for content, I remember putting together folios that attempted to show a wide range of things I could do, only to be told that I should focus on one. Art directors like to see something very similar to what they want, and to know what to expect from you when they commission. So, you'll need a different portfolio for each occasion. It should be a clear statement of intent. Research each of the companies you'll be presenting to, find out what they use and show them work that will fit in with this while being clearly your own. Make sure they see your own style and method, and remember them, and you.

For presentation, keep it really simple; you can overcrowd your work otherwise. Let it speak for itself. And don't put too much in—I have done that and people just get exhausted. Twenty pieces will have much more impact than fifty. Edit, pick your very best stuff and it will be remembered.

If you're visiting your potential client, make sure you have something you can leave with them. Something they'll want to keep and pin up, hopefully, with your contact details on it. Leaving a DVD is a good idea too.

Finally, you might try sending work to a magazine that shares your interests, asking them to publish a portfolio—this can give you invaluable publicity. Exhibit in art and photography exhibitions. Enter competitions. Even doing one or two things for free can be a good idea to get you started. Charities are often very grateful for a free Christmas card, and bands for a CD cover—in return you'll get free advertisements to send out to possible clients. Most importantly, work really hard, believe in what you're doing, and never give up!

Agents

A good agent is worth their weight in gold. Do be careful when choosing one, though. Remember that an agent's primary goal is to make money—they're in business too. While this motivates the good ones to find you work, some of the less scrupulous will be happy to make money from you instead of your clients. Check the agency's terms and conditions carefully before you sign up with them. Many will expect you to pay for such things as website upkeep, portfolio maintenance and print advertising on top of their agreed commission rate, which is usually 30% or more. Unless you ask, they may not mention this until your bill arrives. Check also how many artists they have on their books. If they represent a long list of people you will not get a personal service but simply sit on their website. Having said all that, there are excellent agencies who will ensure your work reaches the right desks.

Permissions and copyright issues

Copyright law is complicated and varies across the world. To sum it up in a sentence, the copyright to any intellectual property resides with the author, except

where the author was employed at the time of making the work, when it resides with the employer. Self-employed people commissioned to make work retain their copyright. Other people's copyright should be treated as you would wish your own to be, with utmost respect. I do understand that sometimes it's tough getting all the source material you need. Certainly, when I was starting with the program and no one saw the work but myself, I used anything and everything, scanning out of books shamelessly! However, now that I publish, I'm very careful. Other people's copyright needs protecting. If you absolutely must have a particular image for your piece, obtain the permission of the owner of the copyright to use it.

Public domain

As a general rule, published imagery and any other form of intellectual property will devolve into the public domain; that is become available for anyone to use for their own purposes, seventy years after the death of the originator and copyright holder. If it was published after the death of the originator, the date is seventy years after its publication. The copyright in unpublished works also expires seventy years after the death of the originator. The length of time will vary from country to country: seventy years applies in the US, UK and European countries. Many other countries apply a fifty-year rule, while a few enforce a longer term. There are exceptions to this, but anything published in the US before 1923 is free of copyright. Once imagery is in the public domain, you are free to reproduce, adapt and incorporate it as you wish.

Taking photographs in public places is usually fine, but there are things of which to be aware. Seemingly public spaces such as shopping malls are actually private land and permission must be sought to photograph

in them. Also, the image rights in some modern buildings are pursued by the architect. Use of imagery of La Géode, a geodesic structure that houses an IMAX cinema in the Parc de la Villette in Paris, for example, is restricted by the architects. The Eiffel Tower itself, constructed in 1889, is not copyrighted, but the rather spectacular lighting at night is, and commercial use of a photograph of it will entail a payment to the operators of the tower.

Finally, take care always to ask permission of their parents if you are photographing children, wherever they are. For politeness I would of course extend this to anyone, but it is especially important to protect the privacy of minors. There has been enormous pressure of indignation on some artists even when using their own children as models. Sally Mann's extraordinarily beautiful, surreal, relaxed and intimate images of her family have unfortunately aroused prurient interest and therefore consternation in some quarters. This reflects badly on society as a whole. An environment in which a picture of a child being itself is seen as potentially erotic is deeply unhealthy. While a photographer cannot ultimately be responsible for a viewer's reaction to an image, they most certainly should be aware of the potential of their work to excite extreme responses—of whatever kind—and must tread carefully, and have the permission of the subject and their guardians when making it.

Pazyryk, 2006. There are some excellent image banks online, where for little or no payment you can find imagery to play with that would otherwise be difficult to find. NASA is very generous with its extraordinary image collections, which are freely available at high resolution. Alaska.AMOA2004068_lrg.jpg courtesy of NASA.

FREQUENTLY ASKED QUESTIONS

How were you taught in your undergraduate studies in design? Conventional methods and techniques?

Yes, conventional. I didn't use a computer until my Masters, and even then very little. I did life drawing, collage, Celtic illumination, calligraphy, printmaking (mostly etching), a bit of watercolor painting and sculpture.

What drew you to photography as opposed to drawing, painting, and so on?

I have long collected books by the greats such as Weston, Brandt, Minor White, and so on, and was also hugely influenced by Ritts and Weber in the 1980s (like everyone else). I wanted to make beautiful, simple, sculptural mono nudes to start with– life drawing plus reality.

When did you first encounter digital imaging technology?

In 1995 I took a job in the Reprographic Services department of a university (I'd been an old-style graphic designer before going back to college for my Masters). The department was entirely computerized. No one even had a pencil, and it was a bit of a shock to the system to a total technophobe; I felt completely lost without my Rotring pens, scalpel and ruler. Soon the learning curve started to level out, however, and I discovered Photoshop. Once I learned about layers I realized that computers could do a lot more than design letterheads. I just needed acclimatization and soon came to love my computer.

What appeals to you about digital capture over conventional imaging–or do you shoot both?

I used to shoot both–elements of my earliest work were shot on a Bronica SQ 6×6 (80mm lens) and a Nikon F401 (28–80mm lens)–but now work exclusively digitally. Most importantly, you can check the results immediately in the LCD monitor on-site, and you can begin work on them as soon as you get them on to the computer. There is no waiting for developing, and you can reshoot straight away if you need to. It also saves a lot of money in film, as I always take four or five shots of each subject, to ensure that one is perfect.

Image quality is no longer an issue. The 18 megapixels that my current camera (a Canon EOS 550D) delivers is more than adequate for my purposes. It has a lot less grain than ordinary speed 35mm film, and also no artifacts or dust from scanning.

Since you were self-taught in the uses of Photoshop, how long did it take you to acquire the skills necessary to create your art?

I'm still learning! I got the basics after a couple of weeks, but it's such a huge program, and so endlessly versatile, that you really never stop discovering things about it, new and better ways of doing things.

Where do the ideas for the art come from?

Everywhere and everything! I always take a camera with me, even when walking the dogs; you never know when a shot will turn up. I obviously look at a lot of

photography. Reading will inspire ideas too, and browsing bookshops and antique shops. Exhibitions, poetry, museums, car boot sales, my extremely beautiful greyhounds... As for found objects–I come across these absolutely anywhere; I am very opportunistic.

What comes first? Does an image
stimulate your imagination or do you develop
the idea and look for source to support it?

It is both–sometimes, an element of an image starts off a line of enquiry, and sometimes the enquiry prompts the acquisition of the element. The best things are usually the result of a combination of both. I work every day, and produce something, but it's only sometimes that it develops an impetus of its own and becomes more than its constituent parts, when all the things in my head–the feelings, the bits of information, the visual collection, the actual collisions that happen onscreen–combine to make something interesting.

Sometimes I'll have an idea, emotion or phrase, which I then "illustrate". These pictures may have a clear end point, and I often take photographs specifically for them. Or, sometimes I take a photograph or scan, a starting point, which will grow a picture around it as allusions and resonances it might have for me are added to it. Then other times I just sit here with my archive, the "back catalogue", and let things happen. I find an old image I like, let associations develop, play about with layer application modes, and find the other things it needs to become a picture. Constantly taking photographs and collecting things on themes that have interested me for years means this method isn't quite as hit and miss as it sounds!

Often the best pieces are made by starting off knowing what I want and then letting the picture go off and

do what it likes. Even when making commissioned pieces I have been known to Save As, and later take an image in a totally different direction from that intended, just for myself. Such an ad hoc method–and Photoshop itself–does allow for a quite intuitive response to the developing picture.

What themes do you express in your work?

There are several themes... most importantly, communication, its difficulties and rewards. Lies and the truth, sharing emotion, and belonging to a society. Which is what all art is about fundamentally, of course. Also our environment–natural and man-made surroundings, and the textures of decay and layering of time.

My work is about making visual the unseen, and creating new realities. It is also hugely and inevitably influenced by my history. I moved from an appalling city to rural bliss but the old feelings of entrapment and threat still surface in the work. I work with other people's memories a lot. I buy ephemera from car boot sales and online auctions–things like old photograph albums, passports and letters–and use them to give a temporal depth as well as an aesthetic texture. I do love the layers of meaning that can be created using layers of objects through time. I like the mysteriousness of scraps and suggestions of memories that are not my own, especially those that are indecipherable to me.

What do you think is the most important
element when creating an image using Photoshop?

Flexibility. In any other medium, if you take a picture in the wrong direction, you're stuck with it, or you have to

work back. Photoshop allows you to experiment without the fear of destroying.

Your work has such strong associations with legend and myth. What are the sources for your themes?

The pieces are always, fundamentally, about emotions—as are myth and legend. The themes don't really change. Communication, lies, singularity, connections between physicality, spirituality and psychology, and so on are recurring themes that have come from the way I live and the people I've known. Specific ideas and subjects, though, are different, and can be sparked off by absolutely anything. I read a lot, and many images have been inspired by a sentence or even a single word in a poem or a novel. The radio is often on while I'm working and many ideas have sprung up in the middle of a play or a discussion. Then there's my occasional trips abroad, talks with friends... and it's often when one of these other stimuli happens to resonate with something in my personal stock of symbols and themes that the images start to happen. The pieces are very personal, and if something I'm trying to say happens to have its equivalent in a myth, I might use that in the title to help explain it to the viewer.

How long on average does a piece take to create from start to finish?

Getting the scans and photos can take a long time; days of scanning nineteenth-century engravings, or photographing in museums, or looking for models. I have more than 500GB of source material that has so far taken fifteen years to collect. Once I have all the elements together, most pieces can take anything from a couple of hours to a week—it really depends on how planned they are. Some are amazingly quick, and are finished in just twenty minutes; usually these ones have been brewing in the back of my mind for a while. Others I just let evolve, see what happens, and I can be working on them for days or even months. These are usually the most interesting images—at least to me, maybe because they've surprised me! Commissioned work obviously has to be done to deadline, so I do as much as I can, sleep on it and come to it fresh—things always look different in the morning.

On average, how many hours do you work a day, how many days a week? What percentage of your day would be taking photographs and what percentage would be spent on a computer?

It varies hugely. I probably work an eight-hour day, all told, and five days a week—but you're never "off duty". I take a camera with me everywhere and grab pictures all the time. Holidays are often my busiest time. One day away can result in more than 1,000 pictures to sort out.

Is consistency within your works important to you or do you like to vary styles completely when working on different collections of imagery?

I don't actually think about style. I seem to have developed a way of working which while it is always evolving is pretty consistent. Obviously, if I'm doing a Christmas card or an illustration I'll consider a more vector-based approach or whatever, but for my own work the image takes over and develops independent of style concerns.

*Would you say you have a signature
technique or medium when working?*

My first forays into the medium were very two-dimensional, compressed, abstracted and restricted to the picture plane; arrangements of elements dictated by gestalt and visual connections rather than literal ones. Now, the work is more fluid and painterly, visually deeper, and often a lot simpler.

*How important is good technique
and craft to the worth of an image?*

I've heard a few assertions that collage isn't "proper" art. Maybe because of the association with newsprint and ephemera, some people seem to think it throwaway and un-serious. I think, though, that every medium is valid; it is what you do with it that counts.

The message is the thing. If lack of technique prevents the message getting across, then it is important to put it right. But I don't think technique alone will make a successful picture. It is too easy to get hung up on the technicalities. If you're busy worrying about the filters and the masks, you're not thinking about the important stuff. Simply get to know the basics, then forget you're using them—just concentrate on the real business of picture-making. The traditional skills of composition, drawing, perspective and tonal control are still the important structural considerations. Develop an instinct for them, and then you can forget those too and think about what you really want to say with an image. Are you conveying a mood? Telling a story? Arranging texture and color? These are the real subject of your picture, and your prime consideration.

*What do you like (and indeed
dislike) about working in digital?*

I just love the flexibility. Wrong turns in a traditional-medium picture need so much reworking and often can't be rectified. Photoshop allows you so much more freedom to experiment without losing previous work. The only thing I dislike about it is the headaches when I get so involved in something I forget to stop!

*How has working digitally affected how you
work, and how has it affected your work?*

It's actually remarkably similar to the way I used to work with collage. I'd draw figures in them (I used to teach life drawing), and I was accustomed to collecting imagery, and looking all the time for things which might have a metaphorical resonance. My subject matter is often the same, as are the themes that I explore. Now, though, I have a lot more freedom with what I include—I don't have to own a piece of paper to use it, and I can include three-dimensional things in a closer version of reality than a drawing. Above all assembling the elements is so much more accurate and versatile than with glue and board.

What role do you think art plays in society?

It's how a society reveals itself. It shows us who we are, and who we were—it can sometimes be hard to recognize one's own society from the inside, and it's only when things have moved on that the art shows what was happening. So I guess that makes it a cultural record as well as actively defining a culture. It's a release mechanism, too, a form of group catharsis. That said, my work

isn't political at all; it's very personal. I have people writing and saying that they've been moved or excited by it, which is wonderful–a communication has happened at an abstract and entirely human level.

What is it like to be an illustrator?

I love it, I really do, and you have to–it's a lonely job sometimes and you do work long hours at things that may never see the light of day... but I still see every job as something new, I never stop thinking about the next image, and even (especially) on holiday I'm always on the lookout for new source material. Less a job, more a way of life! The big drawback is the unreliability of income being self-employed, but maintain a buffer of savings and you'll be fine.

What is the most important skill you can learn in college?

Artists are learning all their lives, so probably the ability to keep your eyes and your mind open. Looking and working all the time is important. Being aware of everything around you as a possible source of inspiration, being prepared to capture it, and making lots and lots of imagery will guarantee you good results.

How do you sell your art to collectors? There is no original as with paintings or the negative in analogue photography, so there is nothing to sell except the rights. Does it not endanger the development and value of this type of art? In 500 years what will Sotheby's auction of your works, maybe a signed CD?

Limited edition archival prints are as much original art as any print or edition of sculpture or photograph–but I don't worry too much about what they'll be worth when I'm dead. Their value lies in the message, not the object. As long as they find an audience, and communicate to the viewer, they've done their job. The pictures are actually best viewed close up by a single viewer. They're very personal, and I feel that enlarging them too much for gallery walls can reduce their intimacy. Publishing in books has always been a primary aim; one-to-one communication and a tactile involvement with a physical object are both important. The work is also published on the internet, where the colors, being in their original RGB mode, are seen at their most luminous–but the limitations of the 72 dpi resolution mean that the end product remains the printed book or, commercially, the book, magazine or album cover.

{ *Acknowledgements* }

I owe many people a great debt of thanks for their help with this project.

Very many thanks to all the artists who have so generously contributed their work to this book. Their beautiful imagery has enlivened its pages immeasurably. To Benedetta Bonichi, Maureen Crosbie, Alexandre Duret-Lutz, Touhami Ennadre, Sandy Gardner, Carolyn Henne, Klaus Kampert, Kris Kuksi, Ysabel LeMay, Macoto Murayama, Nicola Murray, Brian Oglesbee, Luis González Palma, Olivia Parker, Rosamond Purcell, RomanyWG, Albert Watson, Fiona Watson, Carsten Witte, and Chad Wys, my deepest gratitude.

Professor Emeritus Richard Zakia (1925–2012) read a series of magazine articles I had written and suggested that they might be expanded into a book. He was enormously enthusiastic, energetic and generous with his time. He was a dear friend and is sorely missed. Thank you, Dick, for your invaluable encouragement.

Most of these images would not exist without my models. The following people very kindly lent me their time and beautiful selves for the images in this book: Katrina Barron, Alistair Carrie, Toussaint Chevannes-Reeves, Lynsey Murrell, Asha Narsapur, Rashda Rehman, Zoe Sadler, Karen Wilson and Michelle Wolecki. Thank you all so much.

Nude modeling is not an easy job, but my lovely, patient and tireless models make it seem so. Carrie Coupar's wonderful humor and generosity enhances all of her pictures; Sam Longden always brings so many ideas and great energy to a shoot; Victoria Gibbons is the perfect water nymph; Michala Schonewald lends her willowy grace to a large number of pieces and is an inspiration. Thank you all.

Many of the nude shots were taken in the beautiful studio of Hamilton Kerr Studios in Kirriemuir. Many thanks to Kyle Hamilton and Louise Kerr for their generosity—and especially to Louise for her outstanding lighting skills.

I must thank the excellent team at Focal Press for all their hard work on this project: Valerie Geary, Emily McCloskey, Alison Duncan, Denise Power, Victoria Chow, Matt Winkworth, Geraldine Beare, Mat Willis and Alex Lazarou who all smoothed the way. Thank you!

Finally, thank you, Alistair, for so very much.

Many publishers will require a model release for an image. It is a good idea to ask your model to sign one before you start work, just to make sure there will be no problems later. A model release should read something like this:

MODEL RELEASE FORM

MODEL

Name .

Address .

Email .

PHOTOGRAPHER

Name .

Address .

Email .

I authorize the use and reproduction by you, or anyone you may authorize, of the photographs taken of me today for any purpose, without restriction, and without further compensation to me. All files and prints are entirely your property. I allow any use of the images, including distortion, blurring, alteration or use in composite imagery. I waive any right to approve the images or any copy which might be used with them. If I am under the age of majority [usually 18 but sometimes 21], the agreement is signed below by my parent or guardian.

Signature of Model .

Signature of Photographer .

Date .

I hereby certify that I am the parent or legal guardian of the model named above, and I give my consent without reservations to the above on their behalf.

PARENT OR GUARDIAN

Name .

Address .

Email .

Signature .

Date .

{ *Further Looking and Reading* }

This is by no means an exhaustive list of the best photography books, simply a selection of my favorites.

Digital montage and altered photography

David Hiscock: Work from 1982–90, Skoob 1990

A Small Book of Black and White Lies by Dave McKean, Allen Spiegel Fine Arts 1995

Maroc by Albert Watson, Rizzoli 1998

Approaching the Shadow by Jerry Uelsmann, Nazraeli 2000

The End of the Game: The Last Word from Paradise by Peter Beard, Taschen 2008

Altered Images: New Visionaries in 21st Century Photography by Romany WG, Carpet Bombing Culture 2011

Surrealism

Clarence John Laughlin: The Personal Eye by Jonathan Williams and Lafcadio Hearn, Philadelphia Museum of Art 1973

Joseph Cornell: Master of Dreams by Diane Waldman, Abrams 2002

Joseph Cornell: Shadowplay Eterniday by Hartigan/ Hopps/Vine/Lehrman, Thames & Hudson 2003

Dreaming in Black and White: Photography at the Julian Levy Gallery by Katherine Ware and Peter Barberie, Yale University Press 2006

Joan Fontcuberta: Perfida Imago by Jacques Terrasa, Le Temps qu'il Fait 2006

Roger Ballen: Boarding House by Roger Ballen and David Travis, Phaidon 2009

Abstraction

Minor White: Rites and Passages by James Baker Hall, Aperture 1978

Half-Life: Photographs by Rosamond Purcell, Godine 1980

Nature's Chaos, text by James Gleick, photography by Eliot Porter, Scribners 1990

John J. Priola: Once Removed by Andy Grundberg and Rebecca Solnit, Arena Editions 1998

My Ghost by Adam Fuss, Twin Palms 2000

Etienne-Jules Marey: Chronophotographe by Michel Frizot, Nathan/VUEF 2001

The Art of Frederick Sommer: Photography, Drawing, Collage by Keith F Davis, Yale University Press 2005

Elemental by Susan Derges, Steidl 2010

Myth-making

Joel-Peter Witkin: A Retrospective by Germano Celant and Joel-Peter Witkin, Scalo 1996

Lost Diary by Albert Watson, H. Stern Jewellers 1997

Poems of Sorrow by Luis González Palma, Arena 1999

Natural history

Illuminations: A Bestiary by Rosamond Purcell and Stephen Jay Gould, Norton 1986

Finders, Keepers: Eight Collectors by Rosamond Purcell and Stephen Jay Gould, Hutchinson 1992

Flora by Nick Knight, Art Data 1997

Art Forms in Nature: Prints of Ernst Haeckel, Prestel 1998

On This Earth: Photographs from East Africa by Nick
 Brandt, Chronicle 2005
Rainforest: A Photographic Journey by Thomas Marent,
 Dorling Kindersley 2006
Equus by Tim Flach, Abrams 2008
Creature by Andrew Zuckerman, Chronicle 2008
Bird by Andrew Zuckerman, Chronicle 2009
Treasures of the Natural History Museum by Vicky
 Paterson, The Natural History Museum 2009

Anatomy

Schola Medicinae, or, The Universal School of Medicine by
 William Rowley, 1803
Text-book of Anatomy, ed. Gerrish, Lea, 1889; 2nd
 edition Kimpton, London 1903
An Atlas of Animal Anatomy for Artists by W. Ellenberger,
 Dover 1949
Mutter Museum: Of the College of Physicians of Philadelphia
 by Gretchen Worden, Blast Books 2002
Forces of Form: The Vrolik Museum, Vossiuspers UvA
 2009

The nude

Veruschka: Transfigurations by Veruschka Lehndorff and
 Holger Trülzsch, Thames & Hudson 1986
Animal/Vegetal by Javier Vallhonrat, Abril y Buades
 1986
Acqva by Fabrizio Ferri, Industria Produzione SRL 1992
Madagascar by Gian Paolo Barbieri, Harvill Press 1995
Abyss by Hiroshi Nonami, Vents d'Ouest 1996
Work by Herb Ritts, Little, Brown, 1997
Thierry le Gouès: Soul by Veronica Webb, powerHouse
 1997
Illuminations by Joyce Tenneson, Little, Brown 1998
Pool Light by Howard Schatz, Graphis 1998

Look at You Loving Me by Melanie Manchot, Art Data
 1998
Lucien Clergue: Grands Nus by Jacques Outin,
 Umschau/Braus 1999
Skin by Laurent Elie Badessi, Edition Stemmle 2000
Francesca Woodman by Chris Townsend, Phaidon Press
 2006
Aquatique: Photographs by Brian Oglesbee, Insight 2007

Portraiture

African Ark: Peoples of the Horn by Carol Beckwith and
 Angela Fisher, Harvill Press 1995
*Ghost in the Shell: Photography and the Human Soul,
 1850–2000* by Robert A. Sobieszek, Los Angeles
 County Museum of Art and MIT Press 1999
Revelations by Doon Arbus and Diane Arbus, Random
 House 2003
Bailey's Democracy by David Bailey, Thames & Hudson
 2005
Ethiopia: Peoples of the Omo Valley by Hans Silvester,
 Thames & Hudson 2006
The Dead by Jack Burman, Magenta Foundation 2010

Fashion

The Naked and the Dressed: 20 Years of Versace by Richard
 Avedon, Schirmer/Mosel 1998
UFO: Albert Watson by Albert Watson and Gail
 Buckland, Abrams 2010
Alexander McQueen: Savage Beauty by Andrew Bolton
 and Harold Koda, Yale University Press 2011

Architecture and interiors

Mexican Churches by Eliot Porter and Ellen Auerbach,
 Chronicle 1999

Havana by Robert Polidori, Steidl 2001

Andrew Moore: Detroit Disassembled by Philip Levine and Andrew Moore, Damiani/Akron Art Museum 2010

Still Life: Inside the Antarctic Huts of Scott and Shackleton by Jane Ussher, Murdoch 2010

Sanctuary by Gregory Crewdson, Abrams 2010

The Ruins of Detroit by Yves Marchand, Steidl 2011

Beauty in Decay II: Urbex by RomanyWG, CarpetBombingCulture 2012

Landscape

Minor White: The Eye That Shapes by Peter C. Bunnell, Princeton University Art Museum 1989

Bruce Chatwin: Photographs and Notebooks, Cape 1993

Equator by Gian Paolo Barbieri, Taschen 1999

Changing the Earth by Emmet Gowin, Yale University Press 2002

Other Realities by Jerry Uelsmann, Bulfinch Press 2005

Manufactured Landscapes: The Photographs of Edward Burtynsky by Lori Pauli, Yale University Press 2009

Genesis by Sebastião Salgado and Leila Salgado, Taschen 2013

Documentary photography

Bellocq: Photographs from Storyville, the Red-Light District of New Orleans by John Szarkowski, Random House 1996

Dans le Champ des Etoiles: Les Photographes et le Ciel 1850–2000, Réunion des Musées Nationaux, 2000

The Living Dead: The Catacombs of Palermo by Marco Lanza, Westzone 2000

Looking at Atget by Peter Barberie, Philadelphia Museum of Art 2005

Don McCullin in Africa by Don McCullin, Jonathan Cape 2005

City of Shadows—Sydney Police Photographs 1912–1948 by Peter Doyle, Historic Houses Trust of New South Wales 2005

Exposure: The Iconic Photographs of Mary Ellen Mark by Mary Ellen Mark, Phaidon 2006

Tutankhamun's Tomb: The Thrill of Discovery, Yale University Press 2006

Still life photography

Signs of Life: Photographs by Olivia Parker, Godine 1978

Under the Looking Glass: Color Photographs by Olivia Parker, Little, Brown 1983

Inscape: Photographs by John Blakemore by John Blakemore and Val Williams, Zelda Cheatle Press 1991

Broken Spirits by Eberhard Grames, Edition Stemmle 1995

Conserving by Daniel and Geo Fuchs, Edition Reuss 2000

Still Life by Irving Penn, Bulfinch 2001

Ex Libris by Ralph Gibson, powerHouse Books 2001

Karl Blossfeldt: Working Collages, ed. Ann and Jurgen Wilde, MIT Press 2001

Things: A Spectrum of Photography 1850–2001 ed. Mark Haworth-Booth, Cape 2004

Das Leben der Dinge: Die Idee vom Stilleben in der Fotografie 1840–1985, ed. Ritter/Siegert/Primus, Edition Braus 2006

1000 Degrees C Deyrolle by Laurent Bochet, Assouline 2009

Cabinets de Curiosités: La Passion de la Collection by Christine Davenne and Christine Fleurent, Editions de la Martinière 2011

Theory and practice

The Art and Craft of Montage by Simon Larbalestier, Mitchell Beazley 1993

Vaughan Oliver: Visceral Pleasures by Rick Poynor, Booth-Clibborn 2000

Visualizations: The Nature Book of Art and Science by Martin Kemp, Oxford University Press 2000

Spectacular Bodies: The Art and Science of the Human Body by Martin Kemp and Marina Wallace, University of California Press 2001

Photography's Antiquarian Avant-Garde: The New Wave in Old Processes by Lyle Rexer, Abrams 2002

In Camera: Francis Bacon: Photography, Film and the Practice of Painting by Martin Harrison, Thames & Hudson 2005

Francis Bacon's Studio by Margarita Cappock, Merrell 2005

Collage: Assembling Contemporary Art by Blanche Craig, Black Dog 2008

Shadow Catchers: Camera-less Photography by Martin Barnes, Merrell 2010

Perception and Imaging: Photography, a Way of Seeing by Richard Zakia, Focal Press, 4th edition 2012

Drawing, painting and sculpture

Two Worlds of Andrew Wyeth: A Conversation with Andrew Wyeth by Thomas Hoving, Houghton Mifflin 1979

Rodin: La Passion du Mouvement by Dominique Jarrassé, Terrail 1993

Egon Schiele: The Leopold Collection Vienna by Magdalena Dabrowski and Rudolf Leopold, Yale University Press 1998

Lawrence Alma-Tadema by RT Barrow, Phaidon 2001

Goad: The Many Moods of Phil Hale, Donald M. Grant 2001

Euan Uglow: Controlled Passion—50 Years of Painting, Abbot Hall Art Gallery catalogue 2003

Matisse: His Art and His Textiles—the Fabric of Dreams by Hilary Spurling and Jack Flam, Royal Academy of Arts 2004

Jenny Saville by Simon Schama, Rizzoli 2005

The Art of Benin by Nigel Barley and Kevin Lovelock, British Museum Press 2010

Further inspiration

Film

Black Narcissus, directed by Michael Powell and
 Emeric Pressburger, cinematographer Jack
 Cardiff, 1947

Blue Velvet, directed by David Lynch 1986

Edward Scissorhands, directed by Tim Burton 1990

Prospero's Books, directed by Peter Greenaway 1991

Dead Man, directed by Jim Jarmusch 1995

Twin Falls Idaho, directed by Michael Polish 1999

O Brother, Where Art Thou? directed by Ethan and Joel
 Coen 2000

Quay Brothers: The Short Films 1979–2003, British Film
 Institute 2003

Pan's Labyrinth, directed by Guillermo del Toro 2006

Fur: An Imaginary Portrait of Diane Arbus, directed by
 Steven Shainberg 2006

La Antena, directed by Esteban Sapir 2007

Online resources and places to visit

The Visible Human Project:
 www.nlm.nih.gov/research/visible/visible_gallery.
 html

Nature by Numbers, a video about the Fibonacci
sequence by Cristóbal Vila:
 www.youtube.com/watch?v=kkGeOWYOFoA

Science Museum, London, especially the science and
art of medicine, mostly from the Wellcome Collection,
top floor:
 www.sciencemuseum.org.uk

Also the Wellcome Collection itself:
 www.wellcomecollection.org

Muséum national d'Histoire naturelle, Paris–an
unbeatable arrangement of osteology:
 www.mnhn.fr

Extraordinary teratology collections at the
Mutter Museum, Philadelphia:
 www.collegeofphysicians.org
and the Vrolik Museum, Amsterdam:
 www.amsterdam.info/museums/museum-vrolik
The Ethnological Museum in Berlin has huge
collections of art, of which the Oceanic and African
are particularly strong:
 www.smb.museum

All the major Parisian cemeteries are beautiful. Père
Lachaise, Montparnasse and Montmartre are my
favourites. San Michele, the cemetery island off
Venice, is also spectacular.

The souks of Marrakesh. Sensory overload.

The Mezquita, Córdoba. Outside, heat, light and Islamic
architecture's perfect balance between small areas of
detail and the monumental; inside, cool, dark and a
seemingly endless range of rhythmic arches.

Philae Island, the Nile, Egypt. Unbelievably, all the
buildings on this island were moved from another
doomed to flood completely after the building of the
Aswan High Dam. Having been repeatedly submerged
for nearly sixty years, they are every bit as beautiful as
they were when built well over 2,000 years ago.

Cathedrals are medieval time capsules full of color and
light, music and sculpture, life and death; my personal
favorite is Gloucester, in England.

{ *Contributing Artists* }

BENEDETTA BONICHI

www.toseeinthedark.it

Benedetta Bonichi was born in 1968, and has been exhibiting widely since 2002. Working with radiography and photography, she makes digital composites, video and sculpture. Her images strip her subjects down to their essence, creating powerful vanitas pieces that point up the futility of narcissism. Her work has appeared in art journals and scientific and academic magazines, and is in the permanent collections of museums from Rome to São Paulo.

MAUREEN CROSBIE, GALLUS GLASS

www.gallusglass.com

A graduate of Glasgow School of Art, Maureen Crosbie won the Mary Armour Still Life Award in 1983 before gaining a postgraduate degree at Jordanhill College of Further Education. She now combines her life as a teacher with stained glass work. "I have recently become interested in the potential of painted and fused glass with the inclusion of found objects. The glass has a huge range of possibilities of color, intensity and texture… Capturing a piece of someone else's history and adding it to your own time line gives it new life."

ALEXANDRE DURET-LUTZ

www.flickr.com/people/gadl

That Alexandre Duret-Lutz works with outstanding technical proficiency is no surprise; he is an assistant professor at the research and development laboratory at L'école de l'intelligence informatique (EPITA) in France. With a PhD in model checking, he teaches there and makes imagery in his spare time. His Wee Planets series presents a fascinating new way of seeing and recording the landscape and has drawn admiration around the world.

TOUHAMI ENNADRE

www.ennadre.com

Born in Casablanca, Morocco in 1953, Touhami Ennadre's family emigrated to France in 1961; he now divides his time between his homeland and Paris. Since winning the Prix de la Critique at Arles in 1976, his dramatically deep, dark gelatin prints have been exhibited and collected around Europe and the US. He has published three monographs, *Black Light, Geist in Stein (Spirit in Stone): Lebensbilder einer Kathedrale: der Regensburger Dom* and *If You See Something, Say Something.*

SANDY GARDNER

www.sandygardner.co.uk

Sandy Gardner's work is strongly influenced by the beauty of her native Cumbria in the UK. Natural elements blend with human in dreamlike and complex digital montages. Her work is widely exhibited and collected, and she has made illustrations for books, magazines and CD covers. She is also a teacher, training a new generation of artists in the north of England.

CAROLYN HENNE

The Chair of the Department of Art at Florida State University, Professor Carolyn Henne is a lecturer and sculptor who contemplates human anatomy at both the bodily and microscopic scales. She makes installations and stand-alone pieces, inspired by medical imagery both modern and historical. Her work also has a practical aspect; she has collaborated on a female phantom for the teaching and practice of surgical technique.

KLAUS KAMPERT

www.klauskampert.com

A self-taught photographer, Klaus Kampert works in Düsseldorf, Germany, making his profoundly beautiful images of the nude. The naked body, for him, reveals not simply the flesh, but the inner being that it houses– his photographs of dancers, in particular, articulate the achievement of a holistic perfection. He has been publishing and exhibiting his work since 1984 and has won several awards, including the Prix de la Photographie Paris Gold Medal in 2011.

KRIS KUKSI

www.kuksi.com

Born in Missouri in 1973 and brought up in Kansas, Kris Kuksi makes sculptures of astounding intricacy. His meticulous process involves innumerable hours collecting, sculpting and assembling thousands of separate parts. Kuksi has received several awards for his sculpture, which has featured in more than 100 exhibitions in galleries and museums worldwide and is in both public and private collections in the United States, Europe, and Australia.

YSABEL LEMAY

www.ysabellemay.com

Ysabel LeMay was born in Quebec and began her artistic life as a graphic artist and then painter; her aesthetic development moved into photography in 2010, and she now continues her exploration of the power and beauties of nature in richly detailed and vibrant Photo-Fusions. She has exhibited across the US, Canada and Europe, and she won the KiptonART Rising Star program in New York in 2011.

MACOTO MURAYAMA
AT THE FRANTIC GALLERY

www.frantic.jp/en/artist/artist-murayama.html

Macoto Murayama was born in 1984 in Kanagawa, Japan, and has been exhibiting his exquisite flower portraits since 2008. He fuses art and science in his strictly observed, dissected and meticulously reconstructed flora, making masterpieces of elegance and precision. He is a member of the Japanese Association of Botanical Illustration.

NICOLA MURRAY

www.eca.ac.uk/nmurray

A background in science is evident in Nicola Murray's art. After gaining a biology degree, Murray worked as a physiological monitoring technician in an Edinburgh hospital and this period clearly informs her highly analytical and lucid work. Murray then studied drawing and painting in Dundee, Scotland, where she won a scholarship to travel to Italy for ten months. She has now returned to Scotland, where she works with photography, printmaking and digital media, and exhibits internationally.

BRIAN OGLESBEE

www.oglesbee.com

Brian Oglesbee studied in Chicago, Illinois, and has been exhibiting and publishing worldwide since 1982. His monograph *Aquatique: Photographs by Brian Oglesbee* was published by Insight in 2007, and he continues to explore the nude alongside increasingly abstract color and monochrome work. His art is in many public and private collections.

LUIS GONZÁLEZ PALMA

www.gonzalezpalma.com

One of Latin America's most influential photographers, Luis González Palma was born in Guatemala and studied architecture. When his focus turned to photography in the 1980s, he trained his lens on the native Maya Indians of his homeland. He paints and distresses his prints to give them their characteristic warmth and richness of texture and depth of atmosphere. His 1999 book *Poems of Sorrow* presents a selection of these lush, romantic and soulful portraits.

OLIVIA PARKER

www.oliviaparker.com

Olivia Parker's artistic journey began with painting after a degree in the history of art, and moved on to photography in 1970. Her exquisite still life arrangements have featured in three monographs and more than one hundred solo exhibitions since. Working originally with contact prints, Polaroid and Cibachrome, she now works digitally and continues to make her own prints in her studio.

ROSAMOND PURCELL

www.rosamondpurcell.com

Rosamond Purcell is the world's foremost natural history museum photographer, working with natural light and objects to create mesmerizing still lives. Her studio is a veritable wunderkammer, which reflects her fascination with the remains of lives and deaths. She has exhibited around the world, published several books and illustrated many more. As she documents eggs and dice, taxidermies and junk yards, fossils and ruined books, she explores the connections between art and science and the beauty of decay and entropy.

ROMANY WG

www.flickr.com/photos/romanywg

Jeremy Gibbs, aka RomanyWG, has an eclectic curriculum vitae which ranges from making custom vinyl toys and archiving punk artifacts to film and visual effects editing on features as diverse as David Lynch's *Dune*, *Willow* and *Judge Dredd*. He has published several books on urban art and urbex photography, and currently works with the nudes and models in abandoned and industrial settings.

ALBERT WATSON

www.albertwatson.net

Born in Scotland, Albert Watson studied graphic design in Dundee and film and television at the Royal College of Art in London. Photography took over following a move to the US, and he has enjoyed enormous commercial and critical success ever since. His clean, elegant, quirky imagery has graced magazines, books and advertising campaigns the world over, and he has published several monographs, most recently a major retrospective, *UFO*, and *Strip Search*, a study of Las Vegas.

FIONA WATSON

www.fionawatson.co.uk

Born in Newfoundland, Canada, Fiona Watson came to Britain to study biological sciences at Leicester University. She worked for several years as a medical journalist before studying printmaking at Glasgow Print Studio, where she still works in both etching and digital printmaking. Her scientific background and love of nature are both evident in her sensitive, poetic work.

CARSTEN WITTE

www.carstenwitte.com

Carsten Witte attended the Bielefeld school of photography in Germany, and trained further as a photographer's assistant before becoming a freelance photographer in 1989. In demand for fashion and editorial work for magazines in Germany and further afield, he works on his famously elegant and erotic nudes and flower studies from his Hamburg studio.

CHAD WYS

www.chadwys.com

Born in Illinois in 1983, Chad Wys has been exhibiting and publishing his work since completing a Master of Arts degree at Illinois State University. He makes thoroughly modern art by rethinking, re-seeing and occasionally destroying old art. His deeply philosophical, contemplative work explores what art, as object and possession, means to him by overpainting and reworking found objects. It also happens to be very beautiful, and is finding an audience worldwide.

{ *Index* }

absence 76, 77, 79
abstraction 74–5
Adamson, Robert 59–60
Adobe logo 124
Adobe Photoshop 4, 8, 44
 canvas size 121
 clone tool 184–5
 color tools 121, 152, 154, 157, 178
 file size 102–3, 109
 gamut facility 160
 history palette 108–9
 inversions 187–8, *195*
 layer modes 4–5, 99, 101–2, 110, 111, *112*, 113, 115, *117*, 154–5, 157, 165, 180, 184, 188
 proportion 121
 selection tools 104, *105*
agents 211
ambrotypes *2*, 9, 90, 95, 146
anatomy 9, *10–12*
 digital dissections 86
 models 85–6
 textbooks *10*, 86
Ancient Egypt 25–6
animals 9, 13, 64, *65*
architecture 58–9, *62*, *93*
 modern 61
 ruins 59–61
archives 32, 89–90, 210
 back-up your back-ups 210
Arcimboldo, Giuseppe 66
Atget, Eugène 25
Atkins, Anna 5

background 87, 91
 creating 20, 103
 removing 53, 105, 180
 white or black 25, 52, 97
Bacon, Francis 79
Baillière, Jean-Baptiste 86
beauty
 appreciation of 17
 communication 18
 essential to art 17
 facial *41–2*
 finding 17
 harmony/balance 18
 idea 18
 mortal 20
 surrealist 20
 truthful/logical 17
Becher, Bernd and Hilla 7
Bertillon, Alphonse 38, 41

Blakemore, John 70
Blossfeldt, Karl 25, 67
Bonichi, Benedetta 47, 226
 A Francis Bacon (2000) 47
Brancusi, Constantin 26
Bryce software 57
Burman, Jack 47

Carroll, Lewis, 'Alice' 15
Chatwin, Bruce, *The Songlines* 73
Church, Frederic Edwin 54
Churchill, Winston 38, 65
cloning 113, 184–5
color 151
 absence (monochrome, sepia, tints) 164–5, *166–7*, 168
 advancing 152
 ambivalent 156–7
 association 155–6
 balance 154
 color/tone inversions 187–8, *189–93*
 combination 157, 159
 complementary 163
 contrast 160–1, *162*, 163
 gamuts 159–60
 hot/cool proportion *153*
 hue/saturation 152, 154, 163, 164, 165, *166*, *167*, 168
 layers/changes 154–5
 mood 155–7, *158*, 159
 similar 159
 simple 152
 space 151–2, *153*, 154–5
 temperature 151–2
communication 7, 14, 18
complexity 135–6, *137*
composition 121
 complexity 135–6, *137*, 138
 focal point 138–40
 framing 146, *147*, 148, *149*
 geometry 122, 124, *125*, 126–8
 Gestalt theory 128–31
 perspective 141, *142*, 143–5
 proportion 121–2
 symmetry/asymmetry 131–2, *133*, 134
contrast
 color 160–3
 tonal 184–5
copyright/permissions 86, 95, 173, 211–12
 public domain 212
Cornell, Joseph 25
Cottingley Fairies 3
criminals 3, 38
Cromwell, Thomas 38

Crosbie, Maureen 96, 226
 Ménage à trois (2012) *96*
cyanotype 5, 20

daguerrotype 90, 95, 146
Deakin, John 47
del Toro, Guillermo 31
developing image 114–15
 artist's block 205, 207
 finished picture 205
 input 206
 keep a sketchbook 206–7
 move between disciplines 206–7
 rest/recharge 206–7
 revisit old work 207
 style 201–3, *204*
distortions 198–200
Doyle, Arthur Conan 3
drawing 98, *99*
Duncan of Jordanstone College of Art & Design (University of Dundee) 20
Dürer, Albrecht 41
Duret-Lutz, Alexandre 226
 Butte aux canons (2006) *56*
 Parc de Passy (2007) *63*
DVDs 211

Ennadre, Touhami 226
 Hands of the World (1978) *182*
ephemera 80–1, *80–2*
Eugene, Frank, The Horse (1890) 4
experimentation 106, 108–9

Fealy, Maude *42*
file size 102–3, 121
filters 97
final touches 118
finished image
 agents 211
 archiving 210
 exhibitions 211
 getting your work 'out there' 210–11
 permissions/copyright issues 211–12
 portfolios 211
 presentations 211
 publication 211
 social media 210
Flach, Tim, *Equus* 64
focal point 138–9
 centrality 139
 contrast 140
 detail 139
 implied lines 139–40
found photographs 95–6

framing 146, *147*, 148, *149*
Friedrich, Caspar David 54

Gardner, Sandy 209, 226
 Igneous Obsession 208
Gaudí, Antoni 66
Gauguin, Paul 35
geometry
 basic 122
 changing/combining shapes 124, 126
 circles 122, *123*, 124, *126*
 Golden Section (or Mean) 127–8
 psychological resonances 126
 squares 122, 124
 triangles 124, *125*, 126
Géricault, Théodore, *Horse Frightened by Lightning* 64
Gerrish, Frederick Henry 9, *10*, *32*
Gestalt theory 128–9
 closure 130–1
 continuity 130
 proximity 129
 similarity 129
Giacometti, Alberto 98
Gilmour, David 26
Golden Section (or Mean) 127–8
González Palma, Luis 20, 228
 La coraza (1994) *74*
 Lotera 1: la rosa (1989) *22*

Henne, Carolyn 86, 226
 Suspended Self-Portrait (2002) *86*
Hill, David Octavius 59–60

ideas 205–7
influences
 architecture 25
 ethnology collections 25–6, *27–8*
 film 25–6
 found objects 25
 music, literature 26, 29
 natural history 23, 25
 people/artists 20, *21–2*, 23, *24*, 25
 sculpture 25–6
 still life photography 25
inspiration 31–2
 be aware 36
 environment 32, *33–4*, 35–6
 graveyards *34*, 35
 life drawing 32
 museums 35–6
 personal archive 32
interiors 90–2

inversions 187
 color/tone 187–8, *189–93*
 orientation 194, *195*, 196
 solarization 194

Jpeg format 102–3

Kahlo, Frida 32, 47
Kampert, Klaus 227
 No Title 53
Kertész, André 198
Kuksi, Kris 136, 138, 227
 Eden (2010) *73*
 Tribute to the Madness of Beethoven
 (2009) *137*

Lalique, René 66
Landsat satellite imagery 57–8, 177, *178*
landscape 54, *55*, 56–8
layers 4–5, 25, 99, 101–2, 175
Le Corbusier 58
LeMay, Ysabel 227
 Illuminated II (2006) 54, *55*
Lempicka, Tamara de 26
Leonardo da Vinci 66
light 110–11
Luhrmann, Baz 73

McIntyre, Catherine
 1845 (2009) *87*
 1723896 (2008) *140*
 Alice (2003) *15*
 Analogue 2 (2011) *72*
 Anastasia (2009) *139*
 Andromeda (2004) *173*
 animal skeletons *36*
 Archaeology 3 (2011) *88*, 89
 Asha I (2005) *156*
 Augenblick (2005) *164*
 Automaton (2009) *14*
 Bay Tree (2008) *91*
 Birdcage (2010) *52*
 Birth of Venus (2002) *130*
 Bones (2008) *70*
 Botox (2003) *132*
 Bronze (2007) *194*
 Bucephalus (2006) *65*
 Butterfly (2012) *153*
 Butterfly Fish I and II (2012) *192*
 Cemetery (2010) *176*
 City 4 (2011) *61*
 City I, II, III, V, VI (2011) *118–19*
 Cloisters (2012) *101*
 collage *202*

collections *2, 3, 4*, 26, *27*, 81, 89, *206*
Colour (2002) *153*
Columba livia (2011) *172*, 173
Coracias spatulatus (2011) *90*
Corridors (2012) *136*
Cow (2010) *198*
Crewe Hall (2008) *163*
Crow (2012) *102*
Cuckoo (2006) *139*
Curl (2010) *54*
Danaë (2010) *147*
Daphne, versions I-V (2012) *111*
Deeper (2009) *157*
Diamond (2007) *209*
digital montage *114–15*
The Diviner (2006) *156*
Drawing on the Wall (2012) *99*
Earth (2010) *177*
The Entomologist (2008) *9*
Equus grevyi (2004) *51*
Eve (1998) *97*
Eve (2003) *126*
Eve (2012) *199*
Extinction Event (2004) *154*
Fairy (2007) *31*
Falco peregrinus (2011) *142*, 143
Family (2012) *125*
FAQs 214–18
Feathers (2008) *35*
Femi (2008) *190*, *191*
Femme voilée (2008) *93*
Fig.43 (Observatory) (2012) *203*
figure and horse *110*
five portraits *108–9*
Flora I and Flora II (2004) *117*
Frames (2012) *148*, *149*
Genealogy (1999) *125*
Guitarra IV (2010) *122*, 123
Habitat (2009) *156*
Heart (1998) *152*
House Fire (2012) *59*
Hover (2010) *13*
Hyperborea (2010) *182*
Ice White (2004) *33*
Icehorse (2007) *178*
Iloprost (2010) *182*
Incantation (1998) *187*
Innocent (2006) *181*
Interior (2012) *204*, 205
Isis (2004) *44*
Ivy Wall (2012) *138*
K (2010) *157*
knight's tomb *77*
Kudu (2009) *64*

Landscape (2012) *56*
Le Vase Brisé (2011) *45*
life drawing *201*
Maria (2012) *128*
Marine Calligraphy (2009) *71*
Ministry of Truth (1998) *58*
Mirror (2010) *203*
Mirror (2012) *77*
Miyake (2005) *151*
Monument (2010) *135*
The Muscovite (2006) *62*, 63
Nautilus (2012) *80*
Negative (2011) *193*
Nestling (2011) *124*
Net (2010) *176*
Never Tell (2012) *145*
Outside (1999) *151*
Over Ascreavie (2011) *49*
Pazyryk (2006) *213*
Pelt (2010) *65*
Père Lachaise (Paris) *34*, 92
Persephone (2011) *72*
Perspective (2006) *143*
Pianola Man (2008) *165*
Pool (2012) *41*
Quarry (2011) *57*
Queen Ant (1998) *42*
Ram (2010) *135*
Red and Blue (2009) *171*
Reservado (2008) *42*
Restricted Access (2006) *81*
Rôle des Plantes 3 (2011) *69*
Royal Exchange Square (2010) *8*
Run (2009) *75*
St Cyrus Nether Kirkyard *34*
Sakura (2009) *82*
San Michele cemetery *34*
Schematic (2010) *45*
Shatter (2012) *112*, 113
Shells I and II (2003) *192*
Shroud (1998) *148*
Snowfall (2005) *168*
Swimmer (2012) *196*
Tangiers (2012) *96*
The Telepath (2005) *174*
Testimony (2012) *157*
Through the Wall (2010) *76*
Town and Country (2009) *91*
Trajectory (2012) *140*
A Tranced Woman (2006) *130*
Tribu (2012) *166*, *167*
Two Hearts (2012) *146*
Two Mirrors (2012) *85*
Under the Ice (2002) *94*

Underwater (2010) *174*
Unknown Device (2010) *50*
Vampire (1998) *46*
Visible Man *85*
Voyage (2011) *126*
Wall (2010) *141*
wall in Marrakesh *33*
A White Sheet of Paper (2005) *98*
Winter Moon (2008) *106*
The World Turns (2002) *127*
Mann, Sally 47
Mapplethorpe, Robert, *Pistils* 67
Marey, Étienne-Jules 23
Matisse, Henri 26, 138
method
 avoiding selection 106
 cloning 113
 combining textures 111
 creating background 103
 developing the image 114–15
 evolution 106, *107*, 108–9
 final touches 118
 practice 116
 resolution/image quality 102–3
 saving 118
 selection 104–5
 shadows/light 110–11
 technique 101–2
 translucency 4, 111, 113
Michelangelo Buonarroti 75
model release form 220
Modigliani, Amedeo 26
Mondrian, Piet 74
Murayama, Macoto 227
 Spider lily - iii -w (2009) *67*
 Spider lily - i -w (2008) *133*
 Japanese lily - v -w (2007) *133*
Murray, Nicola 227
 Jeanne (2005) *66*
Museum of Archaeology and
 Anthropology (University of
 Cambridge) 35
Museum of Ethnology (Berlin) 26
Muybridge, Eadweard 23
mythology
 classical 73
 Dreamtime (Australian Aboriginal) 73
 Norse 73–4

NASA 57–8, 213
Nash, Paul 56
natural world *64–8*
 fauna 64
 flora 66–7

nudes 8, 43
 abstract 52–3
 classical 44–5
 dissected 51
 erotic 49–50
 expressive 47
 finding a model 82
 idealized 43–4
 mechanized 50–1
 photographing 83–5
 rational 45
 romantic 46
 surreal *48*, 49
 unidentified 52

Oglesbee, Brian 70, 200, 227
 WS-20 (1998) *200*
 WS-82#1 (2001) *71*
O'Keeffe, Georgia 66, 67
online image banks 213
orientation 194, *195*, 196

painting 98
Pan's Labyrinth (film, 2007) *31*
Paris
 Le Muséum national d'Histoire
 naturelle *36*
 Musée du quai Branly 36
 Père Lachaise cemetery *34*, 35, *93*
Parker, Olivia 25, 70, 228
 Children with Acorns (1981) *24*
 The Peach (2012) *69*
 Under the Looking Glass 25
perspective 141, *142*, 143
 aerial 144–5
 focus 145
 linear 143–4
Phidias 44
Philips Anatomical Model *86*
photograms 5
photographs
 as deception 3
 as evidence 3–4
 fantastical 5
 found 95–6
 manipulation of 4–5
 planning 83
 portraits and nudes 83–5
 realism of 2
 reasons for taking 2
 studio shoot 83–5
 taking source photographs 79–80
 urbex (urban exploration) 60, 92
Photoshop *see* Adobe Photoshop

Picasso, Pablo 26, 72
Pictorialist movement 4
Piero della Francesca 57
Pitt Rivers Museum (Oxford) 35–6
portraits 38, *39–42*, 40–1, 43
 finding a model 82
 photographing 83–5
practice 116
Praxiteles 44
proportion
 changing 121
 elongated formats 122
 square format 121–2
public/private collections 94–5
Purcell, Rosamond 23, 70, 163, 228
 Awake your Faith (2011) *175*
 Dice and Deity (2007) *162*, 163
 Finders, Keepers: Eight Collectors 23
 Fish on Music (1990) 23
 Illuminations: A Bestiary 23
 Landscapes of the Passing Strange:
 Reflections from Shakespeare 175

Quay brothers (Stephen and Timothy) 26

RAW format 79, 102–3
Ray, Man 5
rayograms 5
Rembrandt van Rijn 41
resolution 102–3
Ritts, Herb 20, 26
Rodin, Auguste 51
RomanyWG (aka Jeremy Gibbs) 228
 Floating (2012) *60*
Rouilly, Adam 86
rule of thirds 127–8

saving images/files 109, 118, *119*
scanners 97
scanning electron microscope (SEM)
 imagery 177
selection tools 104, *105*, *107*
 avoiding selection 106
 feathering selection 104
 Magic Wand tool 104
 Marquee tool 104
 pen tool 104
Serrano, Andres 47
shadows 110–11
Smith, Ali, *There but for the* 26, 29
social media 210
solarization 194
source material
 anatomy 85–6

building an archive 89–90
drawing/painting 98, *99*
finding a model (portraits/nudes) 82
found photographs 95–6
interiors 90–2
non-photographed input (scanning/
 filters) 97
photographing portraits/nudes 83–5
public/private collections 94–5
still life 87, 89
taking photographs 79–80
treasure hunting 80–1
space, enclosed 90–2
Steichen, Edward 4
still life 69–70, *69–72*
 making your own subjects 87, *88*, 89
Sub-Saharan sculpture 26, *27*
subjects
 absence 76, *76–7*
 abstraction 74–5
 architecture 58–61, *58–63*
 finding 7
 landscape 54, *54–7*, 56–8
 myth 72–4
 natural world 64, *64–8*, 66–7
 the nude 43–7, *44–53*, 49–53
 the portrait 38, *39–42*, 40–1, 43
 still life 69–70, *69–72*
Surrealism 20, 49, 72
symmetry/asymmetry 131–2, *133*, 134, *135*

technique 101–2
texture 111
 bank notes 170–1, 173
 charcoal on paper *201*
 engravings 171, 173
 finding 170–1, *172*, 173
 graffiti 171, *172*
 mirrors 173, *174*, 175
 pattern 175, *176*
 presence of the old 170
 reflections/refractions 173, *174*, 175
 scale 177
 text 170
 textiles *176*
 using 177–8
themes
 aging 14
 anatomy 9, *10–12*
 animals 9, 13
 attachment 13
 communication 14
 dolls 13
 environment 8

finding/identifying 7
natural world 9
nudes 8
portraiture 8–9
threat and containment 14
visual metaphor 7
Titian, *The Deposition* 75
tone 180
 color/tone inversions 187–8, *189–93*
 contrast 184–5
 emotional climate of image 180
 high/low-key images 180, *181–3*
Transfigurations (Veruschka and Trülzsch)
 20
translucency 4, 111, 113
Treasure of Tutankhamun (exhibition, 1972)
 25
Trülzsch, Holger 20
Turner, J.M.W. 54
Tyson, Mike 20, *39*

Uccello, Paolo 57
Uelsmann, Jerry 5
unconscious mind 148
urbex (urban exploration) photography
 60, 92

Van Gogh, Vincent 35
Velázquez, Diego, 'Portrait of Innocent
 X' 38, 40
Veruschka (von Lehndorff) 20
The Visible Human Project 86
Vogue 20

Watson, Albert 20, 228
 Lynn, Birdcage, Marrakesh, Morocco
 (1989) *21*
 Malcolm X Fashion Story, New York City
 (1992) *170*
 Mike Tyson, Catskills, NY (1986) *39*
Watson, Fiona 228
 Love Birds (2012) *155*, 157
 The Moth's Ball (2012) *158*, 159
Wilde, Oscar 35
Witte, Carsten 229
 Nika Smoke, Hamburg (2006) *49*
Wys, Chad 229
 Nocturne 80 and *Nocturne 113* (2011) *40*